D0915736

the complete best of watercolor volumes 1 & 2

ROCKPORT

First published in the United States of America by
Rockport Publishers, Inc.
33 Commercial Street
Gloucester, Massachusetts 01930-5089
Telephone: (978) 282-9590
Facsimile: (978) 283-2742
www.rockpub.com

ISBN 1-56496-688-7

10 9 8 7 6 5 4 3 2 1

Cover Design: Juan Carlos Morales, Madison Design
Cover Image: Pamela Caughey *Poppies*
Back Cover Images (from top): Judith Klausenstock *Yellow Tomatoes*, Anthony Ventura *Edge of the Woods*, Celia Clark *The Rejection*

Printed in China.
Printed in Hong Kong.

ACKNOWLEDGEMENTS

It was great to be asked

to help with this book—

what a show we saw!

Thank you all.

Betty Lou Schlemm, A.W.S., D.F.

As I write this, it could only have happened in the Arabian Nights. In 1959, I was the second vice president of the American Watercolor Society when I was asked by my friend Chen Chi to run for president. Of course I was delighted! But the delight did not last long. I found that we were bankrupt, and, in addition, that we were not tax-exempt—or even

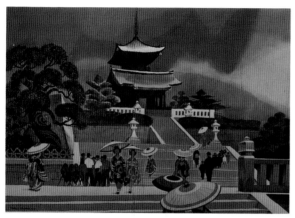

incorporated. We were faced with a manager whose salary had to be paid with our current and next year's dues.

Luckily, I was then teaching watercolor and some of my students knew "persons in high places." Also, I had some dear friends from my active days in the Society of Illustrators. One of them, Lincoln Levine, was a corporation lawyer who came to our aid. In no time, we were tax-exempt and had become a corporation. I got my students involved in the Society, serving as directors and chairmen. The women became officers during my administration—they served brilliantly—and Dale Meyers is now president. I got rid of "purchase awards" (monetary awards that buy works away from the artist who created them) and started a program of medals.

Our awards became famous, and we established the Dolphin Fellowship. I swore that our society would never go begging for awards again. My administration ended in 1986, and after 27 years I was proud to have left the Society with more than half a million dollars in the black.

—Mario Cooper, N.A., P.P.A.W.S., D.M., D.F., President Emeritus

And the show began...
Wonderful...

Just four thousand five hundred paintings before us. What was to be a day of jurying became two days, and then a few more hours. Over and over we reviewed the slides and transparencies, choosing those of excellence, and enjoyed all the hours of seeing some of the finest watercolors done in America. There were far too many great paintings, and with dismay we had to start eliminating many truly good pieces—because of sameness of subject matter, similar style, and, sometimes, perhaps because of a far off reason that is hard to pinpoint. We had to think of the book. A book that would encompass all the styles and thoughts of American art today, a book of great variety.

We saw so many prize paintings from exhibitions all over the country. Not even knowing these artists personally, we felt we had met friends again because of their work.

Tom Nicholas was the other "juror" of this book, a friend for more than thirty years, a member of the National Academy, a member of the American Watercolor Society, and of many other watercolor associations. Little by little, remembrances were brought up, of the impressive painters we were seeing now and of those great painters we have known over the years.

We thought of Mario Cooper, the president of the American Watercolor Society for twenty-seven years, and now president emeritus. It is hard to think of watercolor today—American watercolor—without first thinking of this great man who added so much to the growth and fine tradition of our medium, watercolor as we know it today. How fitting to dedicate the first volume of **THE BEST OF WATERCOLOR** *to Mario Cooper, National Academy, American Watercolor Society.*

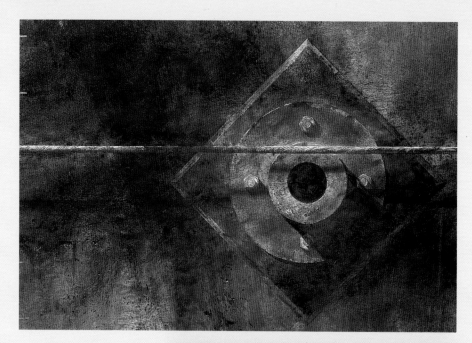

LARRY WEBSTER

CABLE, FLANGE, AND SCALE

39" x 27" (99.1 cm x 68.6 cm)

Fabriano Artistico 100 lb.

M.C. KANOUSE

SISTER MAURA'S CHICKENS II

13.5" x 21" (34.3 cm x 53.3)

Lana Aquarelle 300 lb. cold press

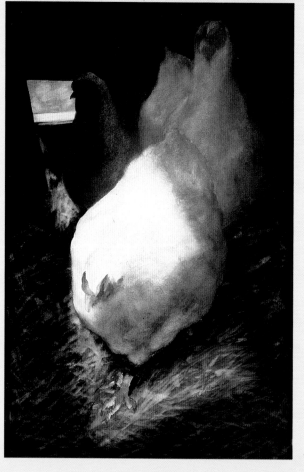

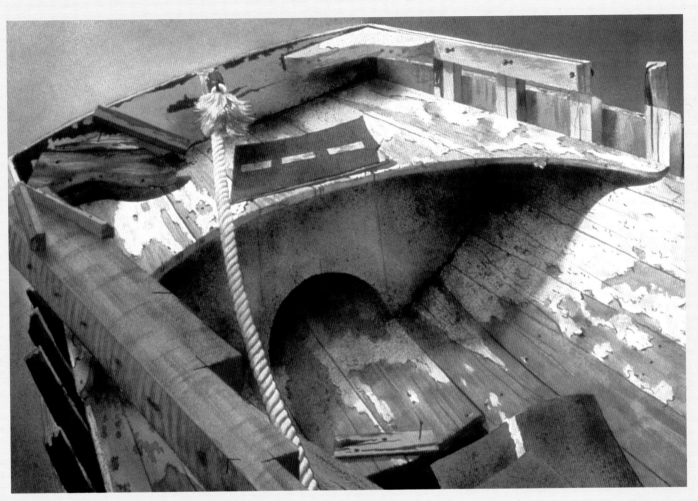

JOHN BRYANS

NEEDS WORK

29.5" x 41" (74.9 cm x 104.1 cm)

Arches 140 lb. rough

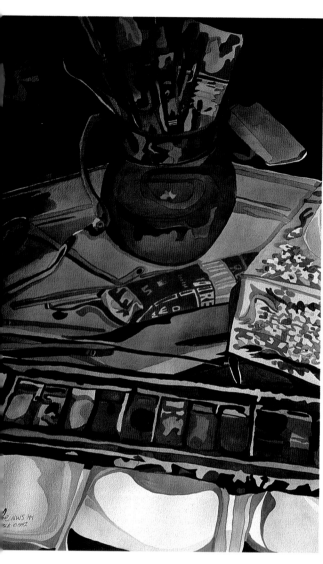

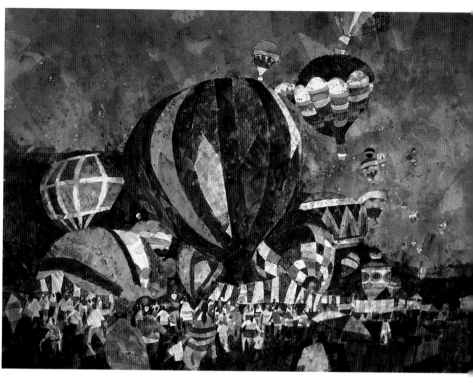

ARNE LINDMARK, N.A., A.W.S., D.F.

LIFT OFF AT DAWN

22" x 30" (55.9 cm x 76.2 cm)

Fabriano Artistico 140 lb. rough

Media: Water based acrylic, watercolor glazes

SANDRA E. BEEBE,
A.W.S., N.W.S.

TOM'S TABLE

30" x 22" (76.2 cm x 55.9 cm)

Arches 140 lb. cold press

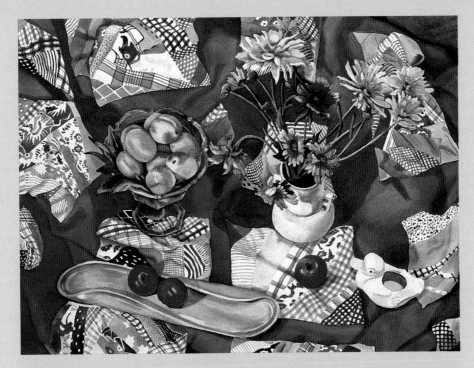

MAXINE YOST

STILL ON CRAZY QUILT

22" x 30" (55.9 cm x 76.2 cm)

Arches 300 lb.

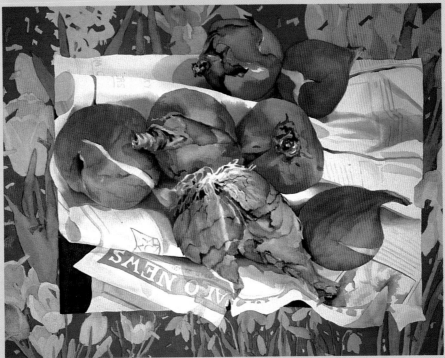

SUSAN WEBB TREGAY

THEY'RE NOT ONIONS

22" x 30" (55.9 cm x 76.2 cm)

Arches 140 lb. cold press

PEGGY BROWN,
A.W.S.. N.W.S.

DUET

26" x 40" (66 cm x 101.6 cm)

Rives lightweight

Media: Transparent watercolor,
graphite, collage

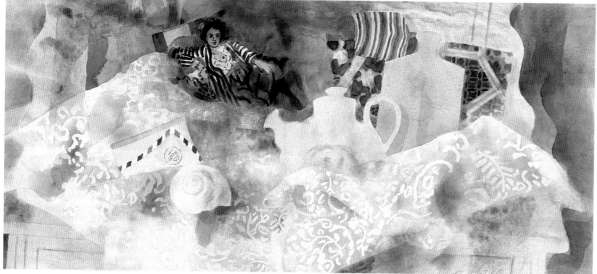

RUTH COBB

HOMAGE TO MATISSE

18.5" x 39" (47 cm x 99 cm)

Whatman 133 lb. hot press

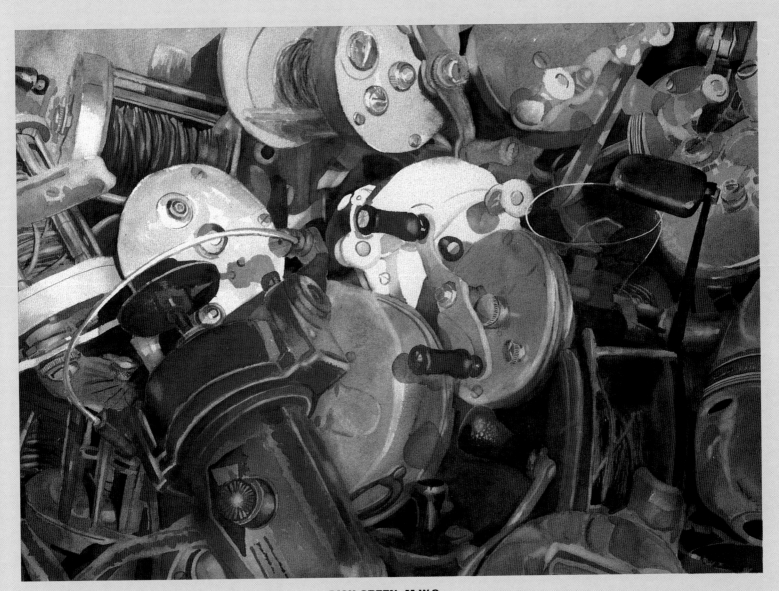

DICK GREEN, M.W.S.

REEL UPON REEL

22" x 30" (55.9 cm x 76.2 cm)

Arches 300 lb. cold press

RENEÉ FAURE

FAMILY PORTRAIT

29.5" x 41.5" (74.9 cm x 105.4 cm)

Arches 300 lb.

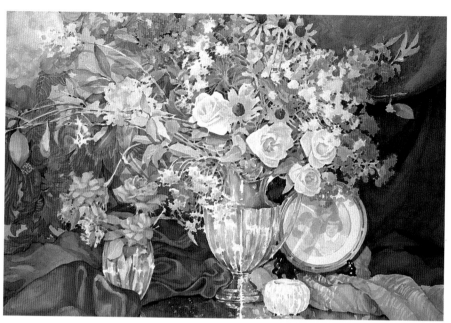

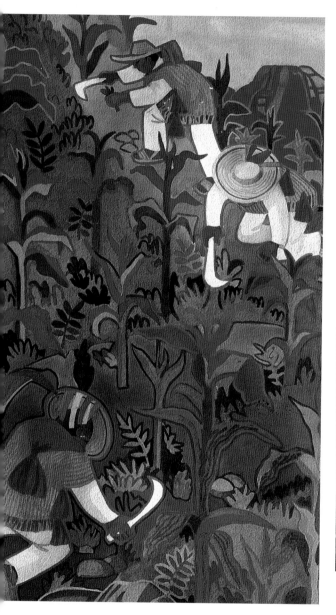

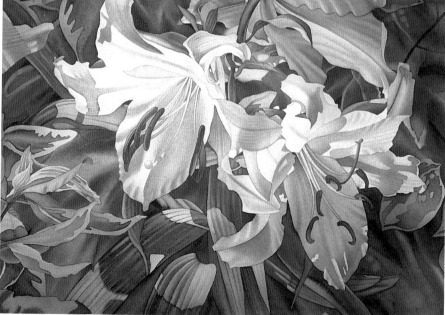

NANCY MEADOWS TAYLOR, N.W.S.

RHAPSODY IN BLUE II

29" x 41" (73.7 cm x 104.1 cm)

Arches cold press

Media: Transparent pigments, occasional gouache

JOANNA MERSEREAU

TAPESTRY OF CORN

30" x 22" (76.2 cm x 55.9 cm)

Arches 300 lb. cold press

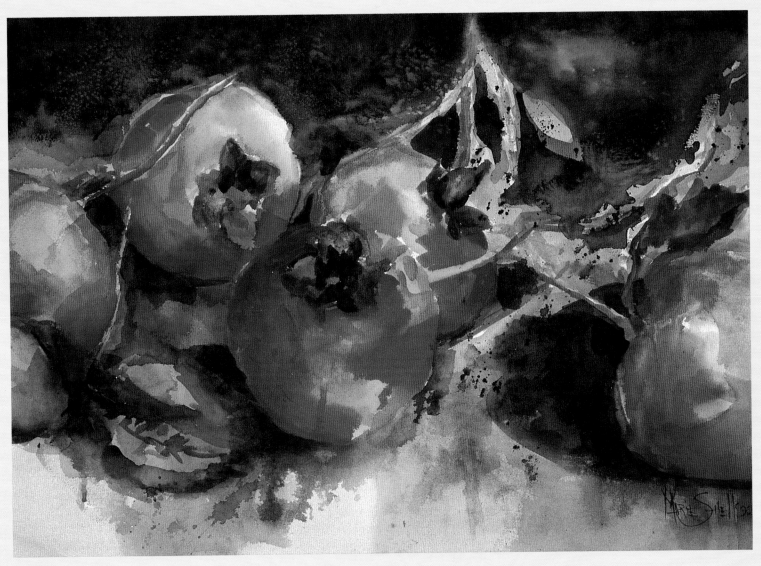

MARIE SHELL

AUTUMN TREASURE

22" x 30" (55.9 cm x 76.2 cm)

Arches 300 lb. rough

JACK JONES

TRINITY CHURCH

21" x 29" (53.3 cm x 73.7 cm)

Arches 140 lb. cold press

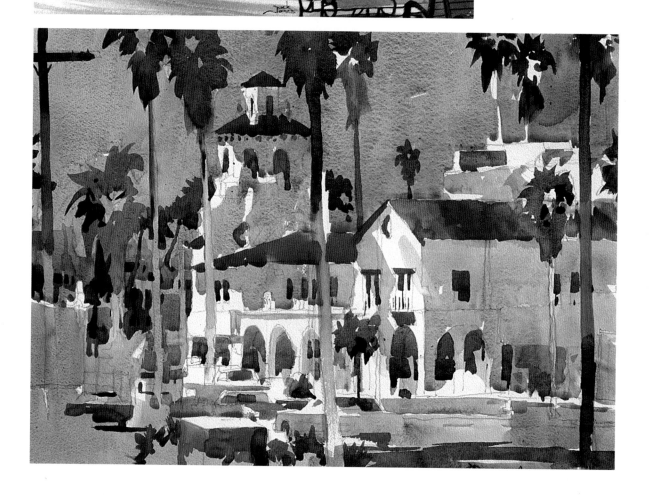

DON O'NEILL, A.W.S.

OLD FOX THEATER

20" x 28" (50.8 cm x 71.1 cm)

Bockingford 140 lb. cold press

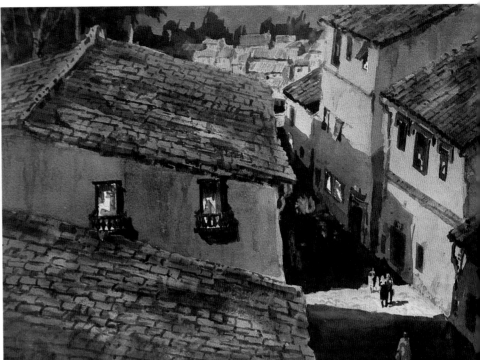

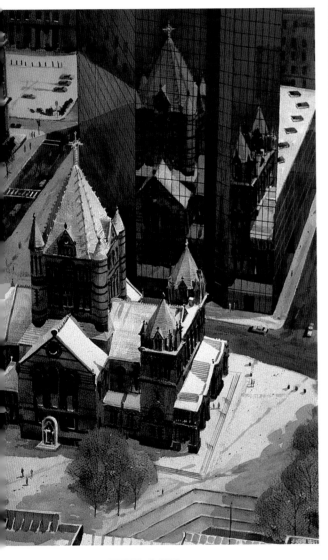

JEAN MUNRO

THINGS THAT GO BUMP
IN THE NIGHT
26" x 34" (66 cm x 86.4 cm)
Arches 140 lb. cold press
Media: Ink, shapes in plastic, rock
salt

**ASTRID E. JOHNSON,
N.W.S.**

COLORADO RIVER
22" x 30" (55.9 cm x 76.2 cm)
Arches 140 lb.

JOAN ASHLEY ROTHERMEL, A.W.S.

HERON HAVEN

12" x 18" (30.5 cm x 45.7 cm)

Arches 140 lb.

J. EVERETT DRAPER, A.W.S.

MAYPORT FERRY I

10" x 14" (25.4 cm x 36.6 cm)

Arches 140 lb. rough

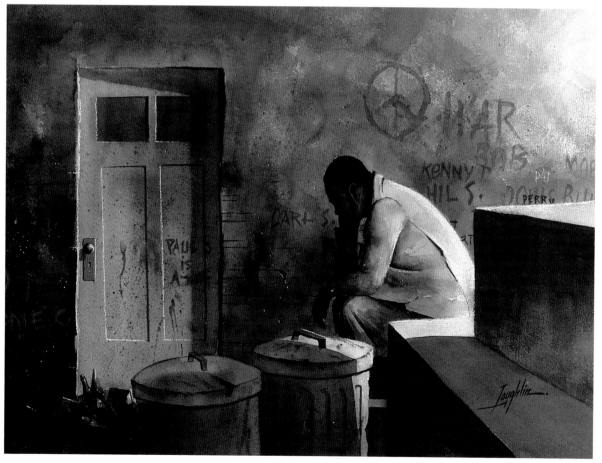

JOHN L. LOUGHLIN

GHETTO THINKER

22" x 30" (55.9 cm x 76.2 cm)

Arches 300 lb. cold press

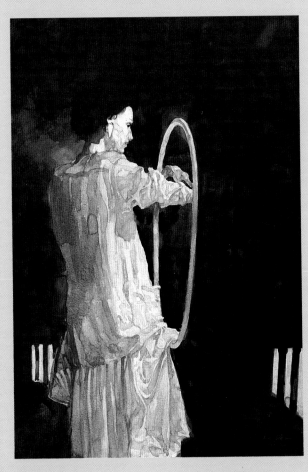

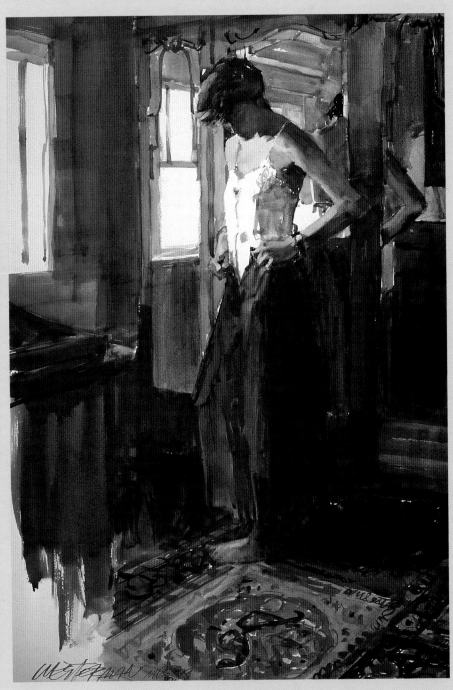

BILL JAMES, A.W.S., P.S.A.

MANNEQUIN WITH HOOP

33" x 26" (83.8 cm x 66 cm)

Crescent

Media: Gouache

ARNE WESTERMAN, A.W.S., N.W.S.

CAROL WITH ANTIQUE WARDROBE

37" x 25" (92.5 cm x 62.5 cm)

Lana Aquarelle 140 lb. hot press

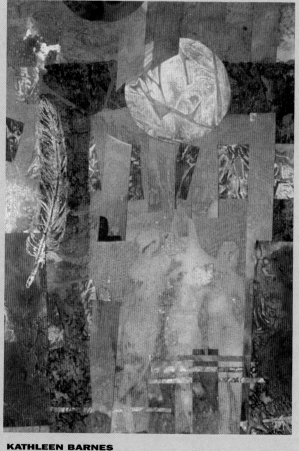

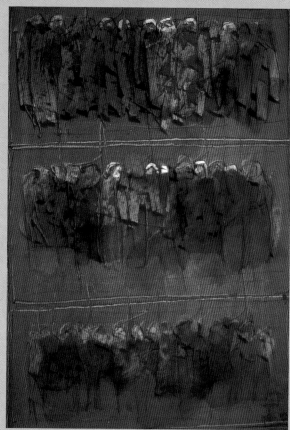

EDWARD REEP

HOW DID YOU KNOW I
NEEDED A ROSE
28" x 38" (71.1 cm x 96.5 cm)
Arches 140 lb. rough

**JOHN McIVER, A.W.S,
N.W.S., W.H.S.**

PARADE IV
35" x 25" (89 cm x 63 cm)
Arches 260 lb. cold press, single
elephant
Media: Acrylic wash, carbon line

KATHLEEN BARNES

MOONDANCE
15" x 20" (38.1 cm x 50.8 cm)
Strathmore Aquarius 90 lb.

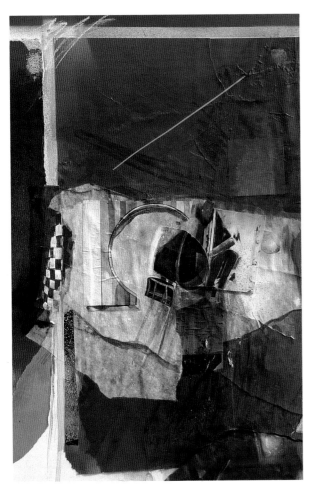

**J. LURAY SCHAFFNER,
N.W.S.**

COLOR, CHAIN AND RED

40" x 30" (101.6 cm x 76.2 cm)

4-ply museum board

Media: Watercolor collage

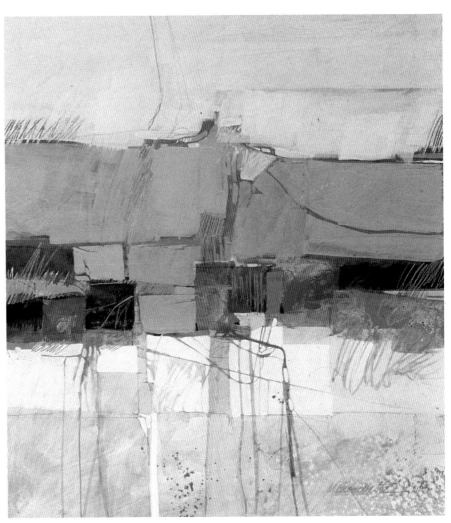

AL BROUILLETTE

HORIZONS III

20" x 18" (50.8 cm x 45.7 cm)

Strathmore 500 board

Media: Transparent acrylic, semi-
opaque and opaque watercolor

**FRED L. MESSERSMITH,
A.W.S., W.H.S.**

MAINE MOODS

22" x 30" (55.9 cm x 76.2 cm)

Arches 300 lb. cold press

Media: Watercolor, gouache

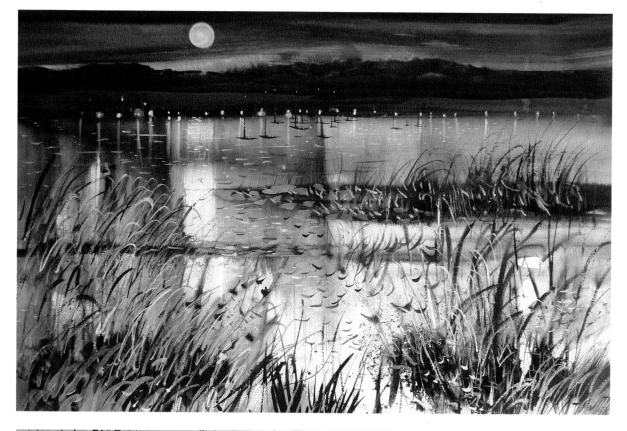

BOGOMIR BOGDANOVIC

WHISPERING BROOK

22" x 28" (55.9 cm x 71.1 cm)

Arches 140 lb. cold press

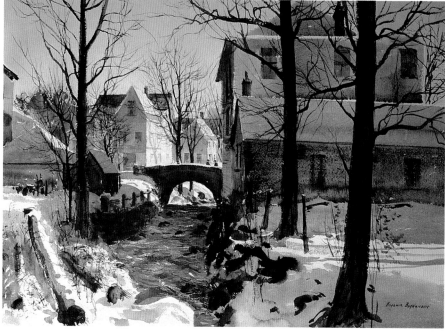

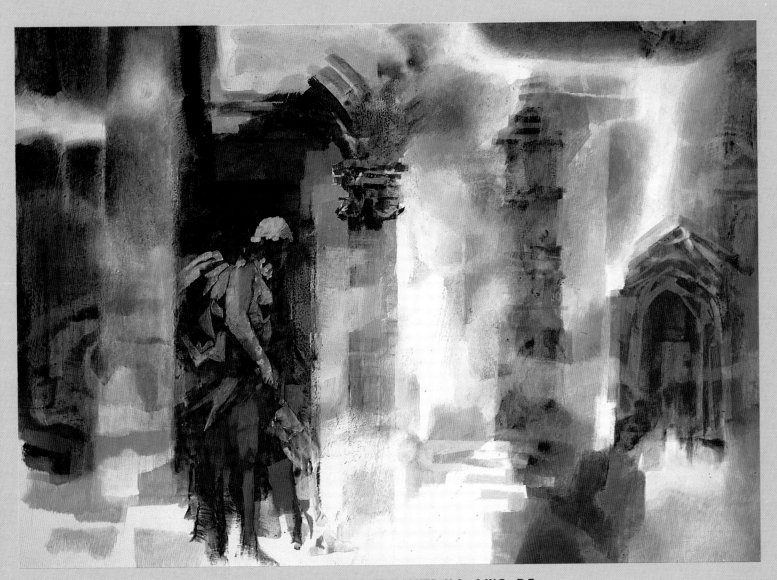

CAROL PYLE JONES, N.A., A.W.S., D.F.

TEMPLE OF APOLLO

60" x 32" (152.4 cm x 81.3 cm)

Illustration board

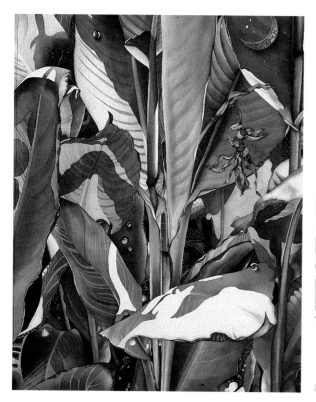

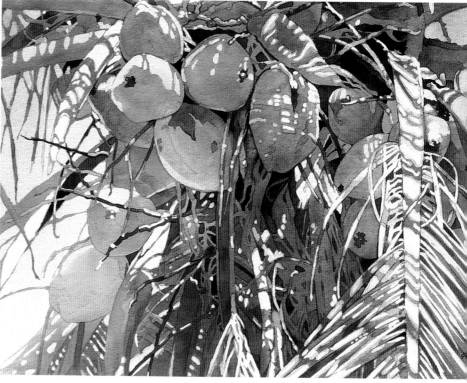

SABINE M. BARNARD, N.W.S.

SUMMER FOREST

22" x 30" (55.9 cm x 76.2 cm)

Arches 300 lb. cold press

Media: Metallic watercolor

JEAN H. GRASTORF, A.W.S., N.W.S.

SUN-KISSED

20" x 28" (50.8 cm x 71.1 cm)

Waterford 300 lb. rough

ANN PEMBER

MAGNOLIA

14" x 21" (35.6 cm x 53.3 cm)

Arches 140 lb. cold press

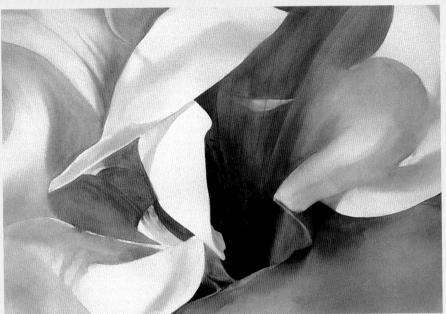

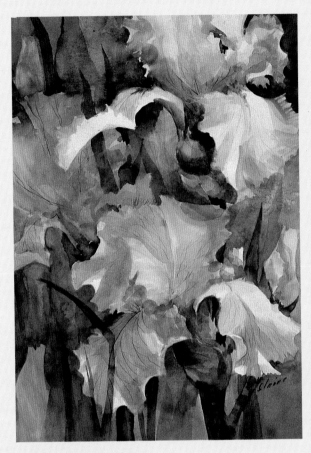

ELAINE FREDERICKSON

WHITE IRISES

22" x 30" (55.9 cm x 76.2 cm)

Whatman 140 lb. cold press

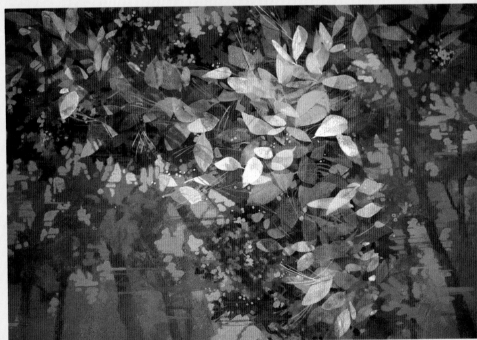

CYNTHIA L. WILSON

WINDSWEPT

15" x 22" (38.1 cm x 55.6 cm)

Arches 140 lb. cold press

Media: 100% acrylic layered washes

CELIA CLARK
ANNA
21.5" x 21.5" (54.6 cm x 54.6 cm)
Arches 140 lb. cold press

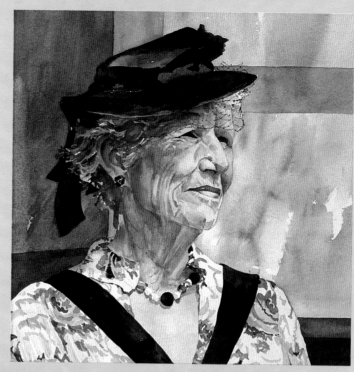

**LINDA J. CHAPMAN
TURNER, W.V.W.S.,
M.W.S.**
THE BLUE VASE
14" x 10" (35.6 cm x 24.4 cm)
Arches 300 lb. cold press

**CAROLYN GROSSÉ
GAWARECKI**
SUNCAST
29" x 21" (73.7 cm x 53.3 cm)
Arches 140 lb. rough

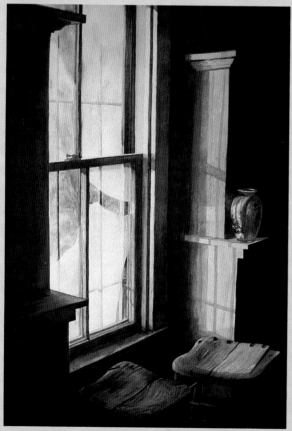

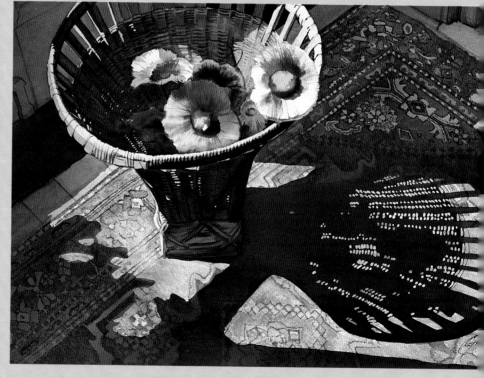

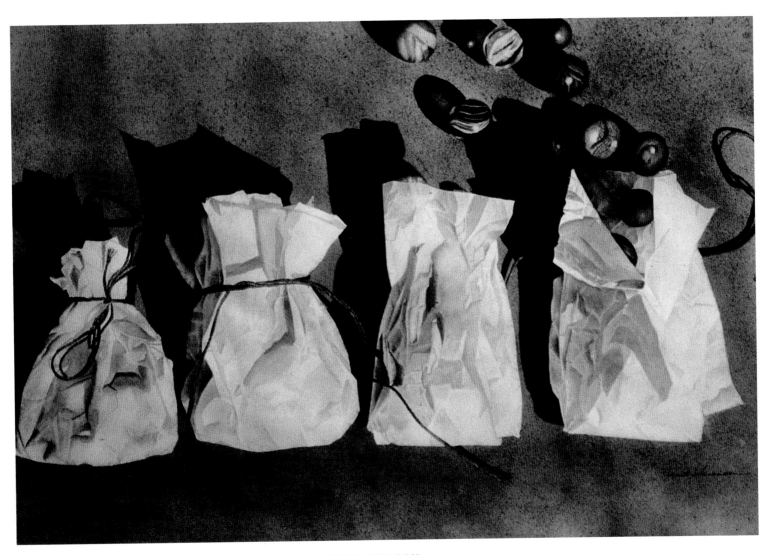

JANET SWANSON

1 - 2 - 3 - GO

28" x 36" (71.1 cm x 91.4 cm)

Arches 140 lb. cold press

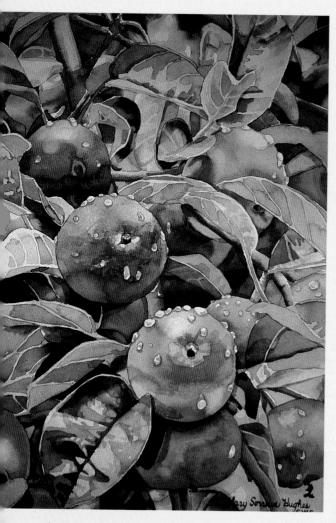

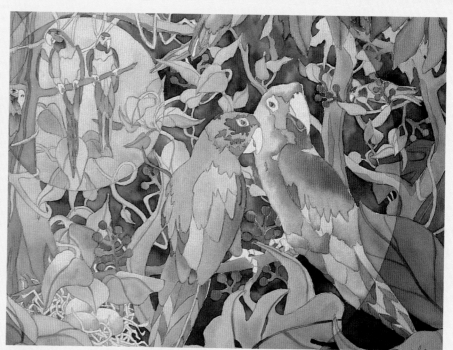

MICKEY DANIELS

MOONLIGHT SERENADE

14" x 20" (35.6 cm x 53.3 cm)

Arches 140 lb. cold press

MARY SORROWS

HUGHES

STRAWBERRY BANKE

APPEAL

15" x 21" (38.1 cm x 53.3 cm)

Arches 140 lb. cold press

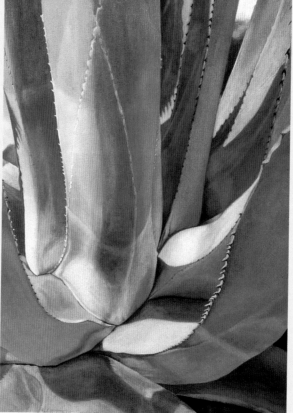

NEDRA TORNAY, N.W.S.

AGAVE CACTUS

30" x 22" (76.2 cm x 55.9 cm)

Waterford 300 lb. rough

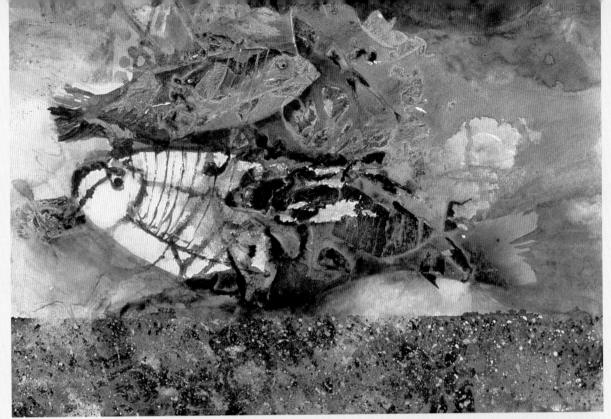

DONNA SHUFORD
FOSSILS
28" x 36" (71.1 cm x 91.4 cm)
Morilla
Media: Watercolor collage

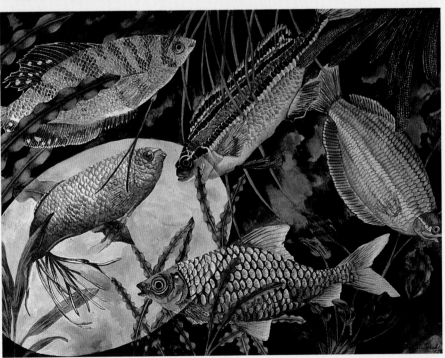

FRANCES KIRSH, F.W.S.
FISHES IN GRAY & YELLOW
15" x 20" (38.1 cm x 50.8 cm)
Crescent smooth

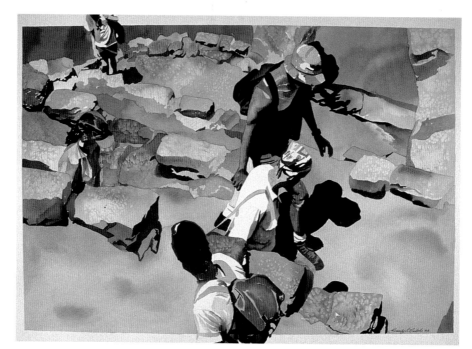

BEVERLY NICHOLS

LABYRINTH OF THE
MINOTAUR

29.5" x 41" (74.9 cm x 104.1 cm)

Arches 555 lb. cold press

ROBERT G. SAKSON,
A.W.S., D.F.

LOCOMOTIVE

22" x 30" (55.9 cm x 76.2 cm)

Arches 140 lb. rough

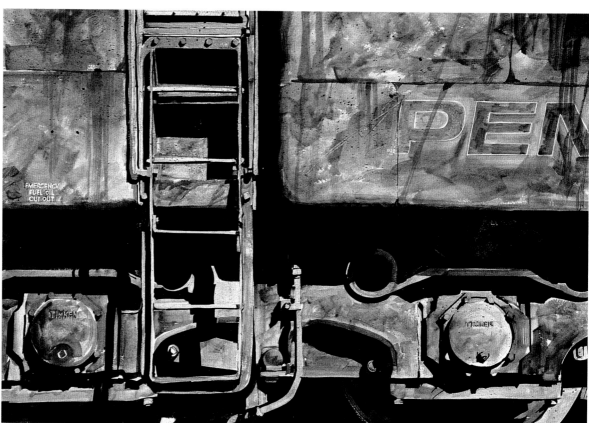

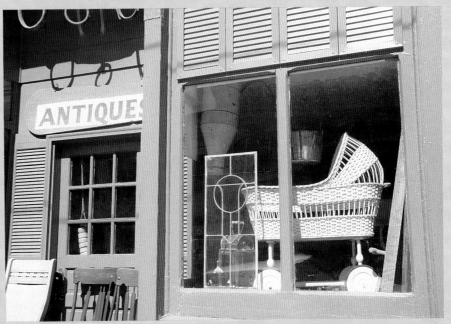

DORIS O. TURNBAUGH

ANTIQUE SHOPPE

24" x 30" (60.9 cm x 76.2 cm)

Arches 140 lb. cold press

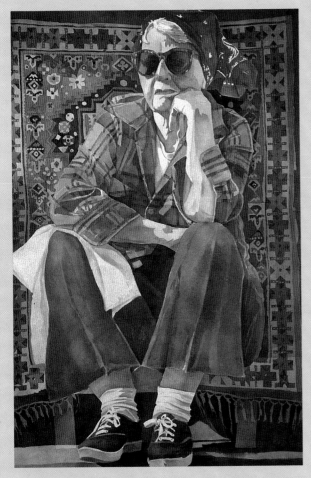

BONNIE PRICE, A.W.S., N.W.S.

LOIS

22" x 30" (55.9 cm x 76.2 cm)

Arches 140 lb. hot press

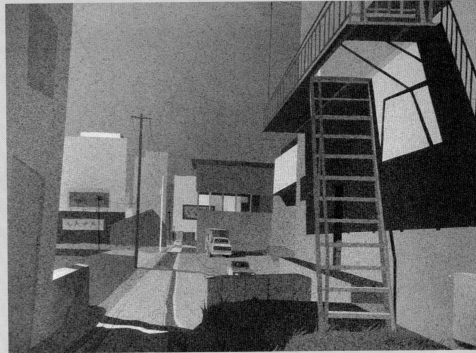

MARK E. MEHAFFEY

SOUTHERN EXPOSURE II

22" x 30" (55.9 cm x 76.2 cm)

Arches 140 lb. hot press

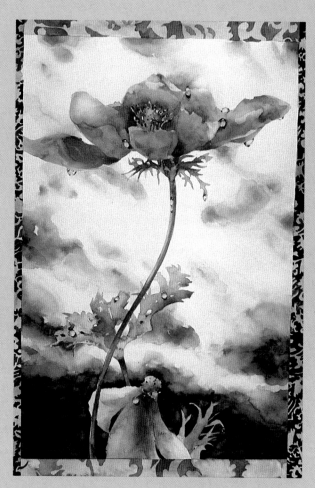

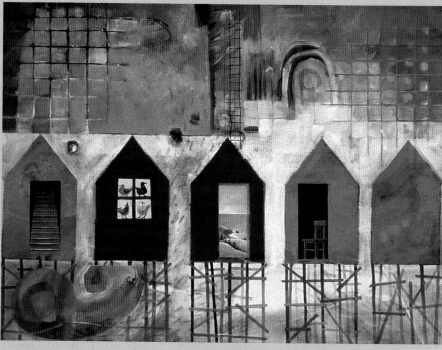

MICHAEL SCHLICTING

LIFE'S CHOICES

22" x 30" (55.9 cm x 76.2 cm)

Arches 300 lb. cold press

Media: Transparent watercolor underpainting, gouache

SHARON HILDEBRAND

ANEMONE

33" x 25" (83.8 cm x 63.5 cm)

Fabriano Classico 280 lb. cold press

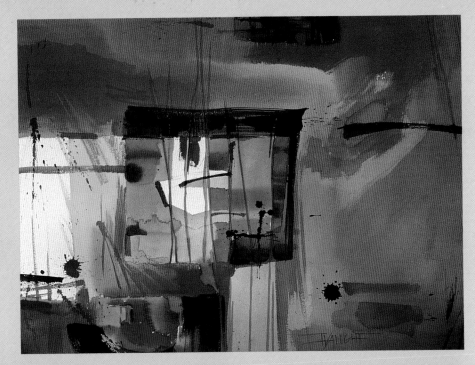

TED VAUGHT

ON THE WARPATH

21" x 29" (53.3 cm x 74.7 cm)

Arches 140 lb. rough

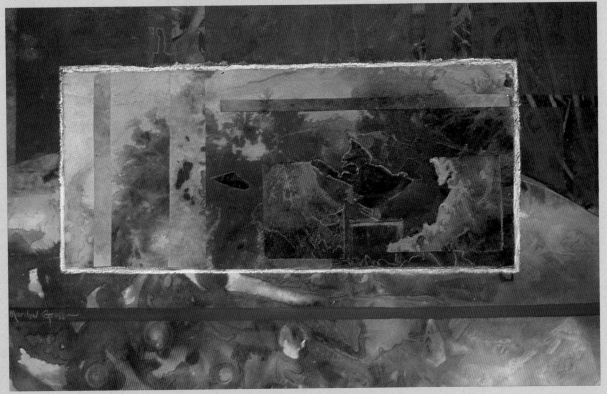

MARILYN GROSS

LIFE FORMS

15" x 21" (38.1 cm x 53.3 cm)

Arches 140 lb. cold press

Media: Watercolor, light fast inks,

quilling paper

MARY BLACKEY

MORNING AND
INDUSTRY

22" x 30" (55.9 cm x 76.2 cm)

Arches 300 lb. cold press

Media: watercolor background,
acrylic for small washes and
details

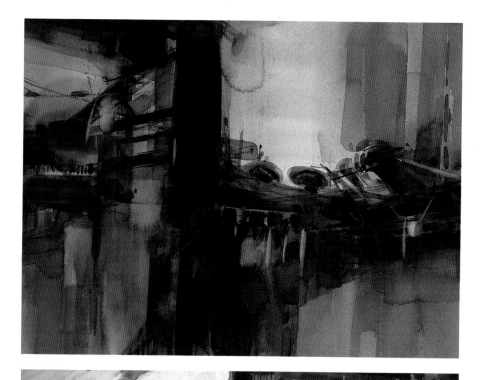

CARLTON B. PLUMMER

VERMONT MILL

21" x 28" (53.3 cm x 71.1 cm)

Arches 140 lb. cold press

Media: Transparent watercolor,
gouache

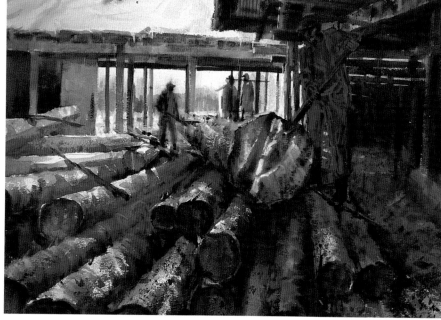

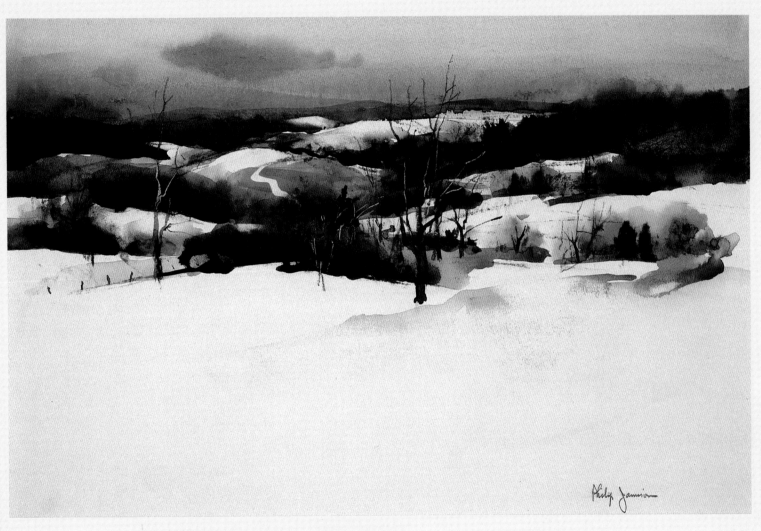

PHILIP JAMISON

HORSESHOE HILLS

9.5" x 14.5" (24.1 cm x 36.8 cm)

Cold press

Media: Watercolor, charcoal

CARMELA C. GRUNWALDT
RETREAT
30" x 40" (76.2 cm x 101.6 cm)
140 lb. hot press

JUDY MORRIS, N.W.S.
AJIJIC'S PEANUT VENDER
20" x 28" (50.8 cm x 71.1 cm)
Arches 300 lb. cold press

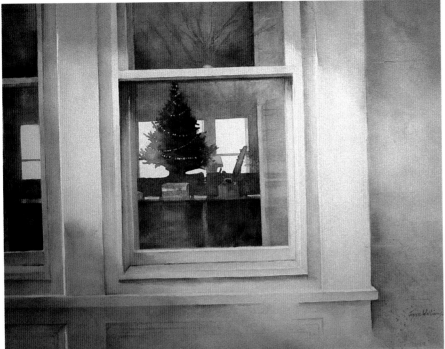

JOYCE WILLIAMS, A.W.S., N.W.S.
TABLE TOP TREE
22" x 30" (55.9 cm x 76.2 cm)
Strathmore Gemini 300 lb. cold press

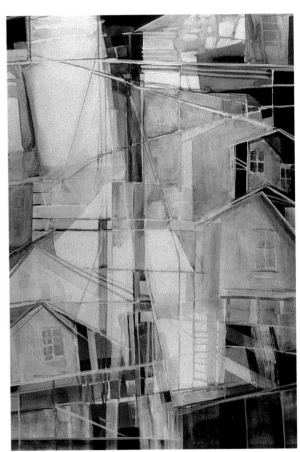

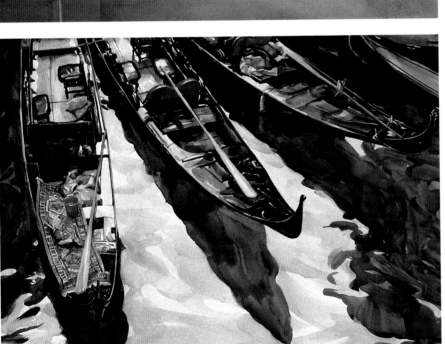

GERALD J. FRITZLER,
N.W.S., M.W.S., C.W.S.
GONDOLA'S
18.25" x 26.75" (46.4 cm x 67.9 cm)
Strathmore 115 lb. hot press

MARY BRITTEN LYNCH
CARIBBEAN CRUISE, 2
30" x 20" (76.3 cm x 50.8 cm)
Arches 300 lb. cold press
Media: Transparent watercolor,
acrylic, gesso

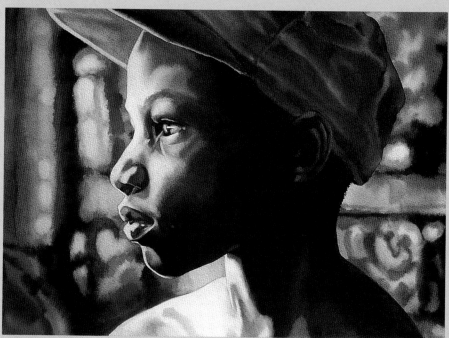

KAREN FREY

BOY WITH BLUE CAP

14" x 20" (35.6 cm x 50.8 cm)

Lana Aquarelle 140 lb. rough

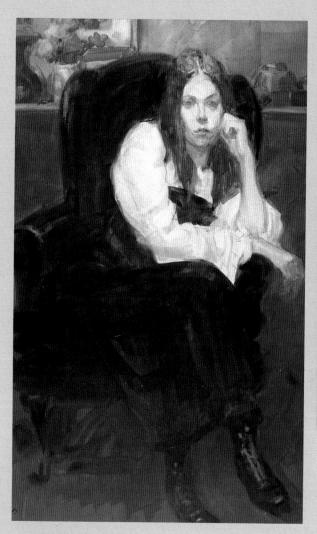

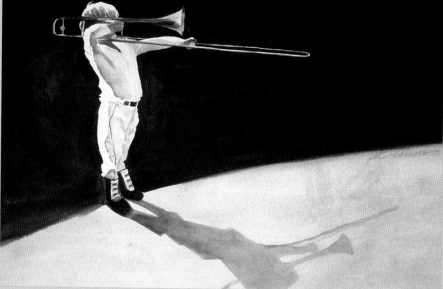

IRWIN GREENBERG

MADELINE

11" x 7" (27.9 cm x 17.8 cm)

Bristol 3-ply plate

PAT CAIRNS

MUSIC MAN

22" x 30" (55.9 cm x 76.2 cm)

Arches 140 lb. hot press

GEORGE JAMES

AWAY FROM THE WIND

25" x 38" (63.5 cm x 96.5 cm)

Synthetic Kimdura 140 lb. hot press

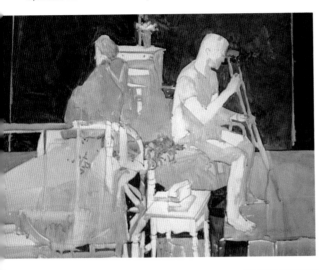

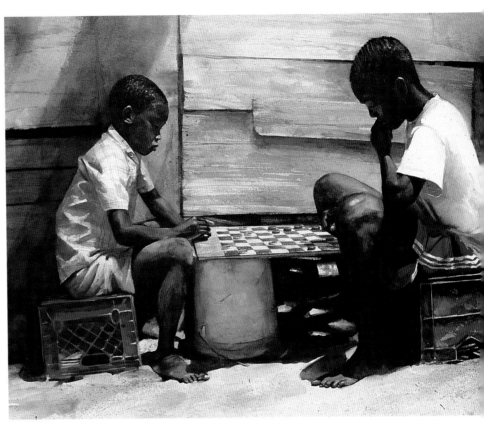

JERRY ROSE

THE CHECKER GAME

21" x 29" (53.3 cm x 73.7 cm)

Fabriano Artistico 140 lb. cold press

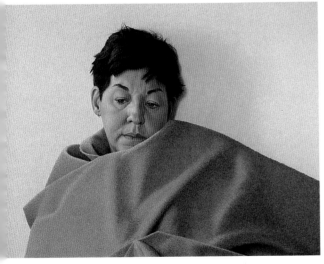

JOSEPH MANNING

UNTIL DEATH DO US PART

17.25" x 23.5" (43.8 cm x 59.7 cm)

Gesso on illustration board

Media: Egg tempera, watercolor

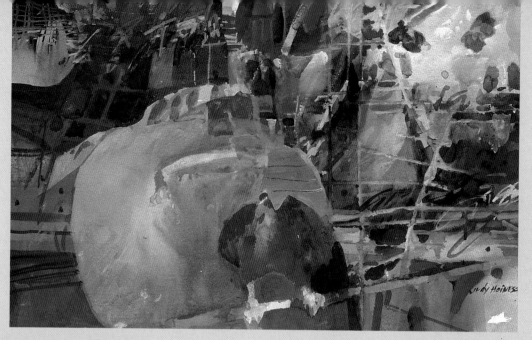

JUDY A. HOINESS

BIRD AND BOUQUET

22" x 30" (55.9 cm x 76.2 cm)

300 lb. cold press

MAXINE CUSTER

JEWELS OF DISCOVERY

22" x 30" (55.9 cm x 76.2 cm)

Arches 140 lb.

Media: Watercolor, acrylic

BARBARA BURNETT

PURSUIT OF THE GOLD

15" x 21" (38.1 cm x 53.3 cm)

Arches 140 lb. hot press

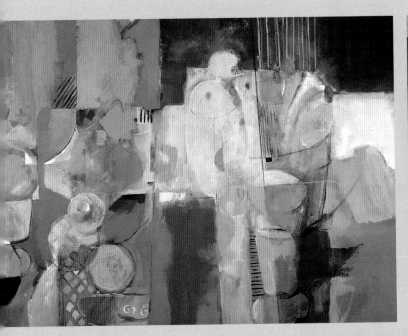

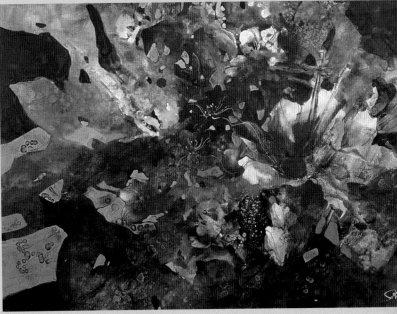

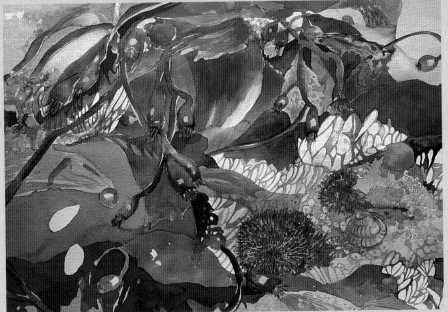

BARBARA MILLICAN

STILL LIFE TAPESTRY

22" x 30" (55.9 cm x 76.2 cm)

Arches 140 lb. cold press

Media: Acrylic

**JOYCE H. KAMIKURA,
F.C.A., N.W.S.**

MYSTIC ARRANGEMENT

22" x 30" (55.9 cm x 76.2 cm)

Arches 140 lb. cold press

Media: Acrylic

**RUTH HICKOK
SCHUBERT, W.W.,
N.W.W.S.**

SHOAL OF BARNACLES

22" x 30" (55.9 cm x 76.2 cm)

Arches 300 lb. cold press

JEAN SNOW
THRU THE GLASS
15" x 20" (38.1 cm x 50.8 cm)
Arches 90 lb. cold press
Media: Acrylic, watercolor, collage

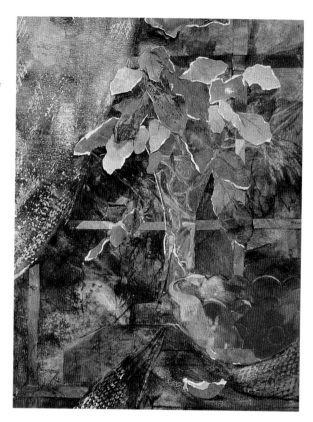

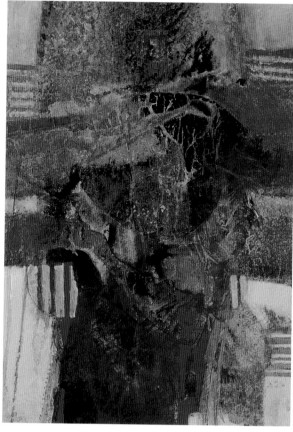

BELLE OSIPOW
THE FORBIDDEN FRUIT
19" x 27" (48.3 cm x 68.6 cm)
Arches 140 lb.
Media: Watercolor, acrylic, collage

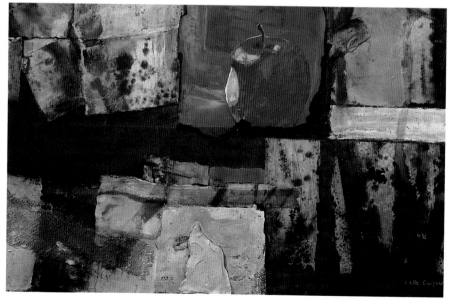

BARBARA LEITES,
N.W.S., T.W.S., S.E.A.
EARTH V
22" x 30" (55.9 cm x 76.2 cm)
Strathmore Aquarius
Media: Acrylic

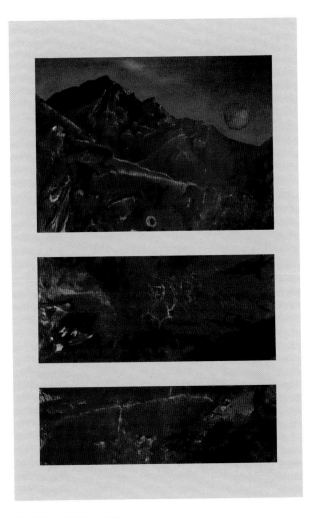

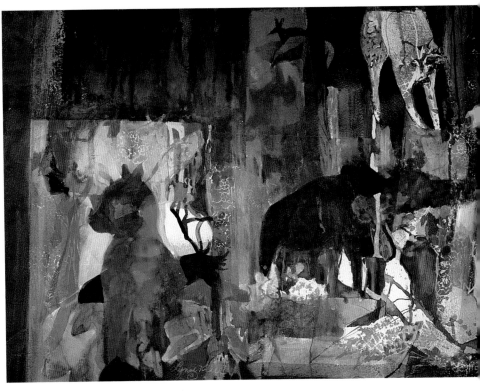

LYNNE KROLL

ANIMAL DREAMS

22" x 30" (55.9 cm x 76.2 cm)

Arches 140 lb. cold press

Media: Golden fluid acrylic,

gouache, watercolor

SANDY KINNAMON

MOONSCAPE

32" x 23" (81.3 cm x 58.4 cm)

Mead hot press

Media: Liquid acrylic, watercolor,

gouache

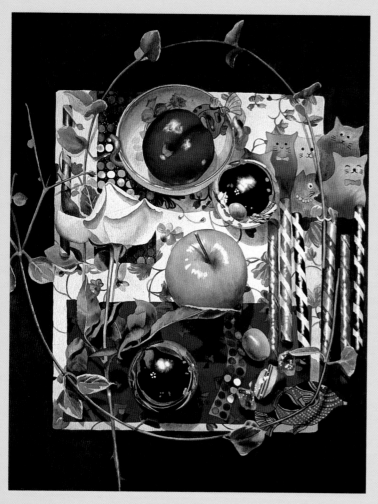

JANE FREY, N.W.S.

GREEN APPLE AND A
WHITE ROSE

21.5" x 25.5" (54.6 cm x 64.8 cm)

Arches 300 lb. cold press

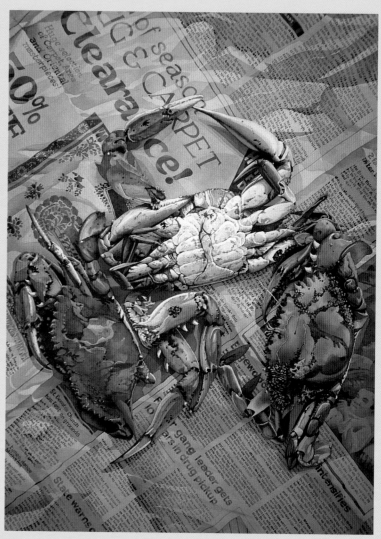

JOSEPH J. CORREALE, JR.

STEAMED IN MARYLAND

21" x 28" (53.3 cm x 71.1 cm)

Arches 140 lb. cold press

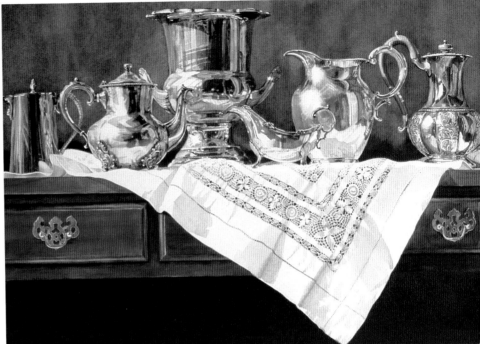

LIZ DONOVAN

SIX PIECES OF SILVER

22" x 35" (55.9 cm x 88.9 cm)

Arches 300 lb. cold press

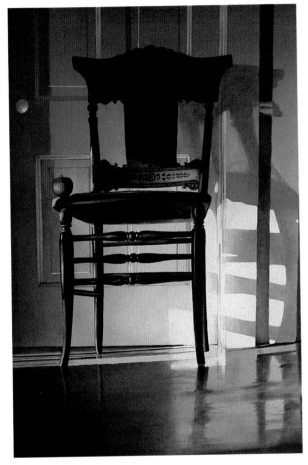

HENRY BELL, A.W.S.

THREE-QUARTER TIME

22" x 30" (55.9 cm x 76.2 cm)

260 lb. Arches hot press

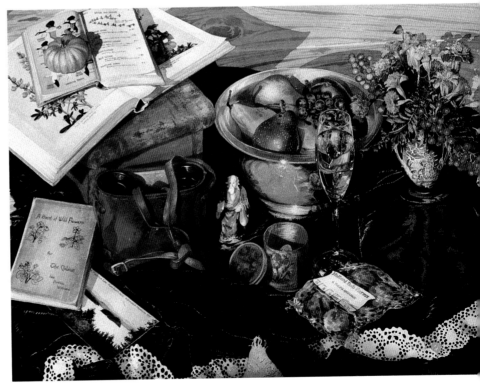

LAUREL LAKE MCGUIRE

AUTUMN PLEASURES

18" x 24" (45.7 cm x 60.9 cm)

Arches 140 lb.

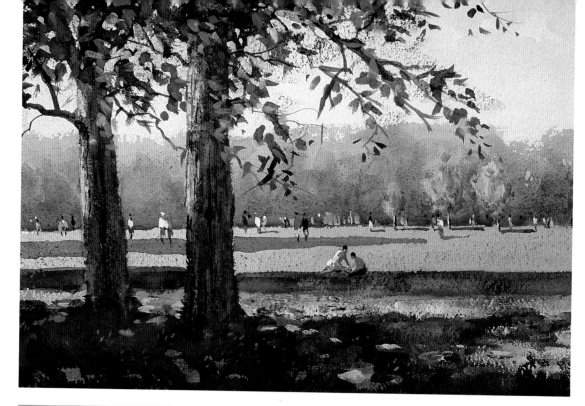

PAUL STRISIK, N.A., A.W.S.
HYDE PARK, LONDON
14" x 21" (35.6 cm x 53.3 cm)
J.B. Green 300 lb. cold press

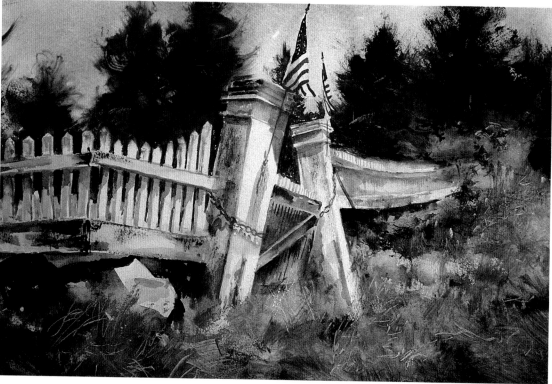

JOAN BORYTA
HALLOWED GROUND
15" x 22" (38.1 cm x 55.9 cm)
Winsor & Newton 140 lb. cold press

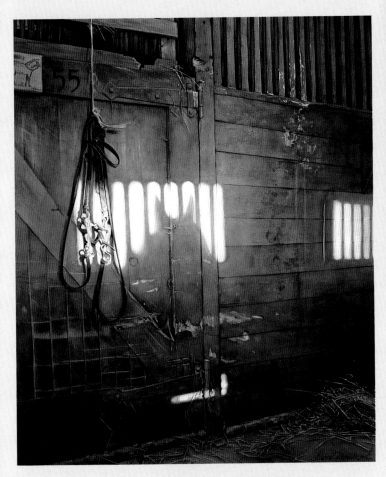

DANIEL J. MARSULA, A.W.S.,
M.W.S
STABLE
19.5" x 23.5" (49.5 cm x 59.7 cm)
Arches 140 lb. cold press

LORING W. COLEMAN
THE LAST CHAPTER
28.5" x 21" (72.4 cm x 53.3 cm)
E.H. Saunders 300 lb.

JOE JAQUA

POWELL STREET, SAN
FRANCISCO

18" x 25" (45.7 cm x 63.5 cm)

300 lb. cold press

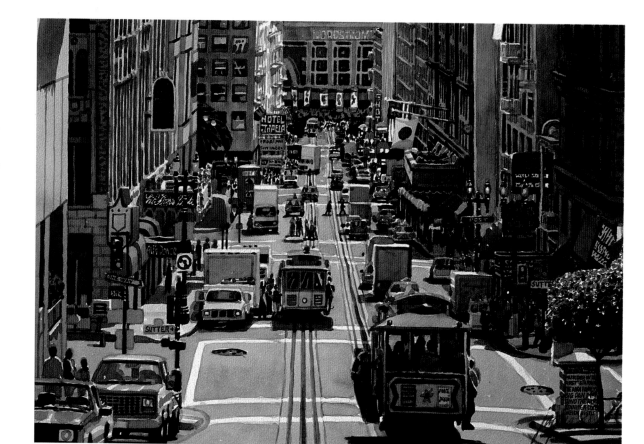

MARGE CHAVOOSHIAN

HARBOR IN
PORTOVENERA

22" x 30" (55.9 cm x 76.2 cm)

Arches 140 lb. cold press

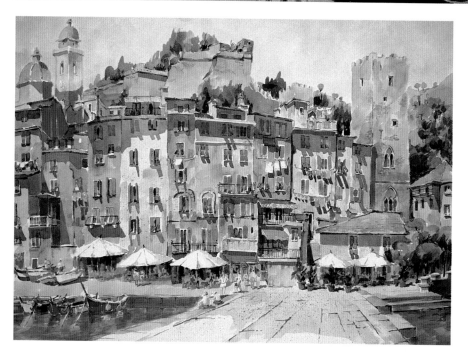

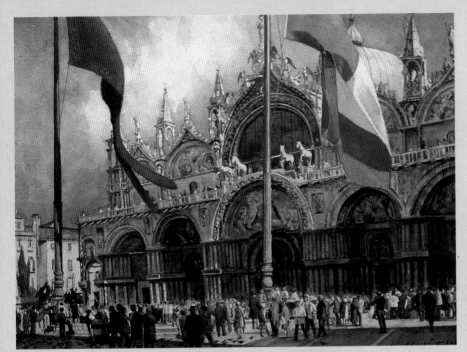

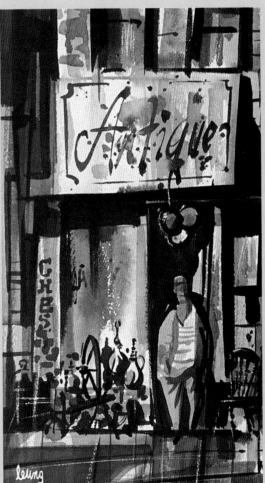

JOSEPH SANTORO, N.A.

SAINT MARKS - VENICE

21" x 29" (53.3 cm x 73.7 cm)

Arches 300 lb.

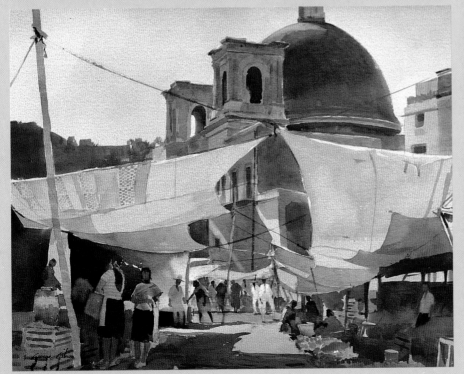

GEORGE GIBSON, N.A., A.W.S., N.W.S.

MARKET DAY - GUANAJUATO

22" x 30" (55.9 cm x 76.2 cm)

Arches 300 lb. rough

MONROE LEUNG

PAWN SHOP

15.5" x 22" (38.4 cm x 55.9 cm)

Arches 140 lb. cold press

EILEEN MONAGHAN WHITAKER

SHE RIDES A WHITE HORSE

22" x 30" (55.9 cm x 76.2 cm)

300 lb. cold press

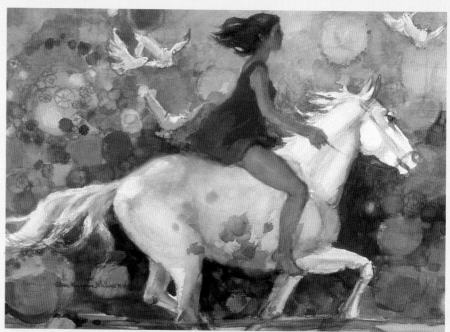

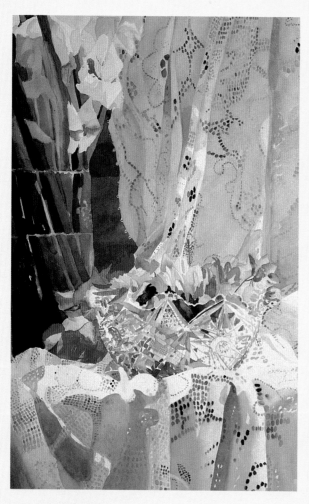

PAT FORTUNATO

COLLECTIBLES I

30" x 22" (76.2 cm x 55.9 cm)

Waterford 140 lb. cold press

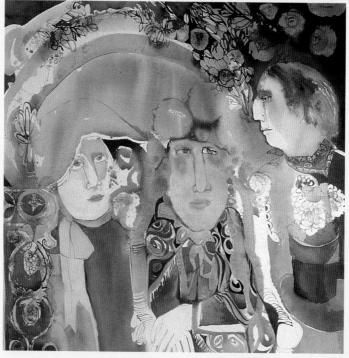

KAREN B. BUTLER

COURT OF TWO SISTERS

36" x 36" (91.4 cm x 91.4 cm)

Arches 140 lb. cold press

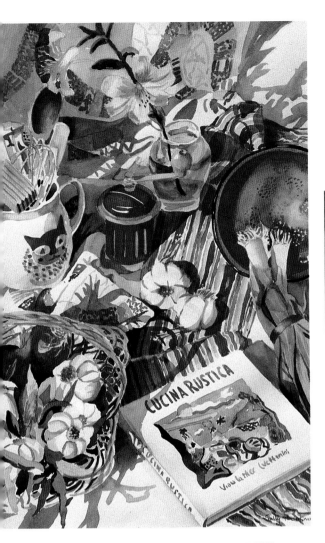

SALLY BOOKMAN

CUCINA RUSTICA

18" x 24" (45.7 cm x 60.9 cm)

Arches 140 lb. cold press

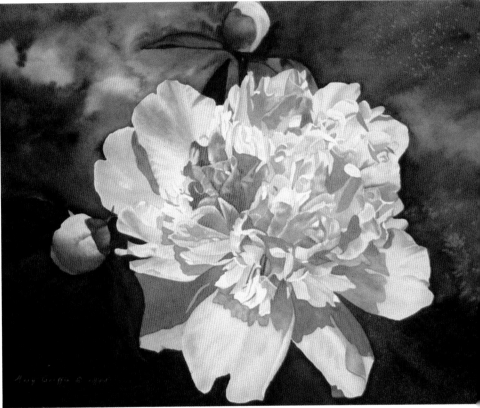

MARY GRIFFIN,

N.E.W.S.

PINK AND WHITE PEONY

30" x 22" (76.2 cm x 55.9 cm)

Arches 300 lb. cold press

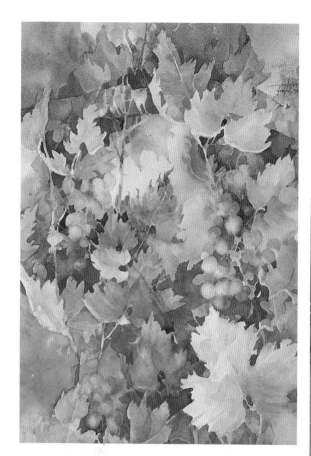

MARGARET HOYBACH

VINTAGE YEAR

22" x 30" (55.9 cm x 76.2 cm)

Arches 300 lb. cold press

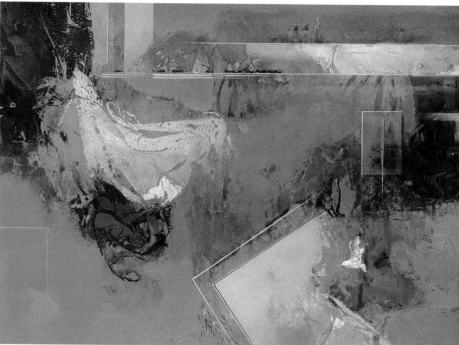

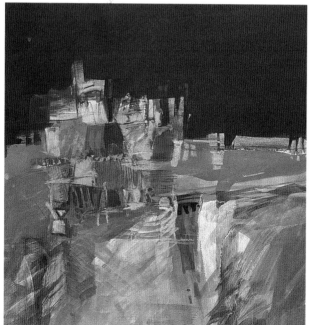

**ROBERT S. OLIVER,
A.W.S.**

NIGHT SCAPE

14" x 14" (35.6 cm x 35.6 cm)

Arches 140 lb. hot press

Media: Watercolor, acrylic, charcoal, watercolor pencils, opaque watercolor pastels

DOUG PASEK

SEARCHING FOR ALICE WONDERLAND

36" x 28" (91.4 cm x 71.1 cm)

Strathmore #112

Media: Acrylic, transparent and opaque watercolor

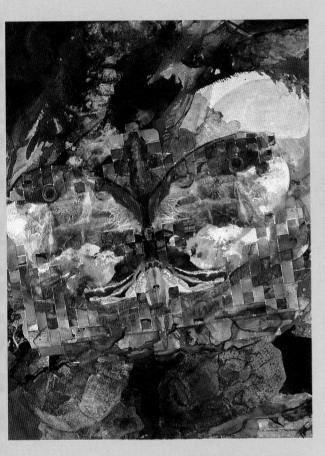

MARGARET C. MANTER
FIREBUG
30.25" x 23.5" (76.8 cm x 59.7 cm)
Arches 140 lb. cold press,
Strathmore Aquarius II 90 lb.
Media: Watercolor, Golden and
Grumbacher acrylic, Pelikan ink

FREDI TADDEUCCI
RIVER'S CREST
21.25" x 28.75" (54 cm x 73 cm)
Arches 140 lb. cold press
Media: Watercolor, acrylic, colored pencil

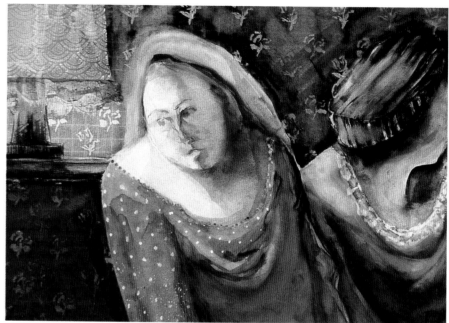

PAULA TEMPLE

VISITING SISTER

24" x 36" (60.9 cm x 91.4 cm)

Morilla

Media: Collage of textured rice
paper, gold sticker dots

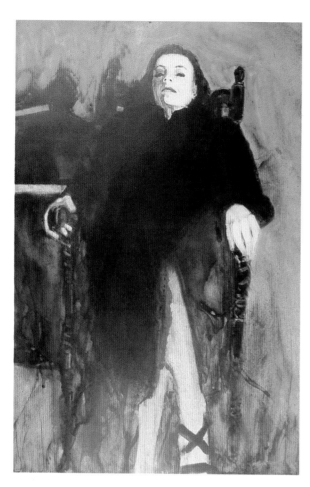

J.A. EISER

TRANQUILITY

15" x 11" (38.1 cm x 27.9 cm)

Bristol 3-ply

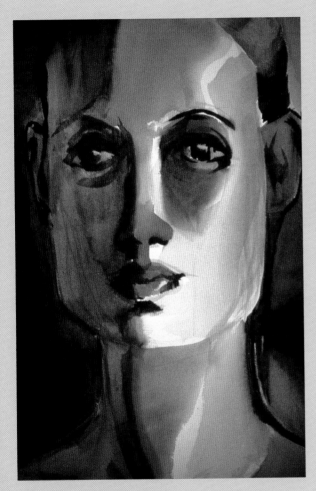

LANCE R. MIYAMOTO, N.W.S.
SIBYL (PERSIAN)
24" x 19" (60.9 cm x 48.3 cm)
Arches 140 lb. rough

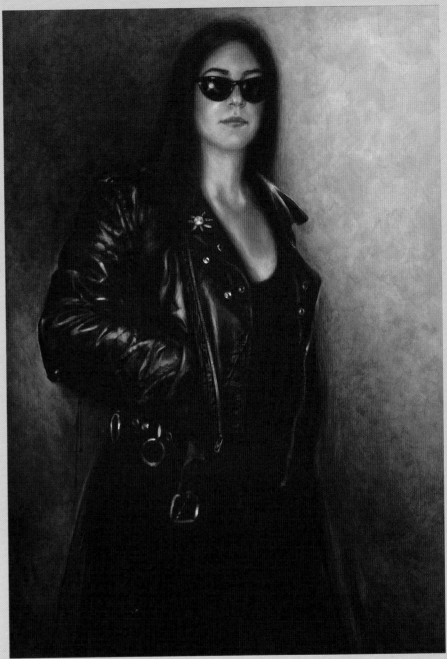

JANE BREGOLI
CREPUSCULE IN BLACK & BROWN: WENDY
40" x 30" (101.6 cm x 76.2 cm)
Strathmore 4-ply bristol hot press medium surface

PATRICIA WYGANT

PAROIKIA AFTERNOON

27" x 39" (68.9 cm x 99.1 cm)

Arches 300 lb. cold press

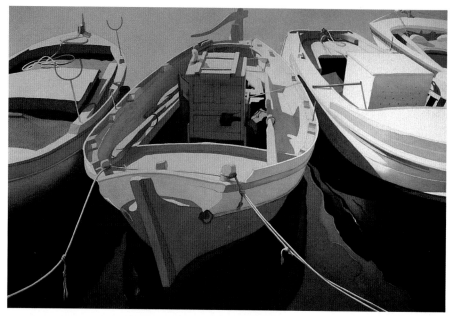

JULIAN BLOOM

TEA WITH MADELINE

22" x 30" (55.9 cm x 76.2 cm)

Arches 300 lb. cold press

CHARLES F. BARNARD

LOOKING BACK

26.25" x 20.5" (66.7 cm x 52.1cm)

Arches 300 lb. cold press

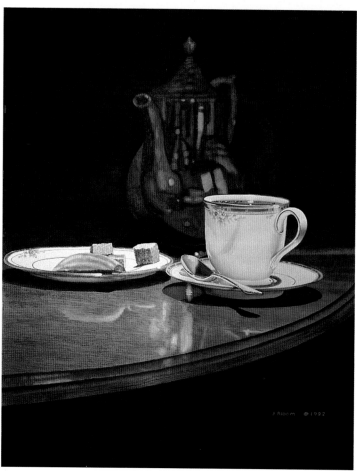

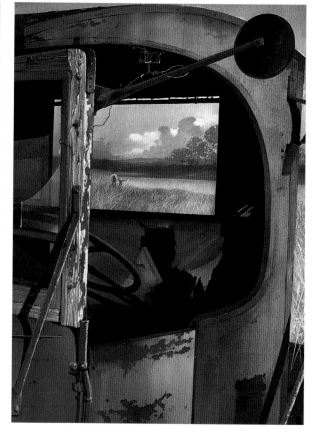

T. THOMAS GILFILEN

FRIEDERICK'S TRUNK

20" x 30" (50.8 cm x 76.2 cm)

Winsor & Newton 260 lb.

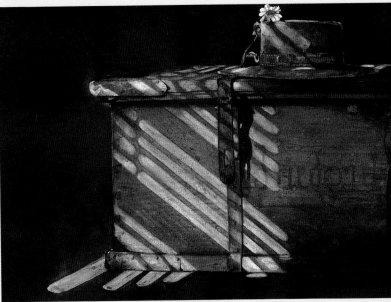

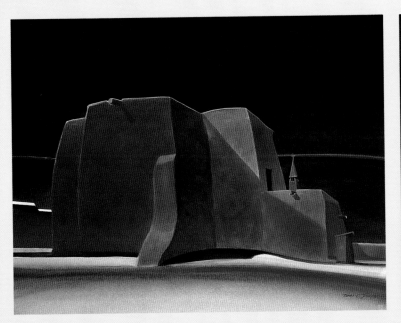

DONAL JOLLEY

CHAPEL, LAS TRAMPAS

22" x 30" (55.9 cm x 76.2 cm)

Arches 300 lb. cold press

Media: Liquitex acrylic

CAROL ANN SCHRADER

MUMPER'S COMPETITION

21" x 29" (53.3 cm x 73.7 cm)

Arches 300 lb. cold press

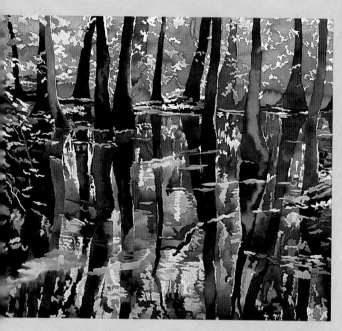

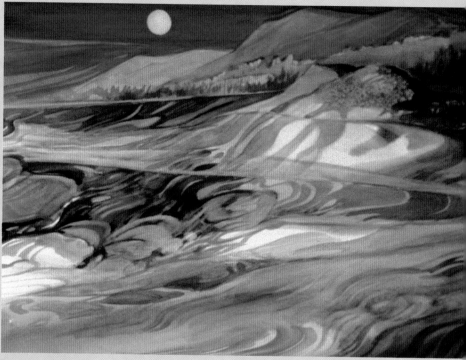

MARY ANN POPE

BEAVERDAM SWAMP IV

26" x 22" (66 cm x 55.9 cm)

Lana Aquarelle 140 lb. watercolor

paper

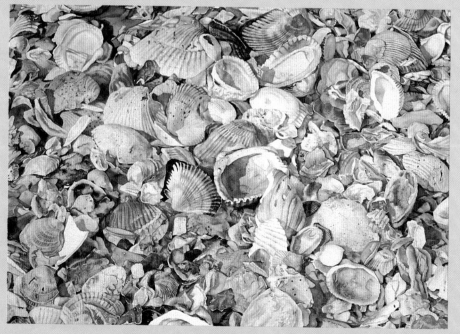

SARA ROUSH

TIDEWATER

22" x 30" (55.9 cm x 76.2 cm)

Lana Aquarelle 140 lb. cold press

Media: Mixed water media,

gouache

ELAINE HAHN

SUNLIT TREASURES

22" x 30" (55.9 cm x 76.2 cm)

Arches 300 lb. cold press

SANDRA HUMPHRIES

GOOD MORNING,
ALBUQUERQUE

22" x 30" (55.9 cm x 76.2 cm)

Arches 300 lb. cold press

Media: Transparent watercolor,
acrylic

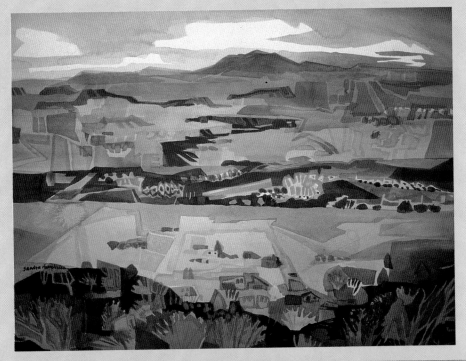

GLORIA PATERSON

LITE PLANE SPACE I

22" x 31" (55.9 cm x 78.7 cm)

Rives BFK, primed with gesso

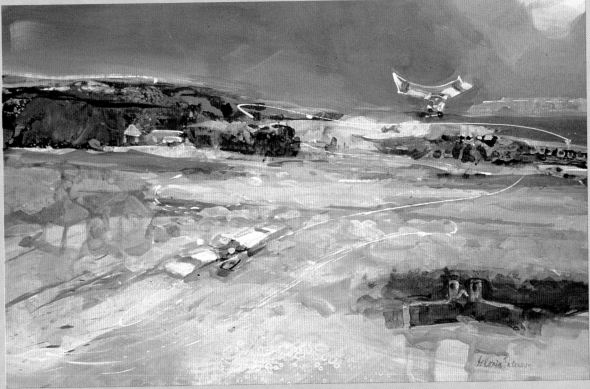

ANITA MEYNIG
POP-THE-WHIP
10" x 22" (25.4 cm x 55.9 cm)
Arches 140 lb. cold press
Media: Watercolor, ink

MICHAEL FRARY
FACTORY RECALL
42" x 30" (106.7 cm x 76.2 cm)
Arches Imperial 140 lb. cold press

THEODORA T. TILTON

HIDDEN DEPTH

12" x 21" (30.5 cm x 53.3 cm)

Arches 140 lb. cold press

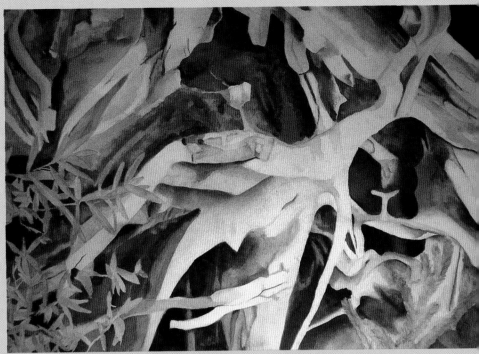

D. GLORIA DEVEREAUX, A.W.S.

BLACK DRAGON SALVAGE

22" x 30" (55.9 cm x 76.2 cm)

140 lb. cold press

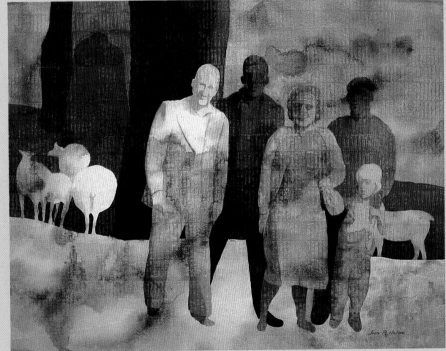

JEAN R. NELSON

TOURISTS V; AVEBURY

22" x 30" (55.9 cm x 76.2 cm)

Waterford 140 lb. cold press

Media: Acrylic and watercolor over acrylic medium grid

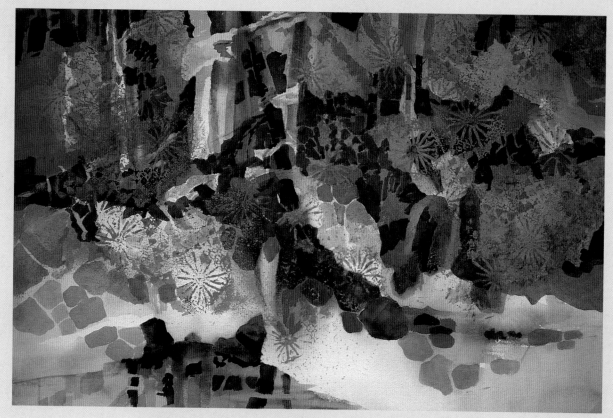

PATRICIA REYNOLDS, M.W.S.
WINTER WEFT
22" x 30" (55.9 cm x 76.2 cm)
Arches 400 lb. cold press

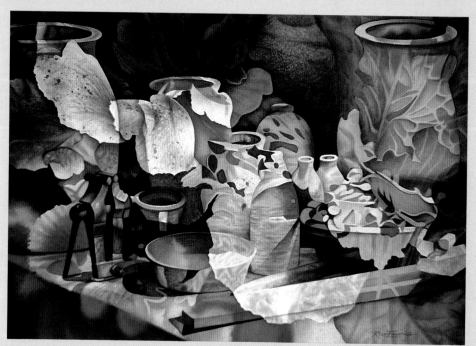

RICH ERNSTING
THYME IN A BOTTLE
27" x 39" (68.6 cm x 99.1 cm)
Arches 555 lb. cold press

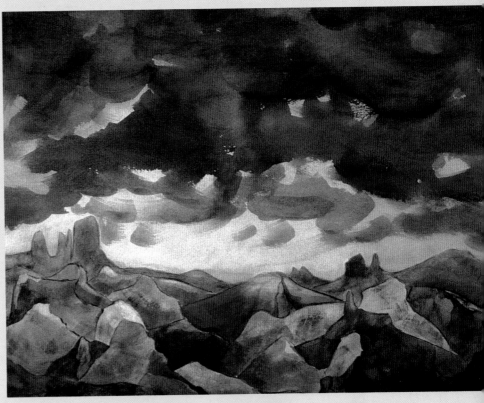

OPHELIA B. MASSEY
IMPRESSIONS, I
28" x 20" (71.1 cm x 50.8 cm)
Crescent 110 lb.

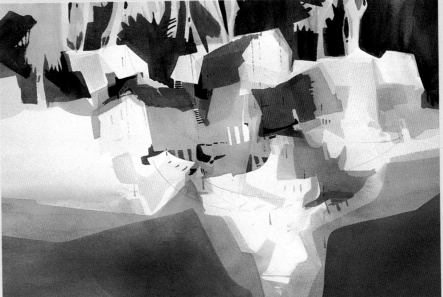

DIANE VAN NOORD
THUNDER
18" x 24" (45.7 cm x 60.9 cm)
Arches 140 lb. cold press

**PAT DEADMAN, A.W.S.,
N.W.S.**
CANEEL BAY
22" x 30" (55.9 cm x 76.2 cm)
Arches 140 cold press

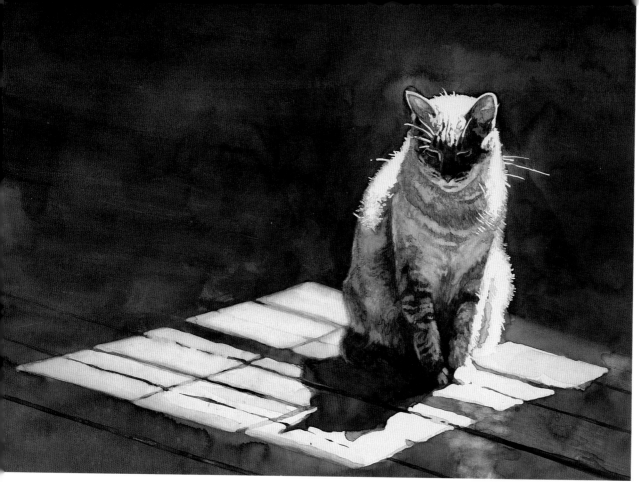

DEBORAH L. CHABRIAN

MUGS IN SUNLIGHT

9" x 12" (22.9 cm x 30.5 cm)

Strathmore 4-ply bristol hot press

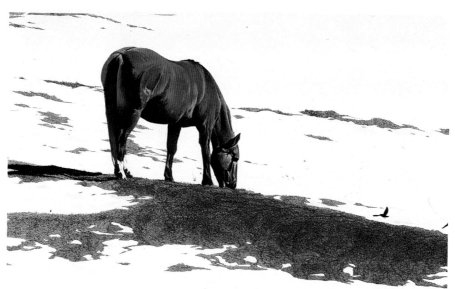

BEN WATSON III

HARMONY

15.5" x 28" (39.4 cm x 71.1 cm)

Strathmore 4-ply medium surface

Media: Watercolor, gouache

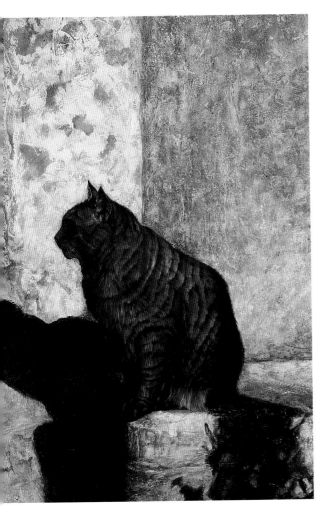

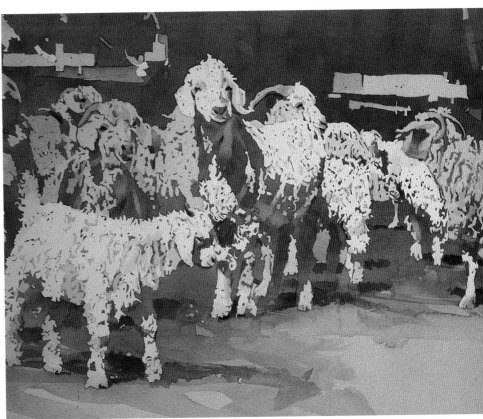

JUDI BETTS, A.W.S.

CARNIVAL CHARACTERS

22" x 30" (55.9 cm x 76.2 cm)

Arches 140 lb. cold press

JANET N. HEATON

ALSACE CHURCH CAT

23" x 17" (58.4 cm x 43.2 cm)

Media: Egg tempera, watercolor

RUTH L. REINEL

CABBAGE

15" x 22" (38.1 cm x 55.9 cm)

Arches 140 lb. cold press

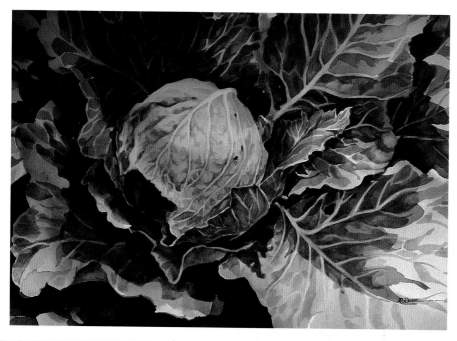

**LINDA L. STEVENS
MOYER**

THE SIXTH DAY

42" x 29.5" (106.7 cm x 74.9 cm)

Arches 300 lb. rough

Media: Transparent watercolor,
23 carat gold leaf

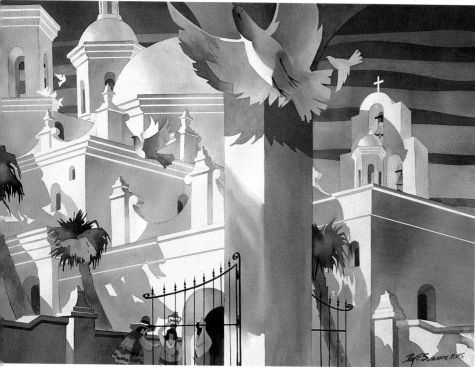

**ROY E. SWANSON,
M.W.S.**

DOVE OF THE DESERT

25" x 35" (63.5 cm x 88.8 cm)

Arches 140 lb. cold press

GEORGIA A. NEWTON

PATTERNS OF AQUILEGIA

22" x 30" (55.9 cm x 76.2 cm)

Arches 140 lb. hot press

CECIE BORSCHOW

DOMINICAN COURTYARD

22" x 33" (55.9 cm x 83.8 cm)

Arches 140 lb.

**MARGARET SCANLAN,
A.W.S., W.H.S.**

MEADOW II

30" x 40" (76.2 cm x 101.6 cm)

Strathmore 500 Series heavy
weight

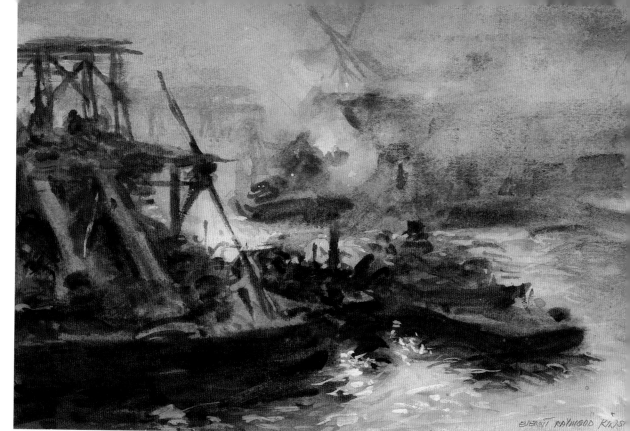

**EVERETT RAYMOND
KINSTLER, N.A., A.W.S.,
P.S.A.**
WATERFRONT, LONDON
6" x 10" (15.2 cm x 25.4 cm)
Slightexture P & O hot press

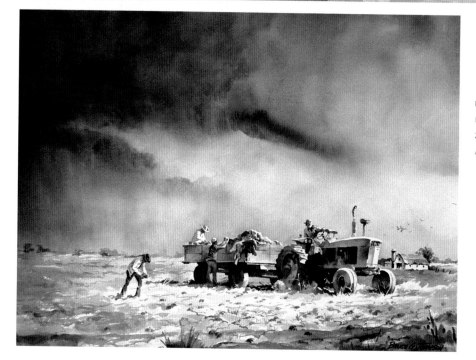

BRUCE G. JOHNSON
HURRYIN' HARVEST
21" x 29" (53.3 cm x 73.6 cm)
Arches 300 lb. cold press

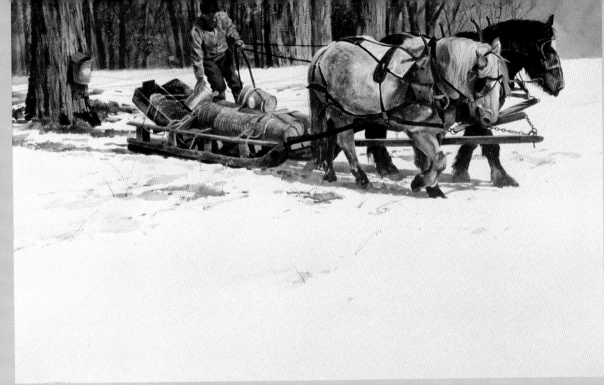

**DON STONE, N.A.,
A.W.S.**
THE UPPER GROVE
21.5" x 29.5" (54.6 cm x 74.9 cm)
Arches 140 lb.

**JORGE BOWENFORBES,
A.W.S., N.W.S.**
UITVLUGT
30" x 40" (76.2 cm x 101.6 cm)
Arches medium

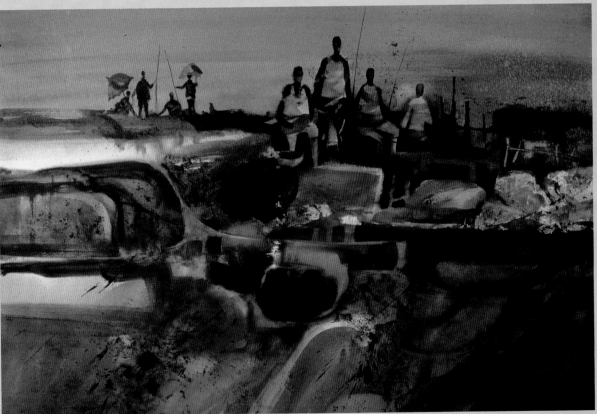

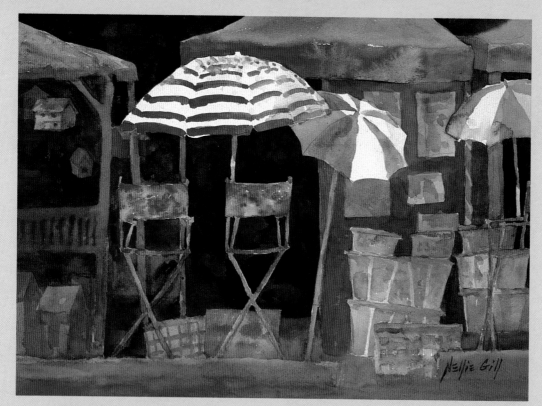

NELLIE GILL

PLEIN AIR PERSONALITIES

11" x 15" (27.9 cm x 38.1 cm)

Arches 140 lb. cold press

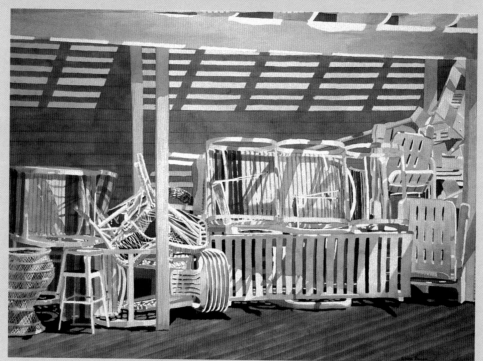

LINDA BAKER

ANTICIPATION V

22" x 30" (55.9 cm x 76.2 cm)

Arches 300 lb.

MARJEAN WILLETT

DOORS OF THERA

22" x 30" (55.9 cm x 76.2 cm)

Arches 140 lb. cold press

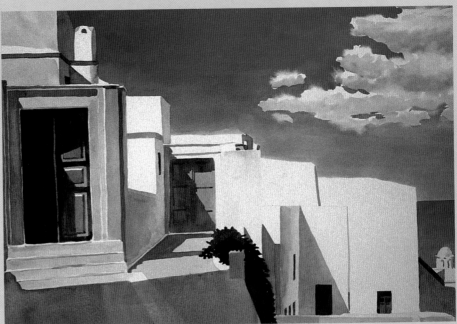

SHARON TOWLE

COLLECTIONS: BOXES

22" x 30" (55.9 cm x 76.2 cm)

Arches 140 lb. cold press

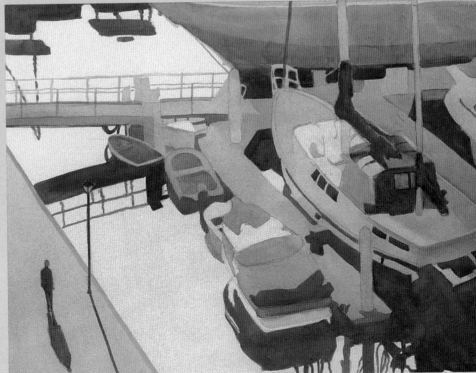

KAREN MATHIS

Marina Morning

22" x 36" (55.9 cm x 91.4 cm)

Arches 140 lb. cold press

JAMES VANCE, A.W.S.

WEST BOTTOMS COLD

22" x 14.5" (55.9 cm x 36.8 cm)

Arches 150 lb. rough

LAWRENCE R. BRULLO

IL PASSIONATO

30" x 22" (76.2 cm x 55.9 cm)

Arches 140 lb. cold press, rice paper

Media: Torn and glued acid-free paper, acrylic

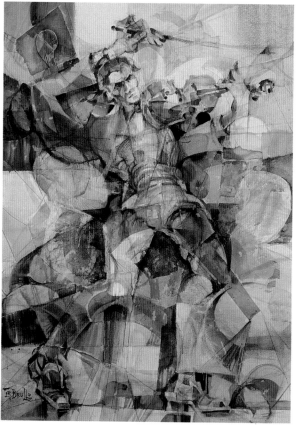

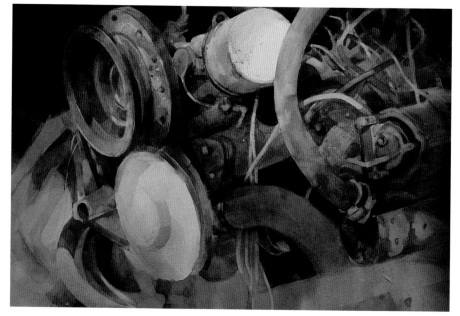

EDWARD MINCHIN, A.W.S.

A TIME TO REST

21.5" x 28.5" (54.6 cm x 72.4 cm)

Arches 140 lb. cold press

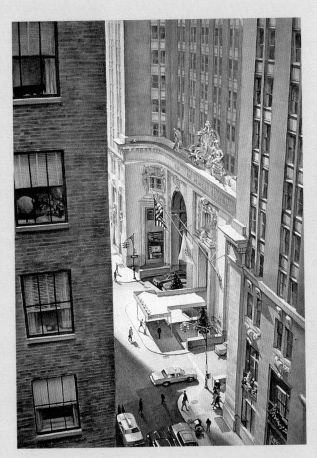

LOIS SALMON TOOLE

PARK AVENUE

PERSPECTIVE

27.75" x 20.5" (70.2 cm x 51.8 cm)

Arches 300 lb. cold press

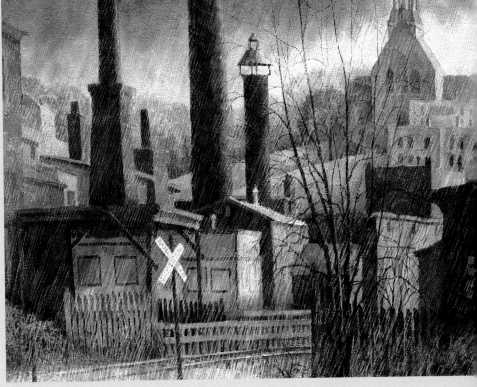

BECKY HALETKY

SUN SHOWER

20" x 28" (50.8 cm x 71.1 cm)

Arches 140 lb. rough

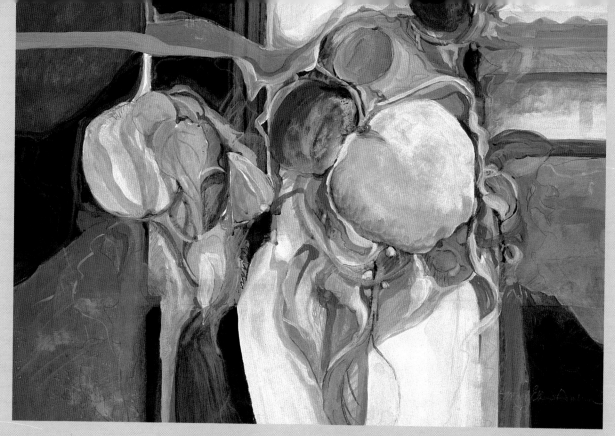

**MARY ELLEN ANDREN,
F.W.S.**

RX: ONE DAILY

28" x 30" (71.1 cm x 76.2 cm)

Strathmore 114 lb.

Media: Watercolor, colored pencil,
acrylic, crayon

SYBIL MOSCHETTI

WRAPPED & RIVETED

30" x 42" (76.2 cm x 106.7)

Arches 300 lb. cold press

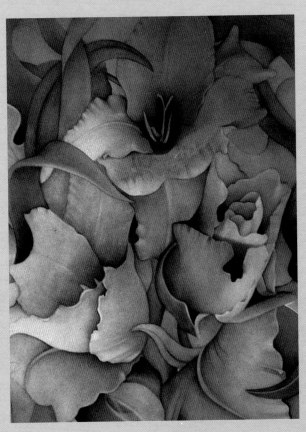

SHARON WOODING

GLADIOLAS

22" x 30" (55.9 cm x 76.2 cm)

Arches 300 lb. cold press

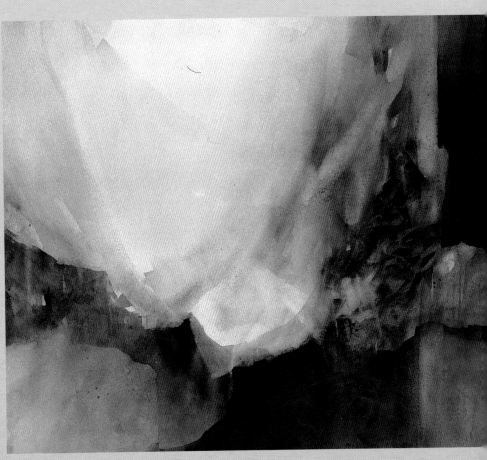

DOROTHY B. DALLAS

TERNATE RHYTHMS

22" x 30" (55.9 cm x 76.2 cm)

Arches 140 lb. cold press

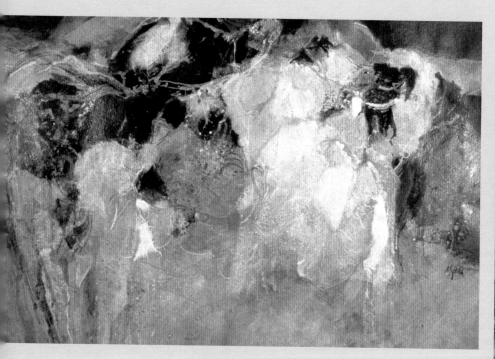

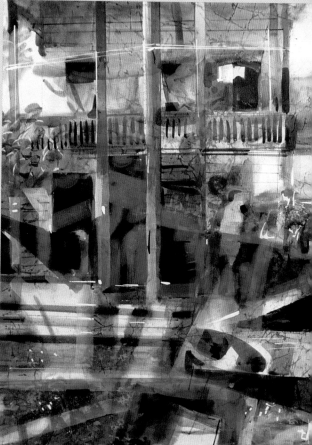

**CAROLE MYERS, A.W.S.,
N.W.S.**
ON THE BEACH
22" x 30" (55.9 cm x 76.2 cm)
Morilla 140 lb. cold press
Media: Watercolor, acrylic, collage

JANE OLIVER
FACADE, KEY WEST
20" x 25" (50.8 cm x 63.5 cm)
140 lb. hot press

HELLA BAILIN, A.W.S.
LEXINGTON LOCAL
23.5" x 34" (59.7 cm x 86.4 cm)
Whatman smooth
Media: Acrylic, watercolor

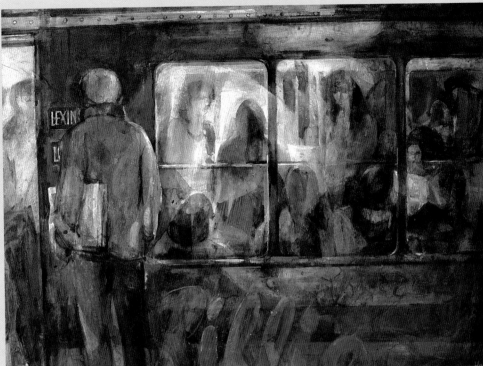

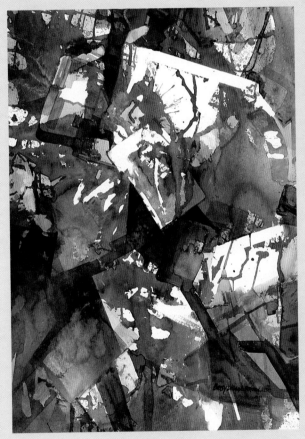

BETSY DILLARD STROUD
POSTCARDS FROM THE
EDGE #1
40" x 30" (101.6 cm x 76.2 cm)
Strathmore 114 lb.

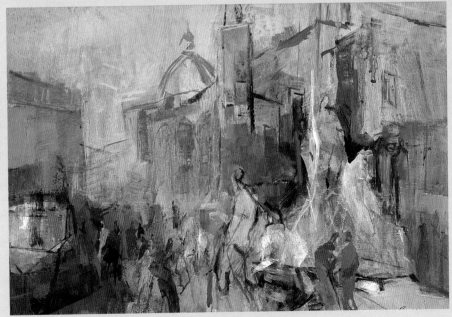

BETTY M. BOWES
ROMAN PIAZZA
25" x 36" (63.5 cm x 91.4 cm)
Sized Masonite

**COLLEEN NEWPORT
STEVENS**

LOS AMIGOS

22" x 30" (55.9 cm x 76.2 cm)

Lana Aquarelle 555 lb.

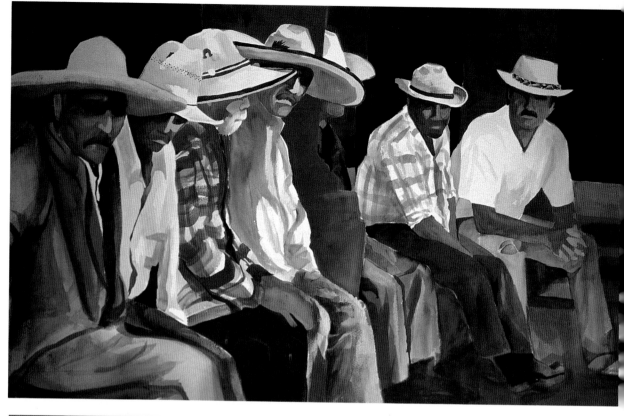

JOSEPH E. GREY II

THE PIETA

16" x 22" (40.6 cm x 55.8 cm)

Arches 140 lb. cold press

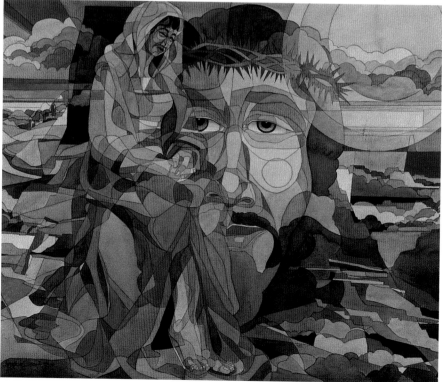

AVIE BIEDINGER

WEST ABOUT

22" x 30" (55.9 cm x 76.2 cm)

Arches 140 lb. cold press

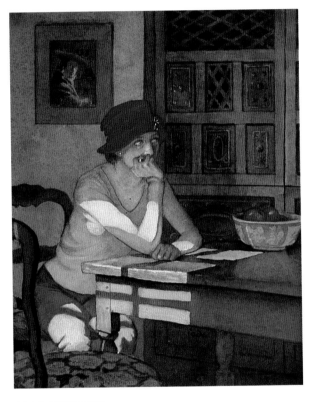

JADA ROWLAND

VERMEER'S TABLE

7.5" x 9.5" (19.1 cm x 24.1 cm)

Arches 140 lb. cold press

LINDA L. SPIES

BUBBLE GUM

20" x 27.5" (50.8 cm x 69.9 cm)

Arches 200 lb. cold press

**PHYLLIS HELLIER,
F.W.S, G.W.S., K.W.S.**

DOORWAY TO BEYOND
22" x 30" (55.9 cm x 76.2 cm)
Arches 300 lb. cold press
Media: Gouache, ink resist, acrylic

PAT REGAN

HORSE OF THE GODDESS
OF THE MOON
22" x 30" (55.9 cm x 76.2 cm)
Arches 140 lb. cold press
Media: Watercolor, acrylic, gold
leaf

ELLEN FOUNTAIN

BUT WHAT WILL HE DO
FOR AN ENCORE?
22" x 30" (55.9 cm x 76.2 cm)
140 lb. cold press
Media: Watercolor, gouache, ink

JANIS THEODORE

THE EMPEROR'S LAST
CALLING
42" x 35" (106.7 cm x 88.9 cm)
4-ply museum board
Media: Gouache

ZHENG-PING CHEN

STILL LIFE #1
22" x 30" (55.9 cm x 76.2 cm)
250 lb. cold press

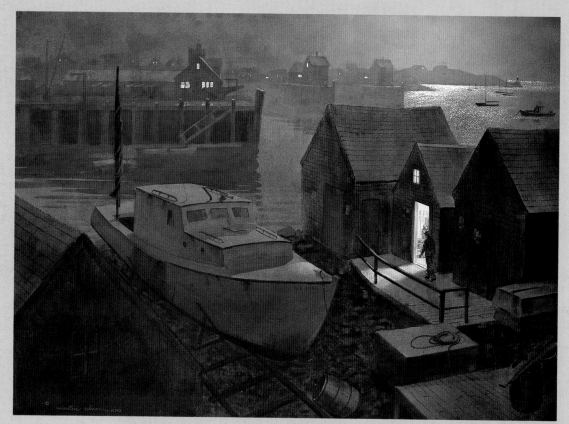

**MARTIN R. AHEARN,
A.W.S.**

MOONLITE, ROCKPORT
HARBOR

45" x 30" (114.3 cm x 76.2 cm)

Arches Elephant 240 lb.

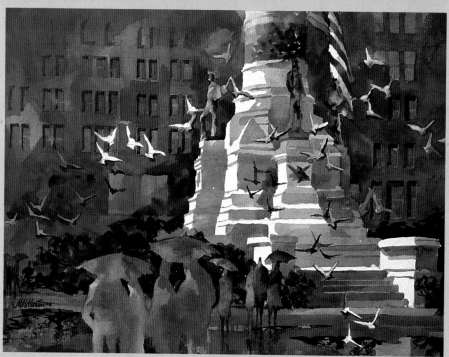

MARGARET M. MARTIN

SALUTE TO SOLDIERS
AND SAILORS

22" x 30" (55.9 cm x 76.2 cm)

Arches 300 lb. cold press

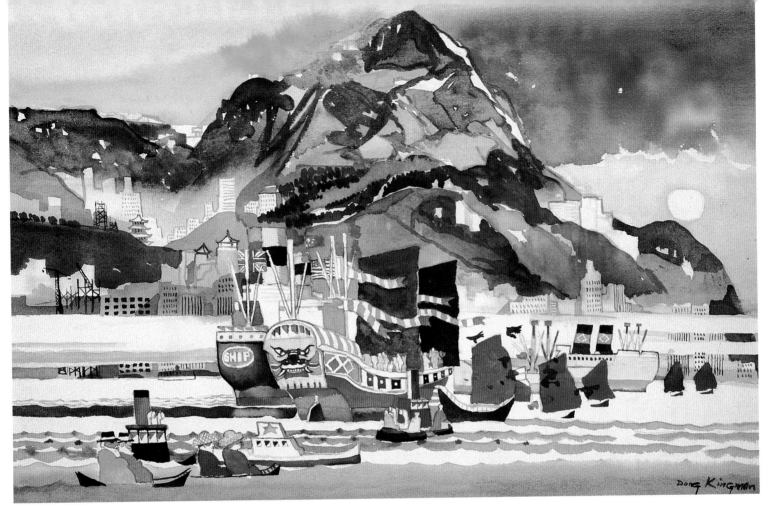

DONG KINGMAN

RED SAIL & EAST WIND

22" x 30" (55.9 cm x 76.2 cm)

Arches 300 lb.

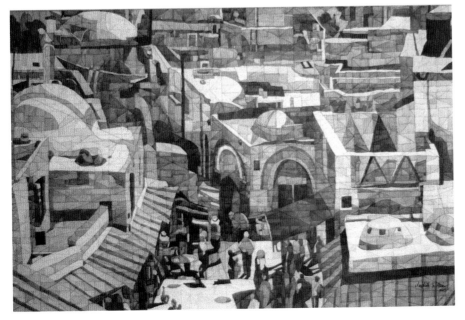

JUDITH S. REIN, M.W.S.

FROM THE DAMASCUS GATE

18" x 24" (45.7 cm x 60.9 cm)

Stonehenge cream printing paper

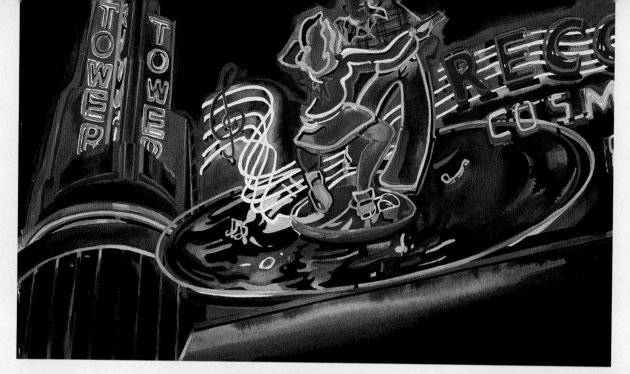

JILL FIGLER

TOWER TWO-STEP

15" x 20" (38.1 cm x 50.8 cm)

Arches 140 lb. cold press

ELLNA GREGORY-GOODRUM

RITUAL LEAF DANCE

30" x 22" (76.2 cm x 55.9 cm)

Arches 140 lb. cold press

PAUL G. MELIA

MY BROTHER'S KEEPER

40" x 41" (101.6 cm x 104.1 cm)

310 illustration board

Media: Permanent inks, gouache

MILES G. BATT, SR.

ROCK MUSIC &
SHRIMPERS

29" x 21" (73.6 cm x 53.3 cm)

Arches 140 lb. cold press

SANDRA SAITTO

CAROUSEL #22

22" x 30" (55.9 cm x 76.2 cm)

Arches 140 lb. cold press

Media: Watercolor, gouache

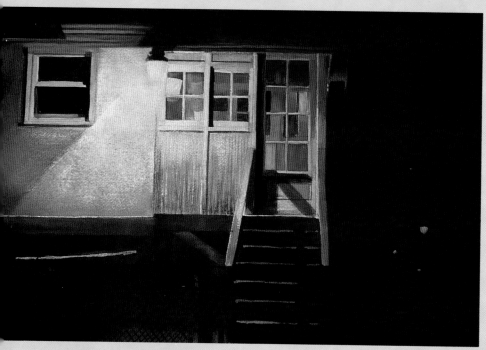

HENRY W. DIXON

NIGHT VISION

14.75" x 22" (37.5 cm x 55.9 cm)

Arches 150 lb.

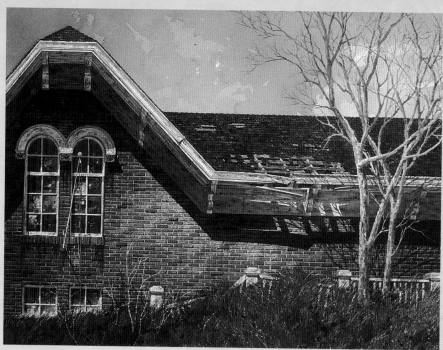

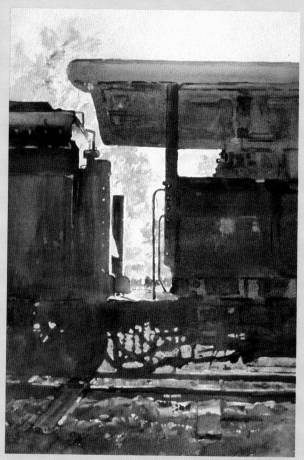

JOHN R. HOLLINGSWORTH, N.W.S.

AGE SHADOWS

30.5" x 22" (77.5 cm x 55.9 cm)

Arches 300 lb. rough

DEE WESCOTT

CONNECTED

19.5" x 13.5" (49.5 cm x 34.3 cm)

Arches 300 lb. cold press

GARY AKERS

SUNLIT RETREAT

20" x 28" (50.8 cm x 71.1 cm)

Strathmore 500 Series bristol 2-ply

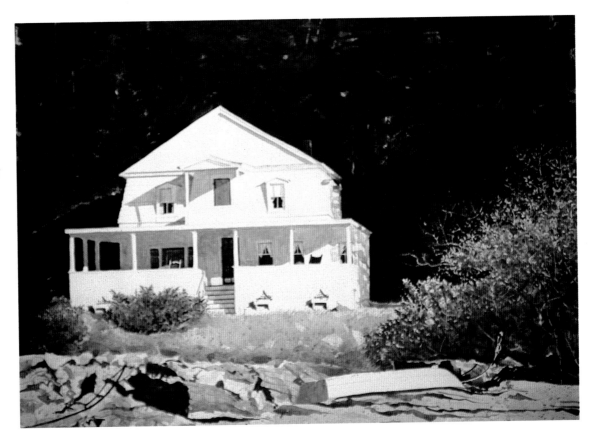

KUO YEN NG

BAY WINDOW

29" x 21" (73.7 cm x 53.3 cm)

Arches 300 lb. cold press

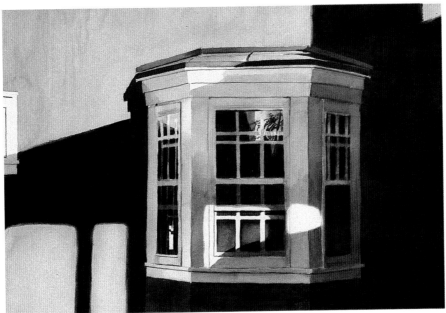

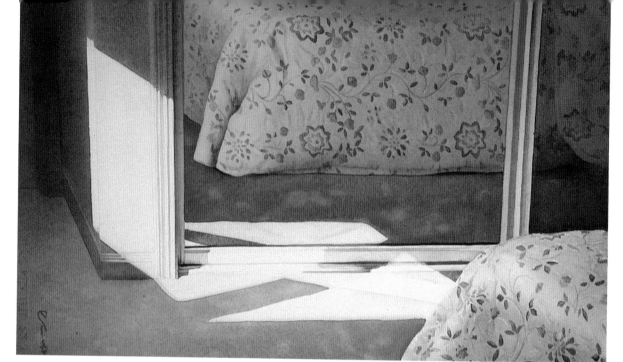

NORIKO HASEGAWA

MIRRORED DOORS

15" x 22" (38.1 cm x 55.9 cm)

Waterford 300 lb. cold press

MARY LOU METCALF

OLD BUT ELEGANT

29" x 21" (73.7 cm x 53.3 cm)

Arches 300 lb. cold press

PHYLLIS SOLCYK

STEINBECK'S SCENERY

30" x 40" (76.2 cm x 101.6 cm)

Arches 140 lb. cold press

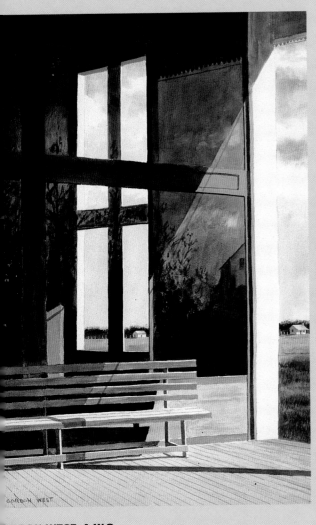

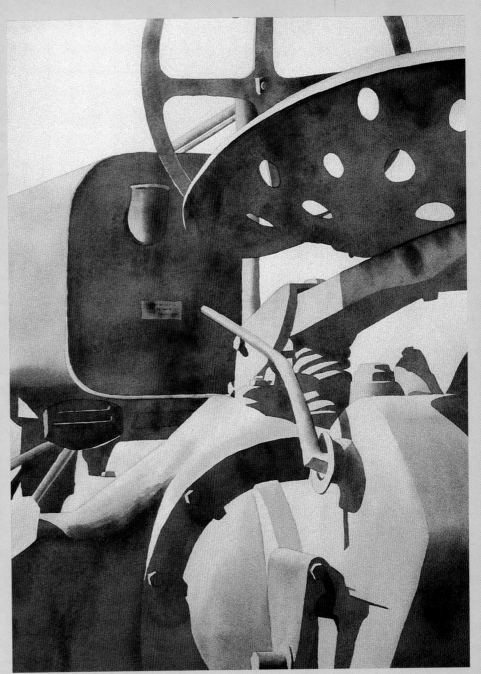

ORDON WEST, A.W.S.

R GRUENE

0" (55.9 cm x 76.2 cm)

300 lb. cold press

JOHN SALCHAK

TRACTOR

29" x 21" (73.7 cm x 53.3 cm)

Magnani Acquaforti 140 lb. cold press

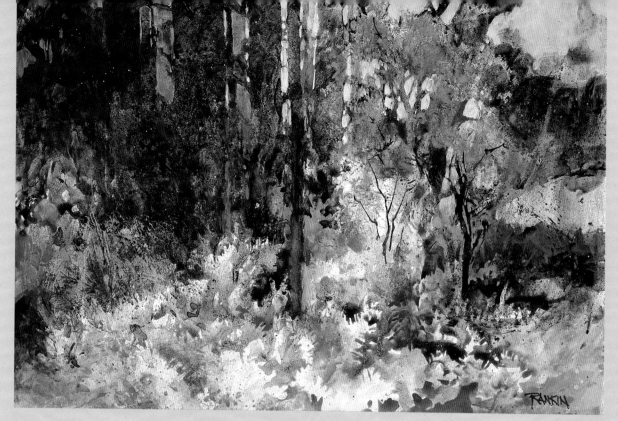

NANCY RANKIN

OLYMPIC RAIN FOREST

15" x 18" (38.1 cm x 45.7 cm)

Strathmore 500 Series

Media: Watercolor, interference
gold, gesso

**MARGARET HUDDY,
N.W.S.**

SYCAMORE, EARLY LIGHT

60" x 40" (55.9 cm x 71.1 cm)

Arches medium

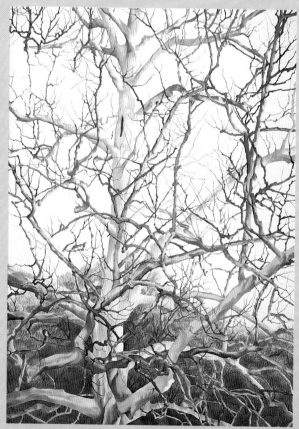

MURRAY WENTWORTH,
N.A., A.W.S.
WINTERED RIDGE
23" x 33" (58.4 cm x 83.8 cm)
Strathmore medium surface

HOWARD HUIZING
MIST TRAIL
36" x 18" (91.5 cm x 71.1 cm)
Arches 140 lb. cold press

BENJAMIN MAU, N.W.S.
HEDGE APPLES
24" x 30" (60.9 cm x 76.2 cm)
Arches 140 lb. cold press

PETER L. SPATARO
BANYAN PARADISE
22" x 30" (55.9 cm x 76.2 cm)
Waterford 140 lb. cold press
Media: Gouache

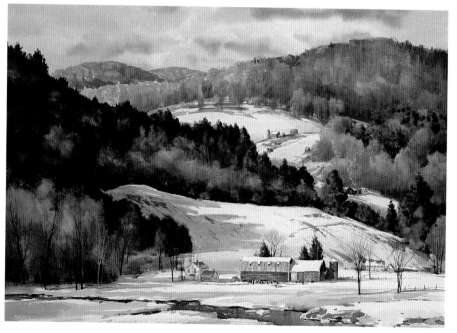

DONALD A. MOSHER
OUTSIDE WOODSTOCK
22" x 30" (55.9 cm x 76.2 cm)
Arches 300 lb.

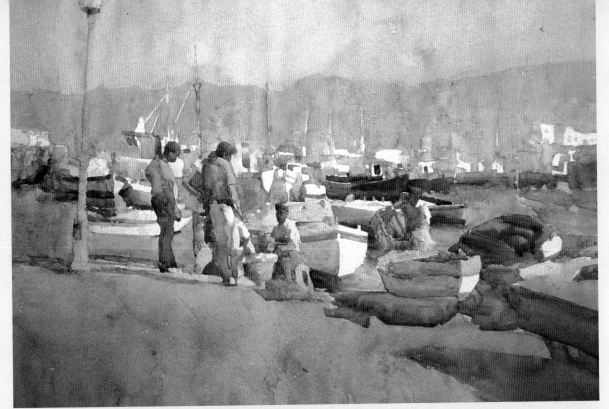

**ANNE ADAMS
ROBERTSON MASSIE**
MYKONOS HARBOR III
28" x 36" (71.1 cm x 91.4 cm)
Fabriano Artistico 140 lb. cold press

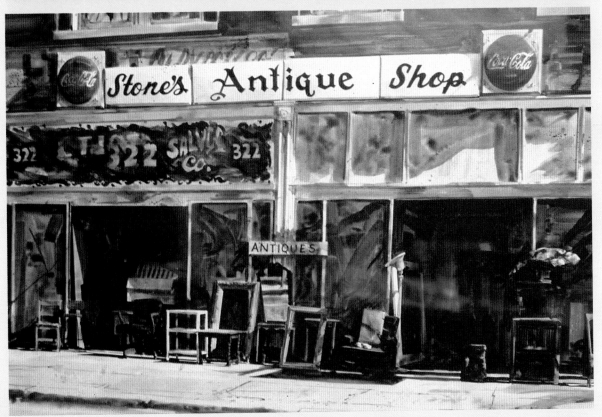

MARVIN YATES
STONE'S ANTIQUE SHOP
20" x 28" (50.8 cm x 71.1 cm)
Strathmore Hyplate

ALEX POWERS
ART BUDDIES
30" x 40" (76.2 cm x 101.6 cm)
Strathmore
Media: Gouache, charcoal collage, pastel, watercolor

BARBARA BURWEN
KIYO
30" x 22" (76.2 cm x 55.9 cm)
140 lb. hot press
Media: Watercolor, charcoal powder, acrylic, watercolor pencils

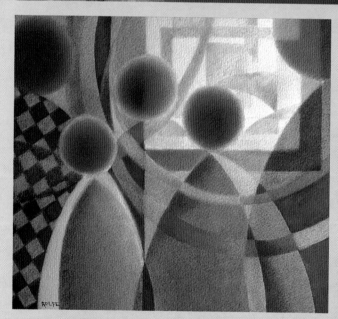

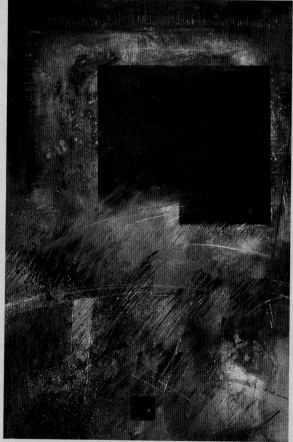

JEAN ROLFE
LOOKING AT MODERN ART
9" x 10" (22.9 cm x 25.4 cm)
Arches 140 lb. rough

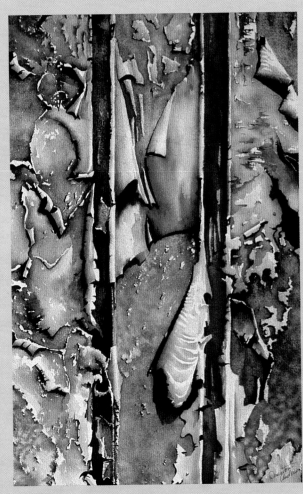

GAYLE DENINGTON-ANDERSON

STARS AND STRIPES (ALMOST) FOREVER

22" x 15" (55.9 cm x 38.1 cm)

Arches 140 lb. rough

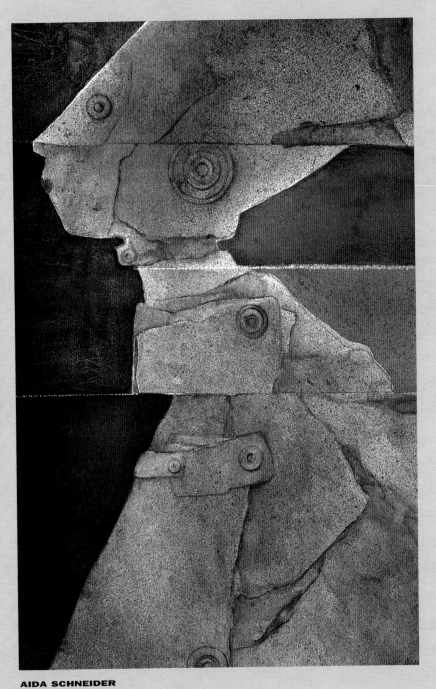

AIDA SCHNEIDER

NEFERTITI -

DECONSTRUCTED

30" x 22" (76.2 cm x 55.9 cm)

Arches 300 lb. cold press

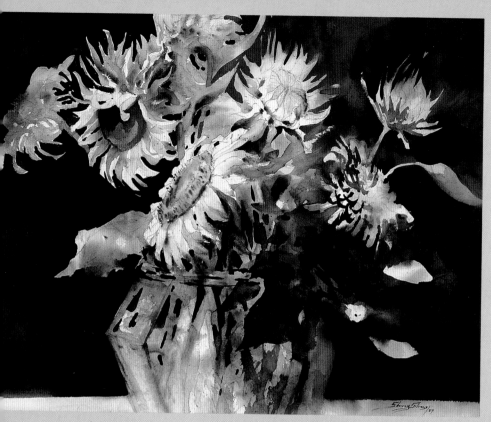

SHERRY SILVERS

SHOW GIRLS

28" x 20" (71.1 cm x 50.8 cm)

Arches 140 lb.

Media: Rice paper, string, pastels

GREGORY LITINSKY, N.W.S.

CAT AND BIRD

22" x 30" (55.9 cm x 76.2 cm)

Arches 140 lb. cold press

JEANNIE GRISHAM

VAN GOGH'S INSPIRATION

21" x 14" (53.3 cm x 35.6 cm)

Lana Aquarelle 140 lb. hot press

JOYCE GOW, M.W.S.

PETALS

21" x 29" (53.3 cm x 73.7 cm)

Arches 140 lb. cold press

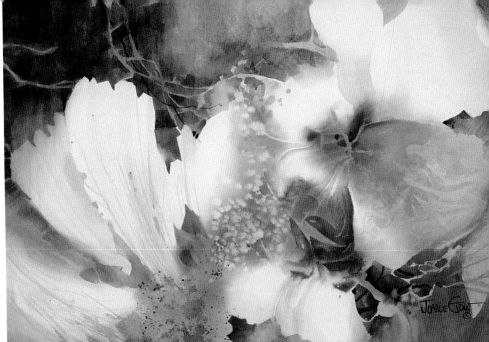

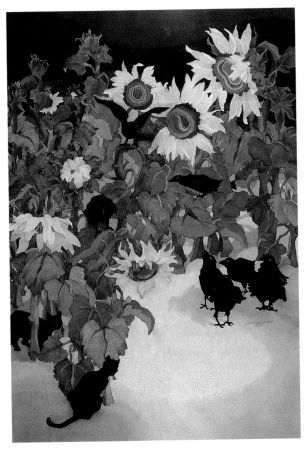

JANET B. WALSH, A.W.S.

WAITING GAME

30" x 40" (76.2 cm x 101.6 cm)

300 lb. cold press

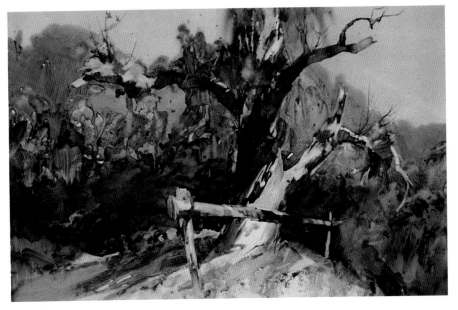

RUTH WYNN

NESTING PLACE

21" x 28" (53.3 cm x 71.1 cm)

Strathmore high surface

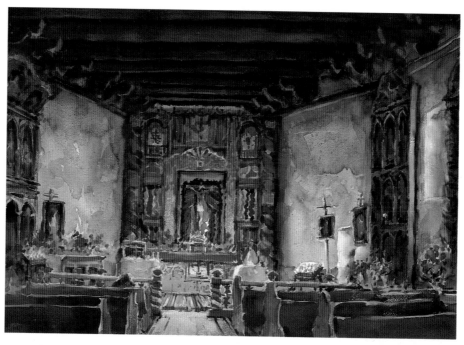

**FRANK LA LUMIA,
H.W.S.**

SANTUARIO (CHIMAYO,
NEW MEXICO)

22" x 30" (55.9 cm x 76.2 cm)

Fabriano Esportazione 147 lb.
cold press

ROSE WEBER BROWN

TROPICAL CANOPY

17.5" x 38.5" (44.5 cm x 97.8 cm)

Strathmore Hyplate

Media: Permanent inks

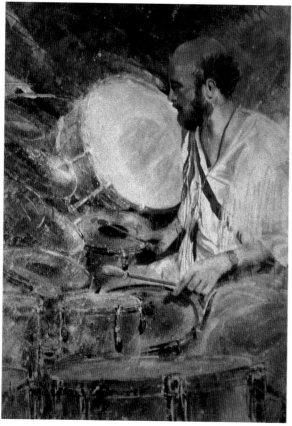

JANICE EDELMAN

SIZZLE

30" x 22" (76.2 cm x 55.9 cm

Arches 300 lb. cold press

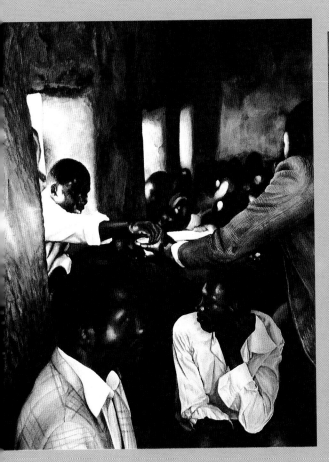

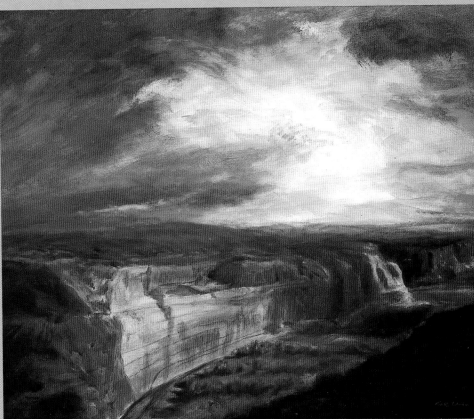

DAVID L. STICKEL

MALAWI COMMUNION

20" x 15.5" (50.8 cm x 39.4 cm)

Winsor & Newton 140 lb. hot
press

CAL DUNN, A.W.S., N.W.S.

AFTERGLOW CANYON DE CHELLY

22" x 28" (55.9 cm x 71.1 cm)

Arches medium

RUTH COCKLIN

THE GILDED GUARDER

32" x 46" (81.3 cm 116.8 cm)

Watercolor board

GERALDINE MCKEOWN

TANK BUILDERS

17.5" x 25" (44.5 cm x 63.5 cm)

140 lb. cold press

DONALD STOLTENBERG

OLD COLONY BRIDGE

22" x 30" (55.9 cm x 76.2 cm)

Arches 140 lb. cold press

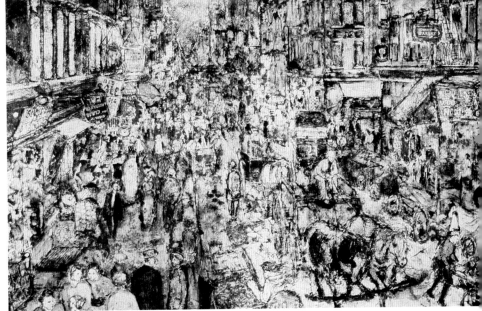

EDITH HILL SMITH,
N.W.S., S.W.S.

TEXTURED FIELDS

22" x 30" (55.9 cm x 76.2 cm)

Strathmore Aquarius II 80 lb.

Media: Acrylic, watercolor

JEROME LAND

N.Y. - 1912

38" x 26" (96.5 cm x 66 cm)

Acetate (transparent engineering paper)

Media: Casein

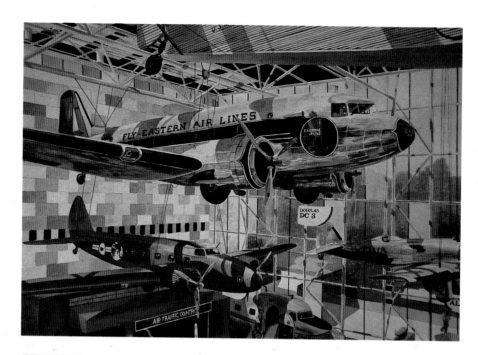

DOUG CASTELMAN

AIR AND SPACE MUSEUM

17" x 24.5" (43.2 cm x 62.2 cm)

Arches 400 lb. cold press

GREG TISDALE

SILVERDALE

17" x 27.5" (43.2 cm x 69.9 cm)

140 lb. medium surface

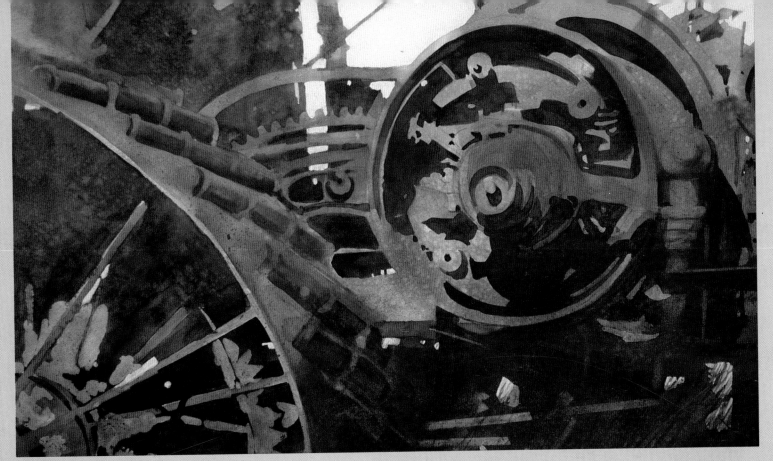

MARY BARTON
OUT OF STEAM
22" x 30" (55.9 cm x 76.2 cm)
Arches 140 lb. cold press

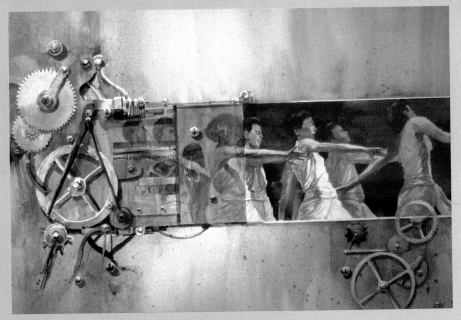

DONALD L. DODRILL,
A.W.S., N.W.S.
TIME MECHANISMS
20" x 29" (50.8 cm x 73.7 cm)
Arches 300 lb.

LOUISE NOBILI

SUN DOWN ORANGE

29" x 41" (73.7 cm x 104.1 cm)

Arches 555 lb. cold press

ALLAN HILL

SUSPENDED DIMENSION

22.5" x 30" (57.1 cm x 76.2 cm)

Arches 140 lb.

MARY ANN BECKWITH

ORIGIN: DREAM CAUGHT

30" x 22" (76.2 cm x 55.9 cm)

Arches 140 lb. hot press

Media: Watermedia, ink, colored

pencil, gouache

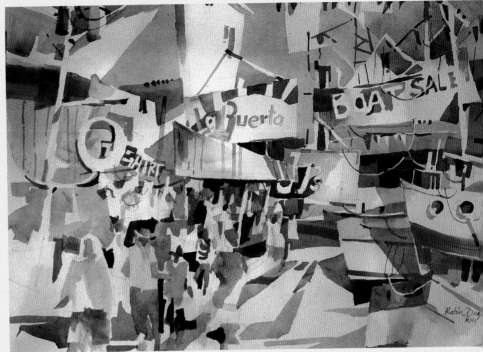

RATINDRA K. DAS,
M.W.S., N.W.W.S.
J.J.'s ETC.
20" x 30" (50.8 cm x 76.2 cm)
Arches 140 lb. cold press

BEA JAE O'BRIEN
FROM SING BURI
9.5" x 14.5" (24.1cm x 36.8 cm)
Masa rice paper
Media: Watercolor, gouache

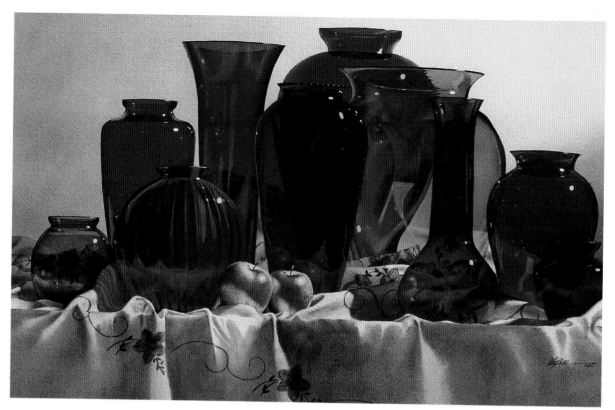

MICHAEL J. WEBER

COMPOSITION WITH
GLASS

16" x 28" (40.6 cm x 71.1 cm)

Arches 300 lb. rough

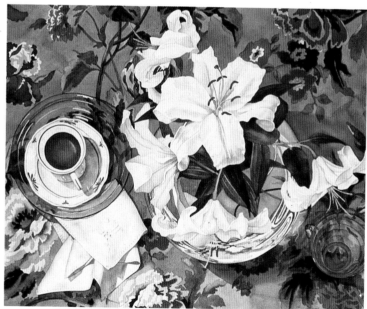

JANICE ULM SAYLES

DUTCH TILE

22" x 30" (55.9 cm x 76.2 cm)

140 lb. cold press

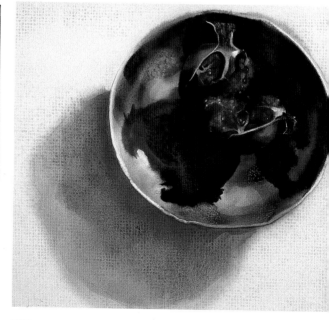

RUTH RUSH

RIPE AND READY

20" x 17" (50.8 x 43.2 cm)

Arches 300 lb. rough

ANNE HAYES
THE BROKEN PROMISE
15" x 22" (38.1 cm x 55.9 cm)
Arches 140 lb. cold press

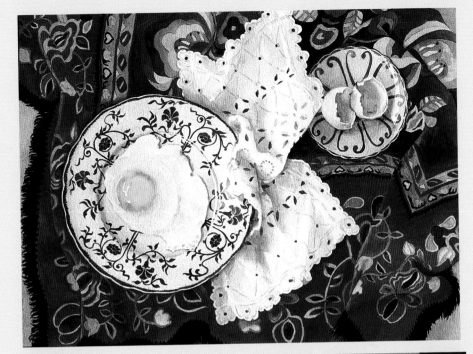

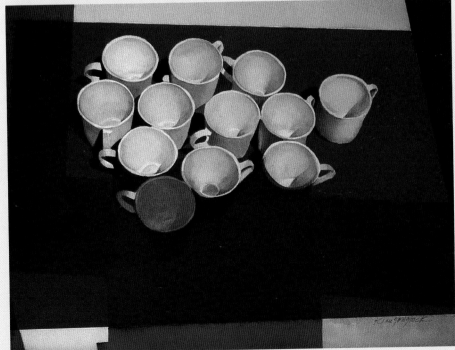

JUDITH KLAUSENSTOCK
12 WHITE CUPS
18" x 23" (45.7 cm x 58.4 cm)
Arches 140 lb. cold press

HEIDE E. PRESSE

COURTNEY'S NEW HAT

14" x 21" (35.6 cm x 53.3 cm)

Arches 300 lb. cold press

Media: Watercolor, gouache

ANN T. PIERCE

THE MIME

21.5" x 29.5" (54.6 cm x 74.9 cm)

Arches 140 lb. rough

Media: Transparent watercolor,
watercolor crayon, acrylic gel
background

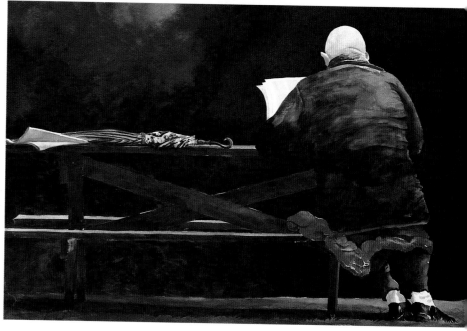

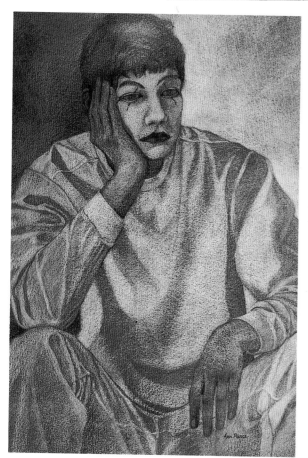

JERRY M. ELLIS, A.W.S., N.W.S.

MR. CLEAN

19" x 28" (48.3 cm x 71.1 cm)

Arches 260 lb. cold press

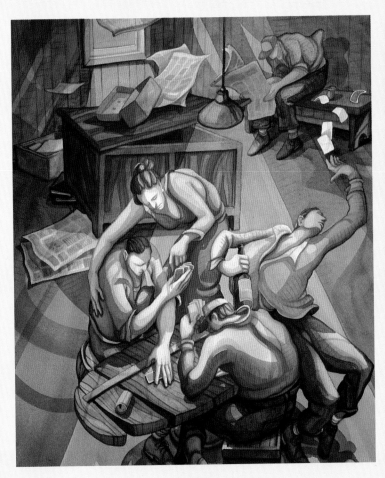

ROBERT L. BARNUM

DOWN TIME

19" x 24" (48.3 cm x 60.9 cm)

Arches 300 lb. rough

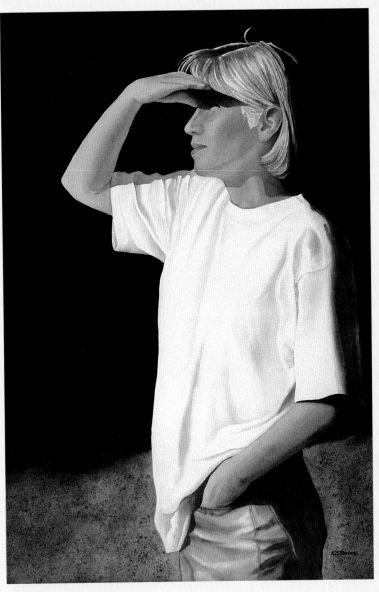

KIM STANLEY BONAR

INTO THE LIGHT

30" x 22" (76.2 cm x 55.9 cm)

Arches 300 lb. cold press

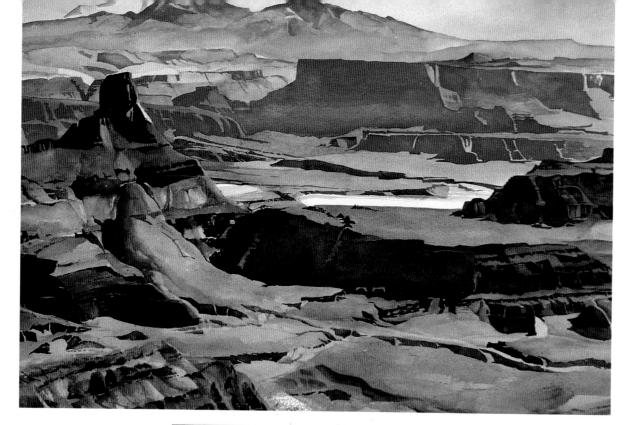

GAYLE FULWYLER SMITH

CANYON OVERLOOK
22" x 30" (55.9 cm x 76.2 cm)
E.H. Saunders 140 lb.
Media: Transparent watercolor,
glazes, wet-on-wet painting

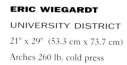

ERIC WIEGARDT

UNIVERSITY DISTRICT
21" x 29" (53.3 cm x 73.7 cm)
Arches 260 lb. cold press

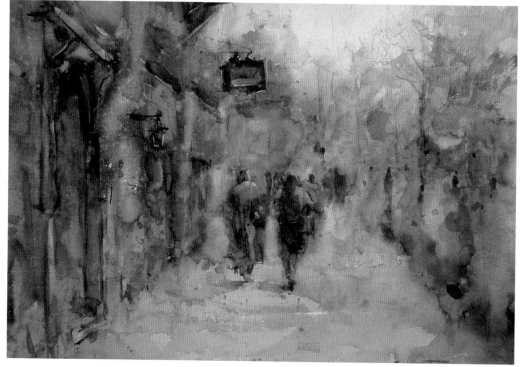

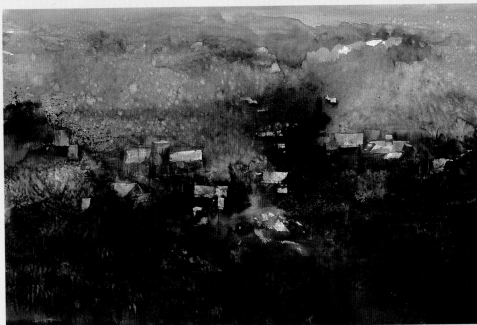

CORY STAID
VERDANT LANDSCAPE
20" x 30" (50.8 cm x 76.2 cm)
Lin-Tex

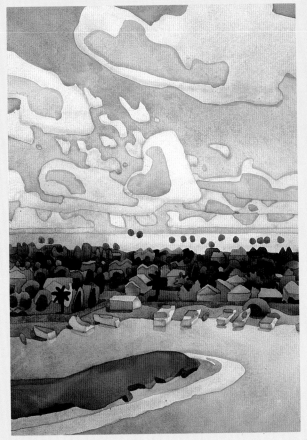

CAROLYN LORD
BRIGHT AND BREEZY:
NEWPORT BEACH
22" x 15" (55.9 cm x 38.1 cm)
Arches 140 lb. cold press

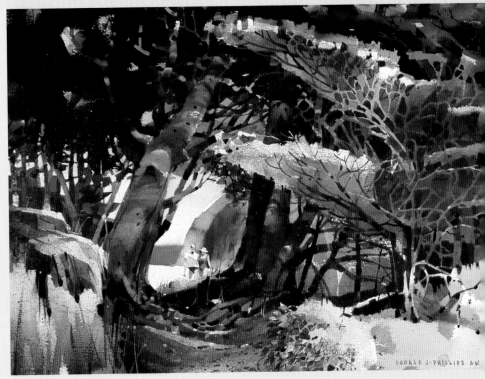

DONALD PHILLIPS
PATH TO JULIA PFEIFFER
BURNS BEACH
20" x 29" (50.8 cm x 71.1 cm)
Arches 300 lb. rough

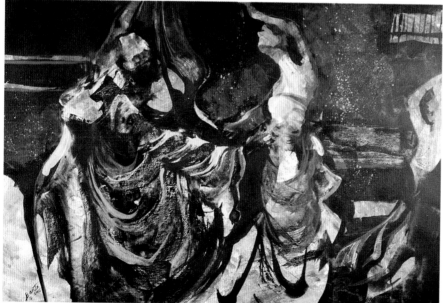

JUDITHE RANDALL

PORTRAIT OF A LIFE

18" x 28" (45.7 cm x 71.1 cm)

Crescent

Media: Grumbacher watercolors,
Rapidograph pen and ink, white
crayon chalk

DOROTHY BARTA

FROM WHENCE IT ALL
BEGAN

21" x 29" (53.3 cm x 73.7 cm)

Arches 140 lb. cold press

Media: Acrylic, gesso

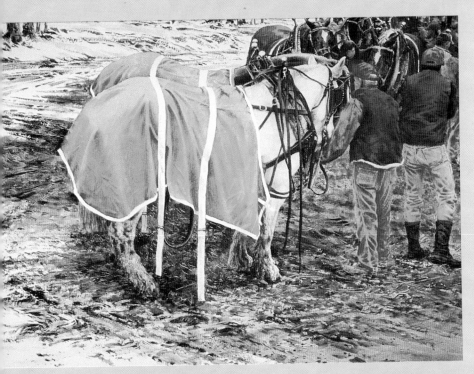

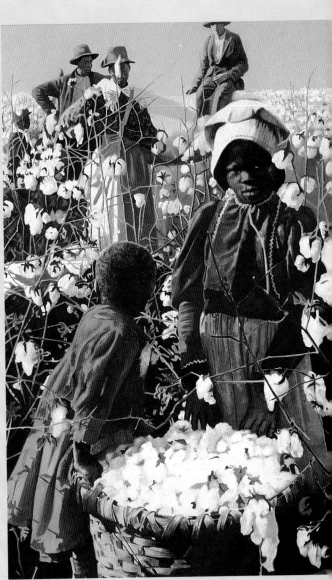

NEIL DREVITSON, A.W.S.
TEAMSTERS
22" x 30" (55.9 cm x 76.2 cm)
Waterford 300 lb. cold press

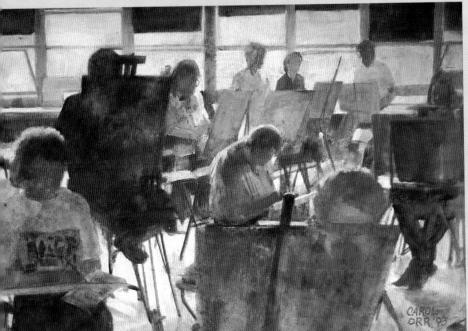

CAROL ORR, A.W.S., N.W.S.
CLASSROOM SITUATION
17" x 28" (43.2 cm x 71.1 cm)
260 lb. Winsor & Newton rough
Media: Gesso, underpainting splashes,
watercolor with gesso.

LAEL NELSON
HIGH COTTON
31" x 19" (78.7 cm x 48.3 cm)
Cold press

113

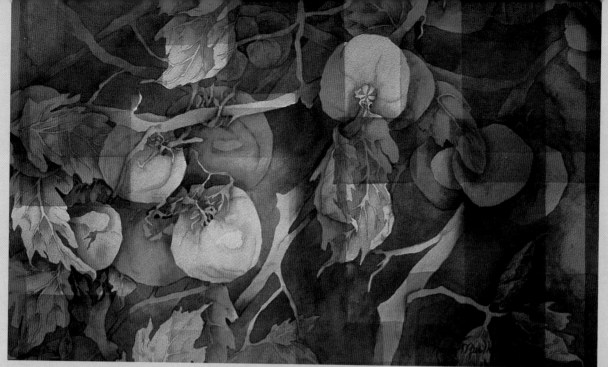

KAREN MUELLER KESWICK
NOUVEAU TOMATOES
23" x 30" (58.4 cm x 76.2 cm)
Arches 140 lb. cold press

ANNE BAGBY
SPRING STILL LIFE
24" x 36" (60.9 cm x 91.4 cm)
Arches 140 lb. cold press
Media: Transparent watercolor,
opaque acrylic, sepia, colored pencil

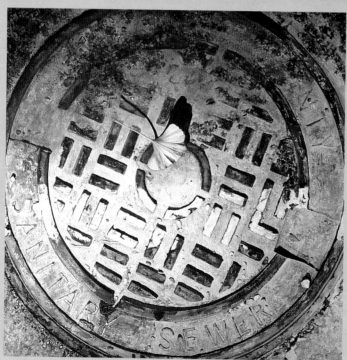

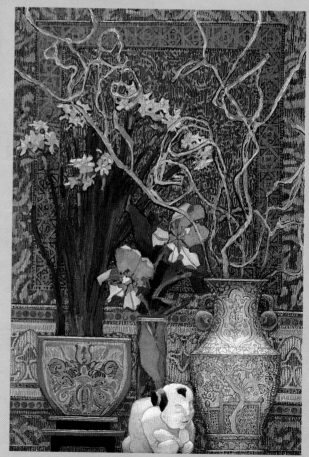

MARY LOU FERBERT
GINKGO LEAF AND MAN-HOLE COVER
28" x 28" (71.1 cm x 71.1 cm)
Tycore

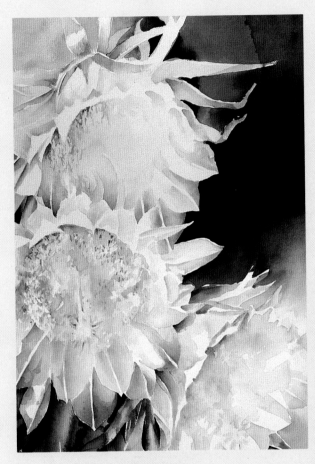

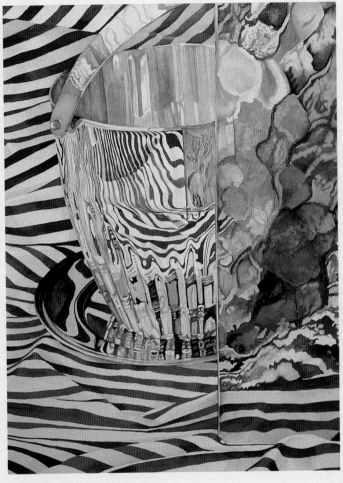

DAVID MADDERN

NIGHT BLOOMING

CEREUS VIII

40" x 32" (101.6 cm x 81.3 cm)

Lana Aquarelle 300 lb. cold press

MARTHA HOUSE, N.W.S.

RED STRIPES

18" x 25" (45.7 cm x 63.5 cm)

Arches 300 lb.

LEONA SHERWOOD

LE DÉJEUNER—
LA NAPOULE

20.5" x 27.75" (52.1 cm x 70.5 cm)

Arches 140 lb. cold press
(unstretched)

Media: Watercolor, gouache

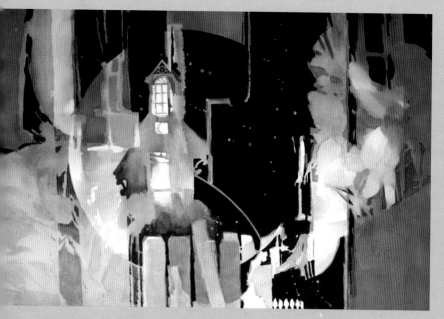

PEGGY PIPKIN

PLANET EARTH

22" x 30" (55.9 cm x 76.2 cm)

Arches 140 lb.

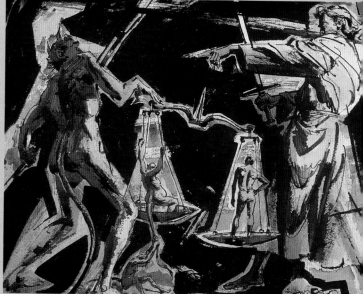

JOHN A. LAWN, A.W.S.

GO TO HELL

16" x 20" (40.6 cm x 50.8 cm)

Arches 140 lb.

Media: Watercolor, acrylic, diluted water, proof black ink

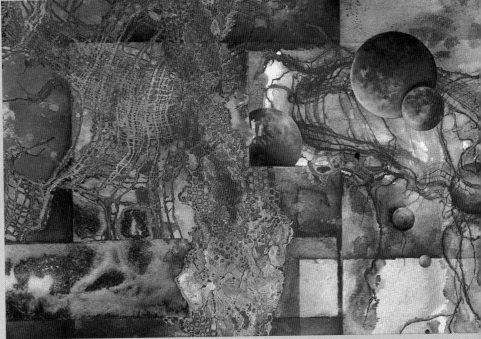

LORRAINE HILL, S.E.A.

INTRICATE PATTERNS

9" x 21" (22.9 cm x 53.3 cm)

Bainbridge

Media: Premixed ink,

watercolor, acrylic, gold pen

WILLENA JEANE BELDEN

MOMENTARY VISION

12" x 18" (30.5 cm x 45.7 cm)

140 lb. cold press

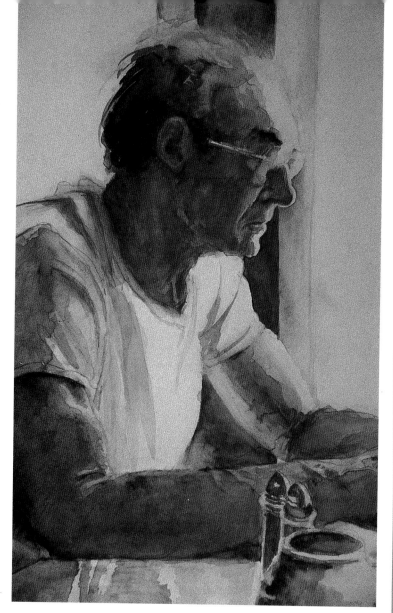

RON TIRPAK

UNTITLED

13.5" x 10" (34.3 cm x 25.4 cm)

Bristol 2-ply plate

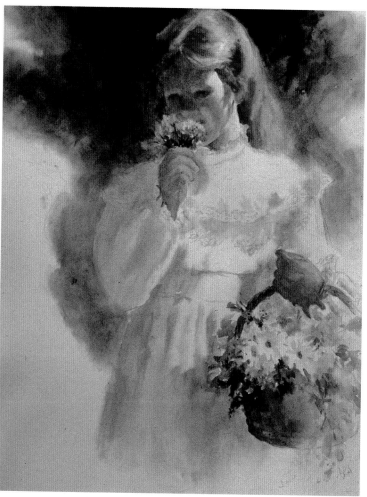

MILDRED BARTEE

SUNNY

21.25" x 28.5" (53.9 cm x 72.4 cm)

Fabriano Artistico 140 lb. smooth

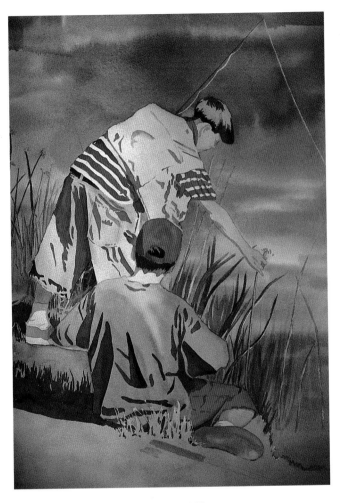

PAULA B. HUDSON
ANCIENT PASTTIMES II
22" x 33" (55.9 cm x 83.8 cm)
Lana Aquarelle 300 lb.

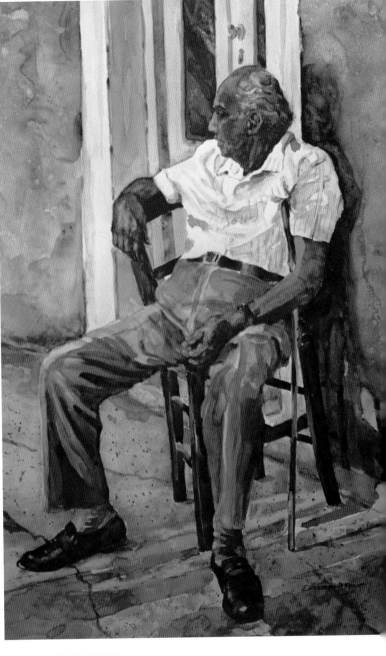

ELIZABETH H. PRATT
SUNDAY AFTERNOON
28" x 22" (71.1 cm x 55.9 cm)
Strathmore 3-ply

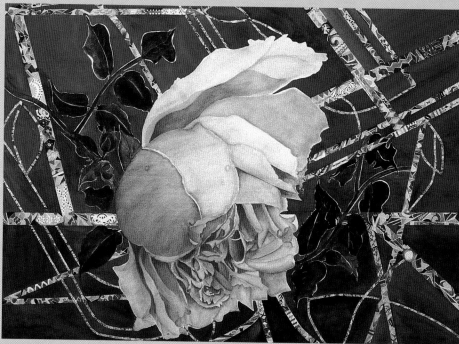

HILDA STUHL

ROSE & RIBBONS

22" x 30" (55.9 cm x 76.2 cm)

Arches 140 lb. cold press

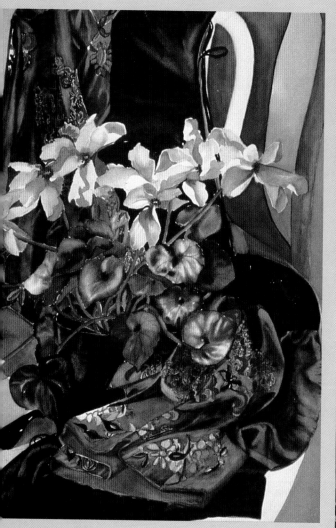

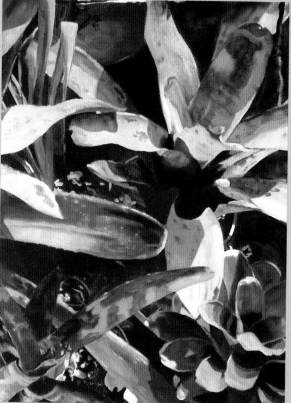

PAT BERGER

BROMELIAD MEDLEY

36" x 22" (91.4 cm x 55.9 cm)

Arches 500 lb. hot press

CAROLYN H. PEDERSEN, N.W.S.

ORIENTAL TREASURE

22" x 30" (55.9 cm x 76.2 cm)

Arches 300 lb. cold press

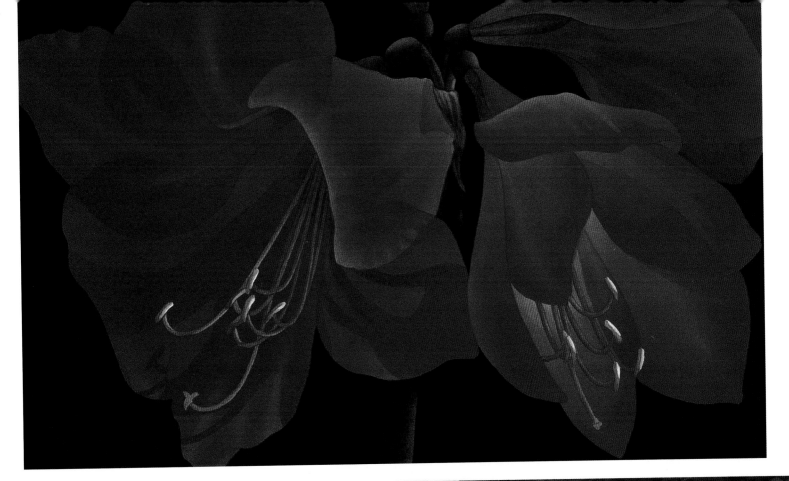

ANN SALISBURY

INNER GLOW

20" x 15" (50.8 cm x 38.1 cm)

Arches 140 lb. cold press

Media: Acrylic, watercolor,

gouache

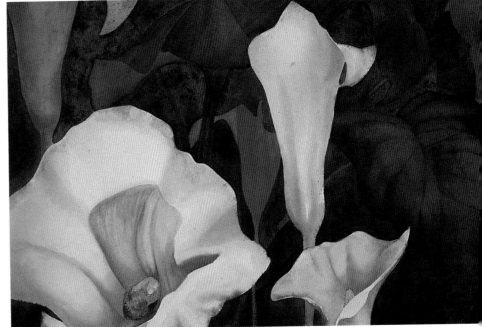

PATRICIA A. HICKS

MIDNIGHT CALLAS

15" x 22" (38.1 cm x 55.9 cm)

Arches 140 lb. cold press

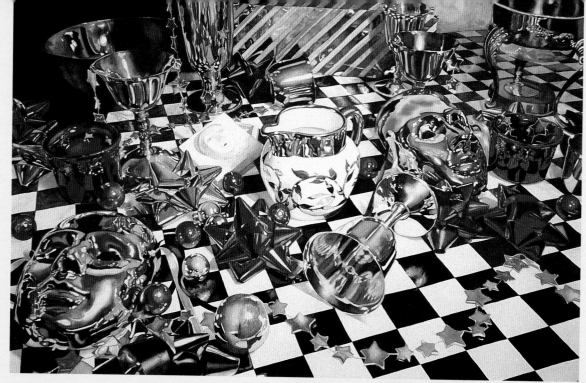

CYNTHIA PETERSON

STARS II

29.5" x 40" (74.9 cm x 101.6 cm)

Lana Aquarelle double elephant

LINDA TOMPKIN,
A.W.S., N.W.S.

HOH SQUA SA GADAH

20" x 22" (50.8 cm x 55.9 cm)

Crescent 100 lb. cold press

Media: Opaque acrylic

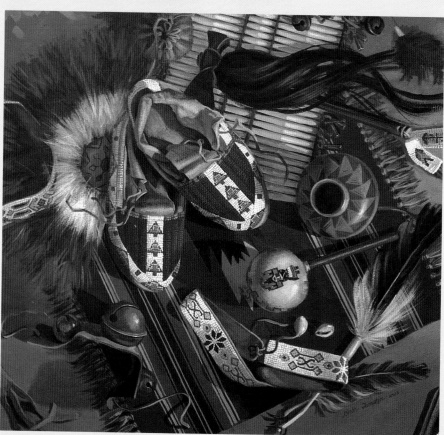

KAREN GEORGE

BEADS AND MORE

26" x 40" (66 cm x 101.6 cm)

Arches 140 lb. cold press

CHRIS KRUPINSKI

QUILT WITH GREEN
APPLES

22" x 30" (55.9 cm x 76.2 cm)

Arches 300 lb. cold press

ELOISE POPE

RED HOT SEATS

22" x 30" (55.9 cm x 76.2 cm)

Arches 300 lb.

KEN HANSEN
AT THE VETS
13" x 20" (33 cm x 50.8 cm)
Arches 300 lb. cold press

KITTY WAYBRIGHT
OLD SHAY #5
29" x 21" (73.7 cm x 53.3 cm)
Fabriano Esportazione 147 lb.

REVELLE HAMILTON
CATCHING THE BREEZE
21" x 29" (53.3 cm x 73.7 cm)
Strathmore Aquarius II
Media: Acrylic

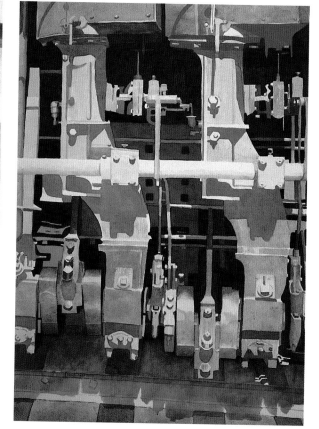

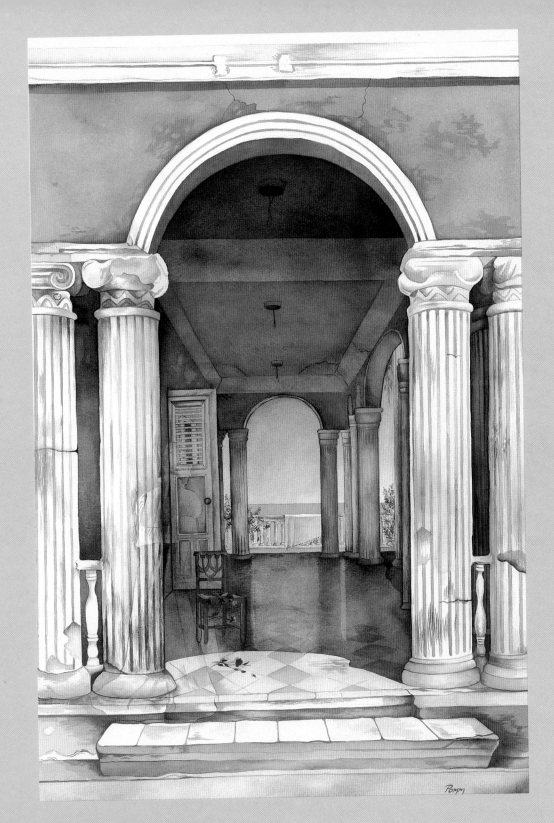

POMM

SPLENDID MEMORIES

23" x 33" (58.4 cm x 83.9 cm)

Arches 140 lb. cold press

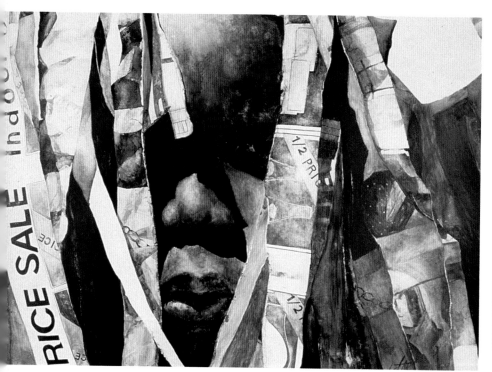

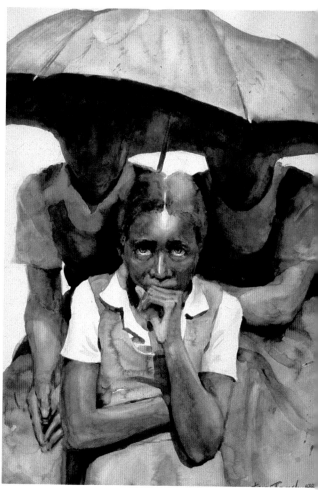

S.J. HART

NATHANIEL

40" x 60" (101.6 cm x 152.4 cm)

Foam core

THOMAS V. TRAUSCH

IN PASSING

26" x 20" (66 cm x 50.8 cm)

Arches 140 lb. hot press

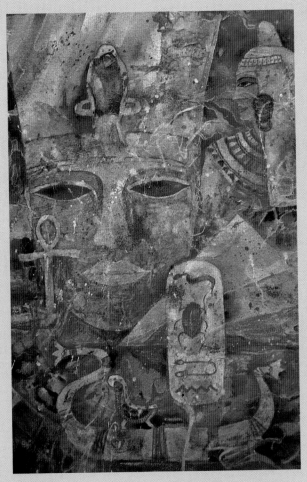

MARY UNTERBRINK

LAND OF THE PHARAOHS

13" x 18" (33 cm x 45.7 cm)

Arches 140 lb. cold press

LOIS DUITMAN

DON DIEGO DE VARGAS

18" x 24" (45.7 cm x 60.9 cm)

140 lb. cold press rough

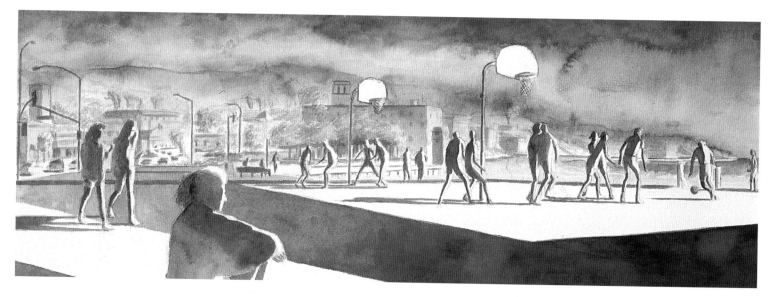

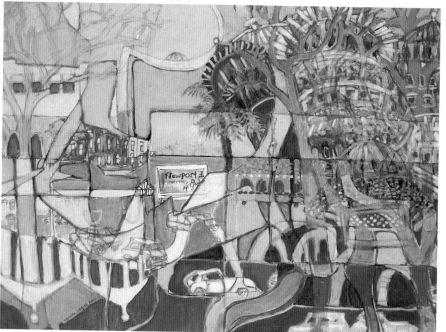

MARY T. MONGE

SHOOTING HOOPS IN
LAGUNA BEACH

30" x 11" (76.2 cm x 27.9 cm)

300 lb. cold press

MERWIN ALTFELD

GREEN HOTEL PASADENA

30" x 40" (76.2 cm x 101.6 cm)

Crescent

Media: Watercolor, acrylic

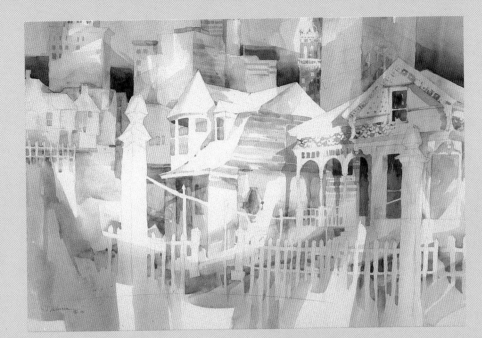

JEAN WARREN

PRESERVATION PARK

22" x 30" (55.9 cm x 76.2 cm)

Arches 140 lb. cold press

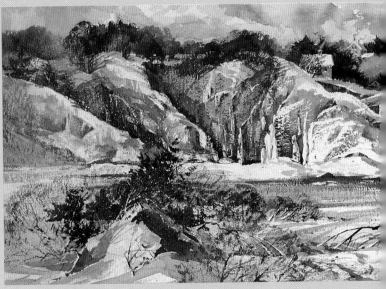

YEE WAH JUNG

COUNTRY SIDE

22" x 30" (55.9 cm x 76.2 cm)

Arches 140 lb.

Media: Watercolor and acrylic mix

NATHALIE J. NORDSTRAND, A.W.S.

WINTER AT FLAT LEDGE QUARRY

18.5" x 26" (47 cm x 66 cm)

Fabriano Esportazione 300 lb.

Media: Watercolor, gouache

LOU RIZZOLO
CHARLEVOIX BREEZE
25.5" x 34" (64.8 cm x 86.4 cm)
Fabriano Artistico 190 lb., rice
paper

JUDI COFFEY, N.W.S.
SILK SCARF SERIES: HIDDEN TREASURERS
22" x 30" (55.9 cm x 76.2 cm)
Arches 140 lb. hot press, rice paper
Media: Collage, acrylic

PAT SAN SOUCIE
VEGETATIVE
39" x 28" (99.1 cm x 71.1 cm)
E. H. Saunders 156 lb. hot press
Media: Watercolor, gouache

MARY LIZOTTE

LEMON & LIME

21" x 28" (53.3 cm x 76.2 cm)

Lana Aquarelle 140 lb.

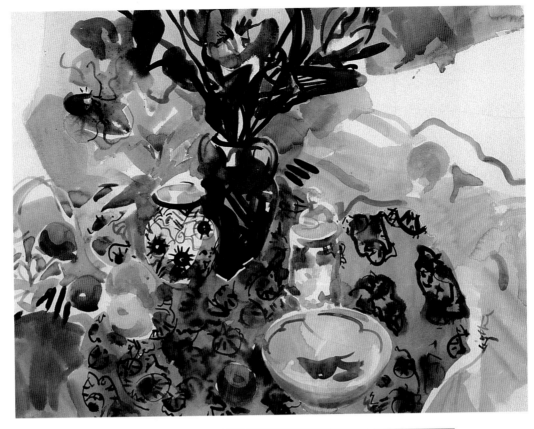

**CHENG-KHEE CHEE,
A.W.S., N.W.S.**

GOLDFISH 92 NO. 1

30" x 40" (76.2 cm x 101.6 cm)

Arches 300 lb. cold press

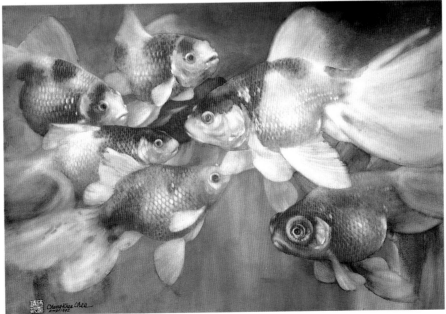

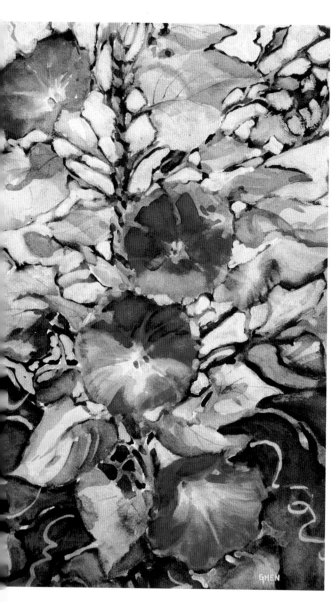

SHERRY LOEHR

VARIATION WITH LEMONS

24" x 24" (60.9 cm x 60.9 cm)

Arches 140 lb. cold press

Media: Acrylic wash, watercolor

EDYTHE SOLBERG GHEN

MORNING GLORIES

15" x 22" (38.1 cm x 55.9 cm)

Waterford 140 lb.

Media: Watercolor, gouache

EUDOXIA WOODWARD

BALLOON FLOWER IN

FLIGHT #2

22" x 30" (55.9 cm x 76.2 cm)

Arches 140 lb. cold press

MARIJA PAVLOVICH MCCARTHY

THREE ROSES

15" x 22" (38.1 cm x 55.9 cm)

Fabriano Artistico 150 lb. rough

GLORIA BAKER

THE REVERANCE

29" x 21" (73.7 cm x 53.3 cm)

Arches 140 lb. cold press

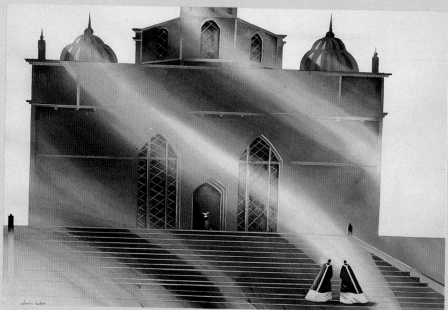

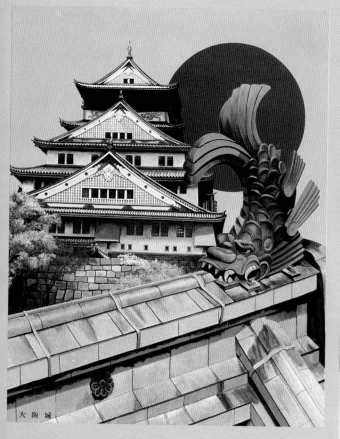

GEORGE W. KLEOPFER, JR.

OSAKA CASTLE AND FRIEND

23.75" x 29.25" (60.3 cm x 74.3 cm)

2-ply illustration board

Media: Acrylic

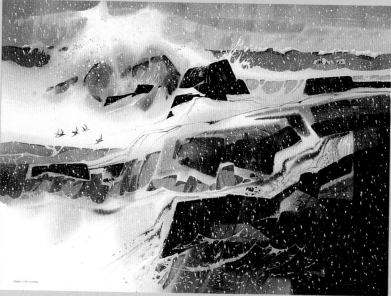

ROBERT ERIC MOORE, N.A., A.W.S.

SNOW AND WIND BIRDS

21" x 29" (53.3 cm x 73.7 cm)

Arches 140 lb. cold press

GERARD F. BROMMER

MYKONOS CHAPEL

11" x 15" (27.9 cm x 38.1 cm)

Arches 300 lb. rough

Media: Watercolor, gouache,

collage

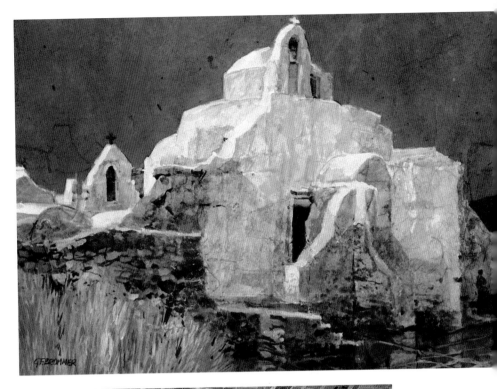

LAUREL COVINGTON-VOGL

POSTCARD FORM MILAN:
PATCHWORK PIAZZA

25" x 32" (63.5 cm x 91.4 cm)

140 lb. cold press

MARY FIELD NEVILLE

TENNESSEE TAPESTRY

30" x 40" (76.2 cm x 101.6 cm)

Strathmore cold press

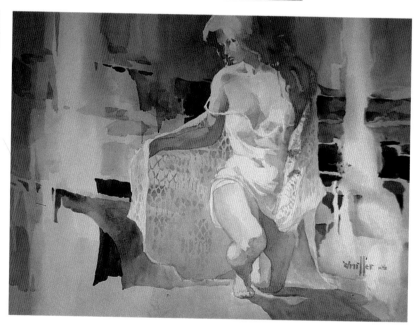

CARL VOSBURGH MILLER

PAULA

22" x 30" (55.9 cm x 76.2 cm)

Arches 140 lb. cold press

ROBERT DI MARZO

VICTORIAN LACE WINDOW

16.25" x 19.5" (41.2 cm x 49.5 cm)

140 lb. cold press

HERB RATHER, A.W.S., N.W.S.

SULLIVAN STYLE

22" x 30" (55.9 cm x 76.2 cm)

Arches 140 lb. rough

DAN BURT, A.W.S., N.W.S.

CALLEJON II

30" x 22" (76.2 cm x 55.9 cm)

Arches 300 lb. cold press

INCHA LEE

DEEP IN THE WOODS

22" x 30" (55.9 cm x 76.2 cm)

Arches 140 lb. hot press

Media: Ink

DOROTHY SKLAR

LANDMARK

13.5" x 20.5" (34.3 cm x 53.1 cm)

Whatman cold press

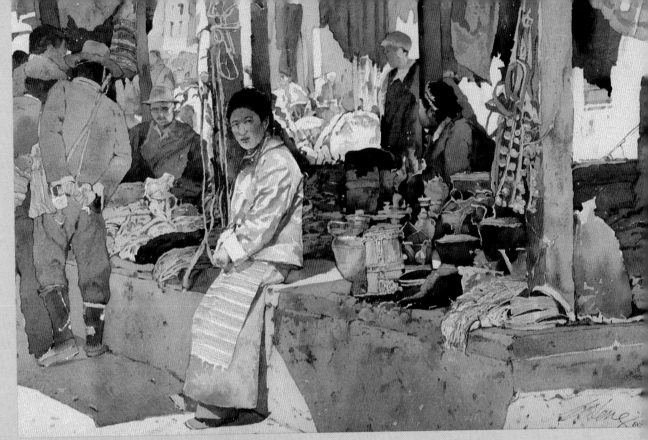

KIM SENG ONG, A.W.S.

GYANTSE MARKET

21.5" x 30" (54.6 cm x 76.2 cm)

Arches 850 G/M2 rough

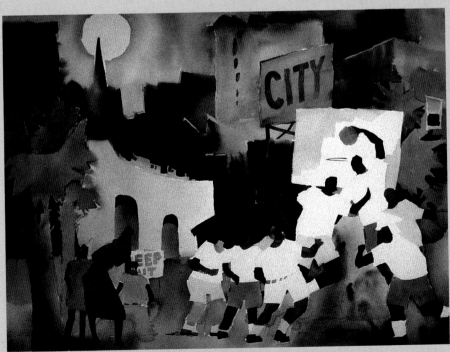

EDWIN C. SHUTTLEWORTH, M.D.

INNER CITY #3

21.5" x 29.5" (54.6 cm x 75 cm)

Arches 140 lb. cold press

WILLIAM VASILY SINGELIS

RED ROSES

34" x 39" (86.4 cm x 99.1 cm)

Illustration board

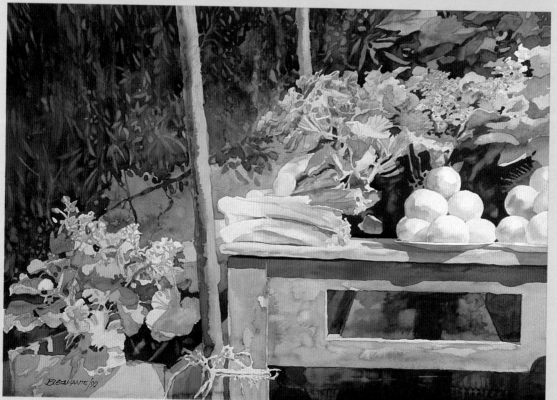

JORGE BUSTAMANTE

SURVIVORS

28" x 20" (71.1 cm x 50.8 cm)

Guarro 140 lb

ABOUT THE JUDGES

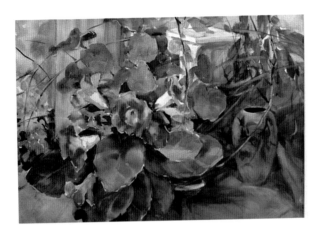

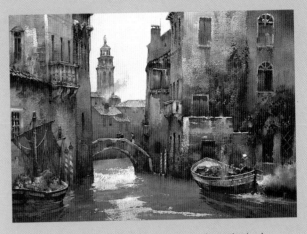

BETTY LOU SCHLEMM, A.W.S., D.F., has been painting for more than thirty years. Elected to the American Watercolor Society in 1964, and later elected to the Dolphin Fellowship, she has served as both regional vice-president and director of the American Watercolor Society. Ms. Schlemm is also a teacher and an author. Her painting workshops in Rockport, Massachusetts have become reknowned during the past twenty-seven years. Her book, *Painting with Light*, published by Watson-Guptill in 1978, has remained a classic. Her techniques have recently been featured in *Learn to Watercolor the Edgar Whitney Way*, a new publication from North Light.

TOM NICHOLAS, N.A., A.W.S., D.F., has maintained a gallery, home, and studio in Rockport, Massachusetts since 1982. His work is represented in a dozen museum collections, including the Butler Institute of American Art in Ohio, the Farnsworth Museum in Maine, the Springfield Art Museum in Missouri, and the Peabody Museum in Massachusetts. An award-winning artist, Nicholas' work has been featured in more than 35 one-man shows across the United States.

Martin R. Ahearn
102 Marmion Way
Rockport, MA 01966

Gary Akers
P.O. Box 200
Spruce Head, ME 04859

Merwin Altfeld
18426 Wakecrest Drive
Malibu, CA 90265

Mary Ellen Andren
8206 B. Willowbrook
Circle SE
Huntsville, AL 35802-3336

Anne Bagby
242 Shadowbrook
Winchester, TN 37398

Hella Bailin
829 Bishop Street
Union, NJ 07083

Gloria Baker
2711 Knob Hill Drive
Evansville, IN 47711

Linda Baker
17763 148th Avenue
Spring Lake, MI 49456

Charles F. Barnard
4740 North Kelsey Place
Stockton, CA 95207

Sabine M. Barnard
1722 S. Delaware Place
Tulsa, OK 74104-5918

Kathleen Barnes
2413 S. Eastern Avenue
#144
Las Vegas, NV 89104

Robert L. Barnum
9739 Calgary Drive
Stanwood, MI 49346

Dorothy Barta
3151 Chapel Downs
Dallas, TX 75229

Mildred Bartee
34 Cary Avenue
Lexington, MA 02173

Mary Barton
P.O. Box 23133
Waco, TX 76702-3133

Miles G. Batt, Sr.
301 Riverland Road
Fort Lauderdale, FL 33312

Mary Ann Beckwith
619 Lake Avenue
Hancock, MI 49930

Sandra E. Beebe
239 Mira Mar Avenue
Long Beach, CA 90803

Willena Jeane Belden
2059 Rambler Road
Lexington, KY 40503

Henry Bell
150 N. Millcreek Road
Noblesville, IN 46060

Pat Berger
2648 Anchor Avenue
Los Angeles, CA 90064

Judi Betts
P.O. Box 3676
Baton Rouge, LA 70821-3676

Avie Biedinger
6158 Kaywood
Cincinnati, OH 45243

Mary Blackey
Harbor Lights C-15
1032 Radcliffe Street
Bristol, PA 19007

Julian Bloom
4522 Cathy Avenue
Cypress, CA 90630-4212

Bogomir Bogdanovic
108 Park Lane
Warwick, NY 10990

Kim Stanley Bonar
9870 Van Dyke
Dallas, TX 75218

Sally Bookman
151 Manresa Drive
Aptos, CA 95003

Cecie Borschow
735 Sherwood Drive
Richardson, TX 75080-6018

Joan Boryta
133 East Main Street
Plainfield, MA 01070

Jorge Bowenforbes
P.O. Box 1821
Oakland, CA 94612

Betty M. Bowes
301 McClenaghan
Mill Road
Wynnewood, PA 19096-1012

Jane Bregoli
401 State Road
Dartmouth, MA 02747

Gerald F. Brommer
11252 Valley Spring Lane
North Hollywood, CA 91602

Al Brouillette
1300 Sunst Court
Arlington, TX 76013

Peggy Brown
1541 N. Claylick Road
Nashville, IN 47448

Rose Weber Brown
10510 Winchester Court
Fort Myers, FL 33908

Lawrence R. Brullo
1146 San Lori Lane
El Cajon, CA 92019

John Bryans
2264 N. Vernon Street
Arlington, VA 22207

Barbara Burnett
8916 Hadley Place
Shawnee Mission, KS 66212

Dan Burt
2110-B West Lane
Kerrville, TX 78028-3838

Barbara Burwen
12 Holmes Road
Lexington, MA 02173

Jorge Bustamante
7730 Camino Real F407
Miami, FL 33143

Karen B. Butler
169 W. Norwalk Road
Norwalk, CT 06850

Pat Cairns
4895 El Verano
Atascadero, CA 93422

Doug Castleman
14629 Hilltree Road
Santa Monica, CA 90402-1009

Deborah L. Chabrian
28 Spooner Hill Road
South Kent, CT 06785

Linda J. Chapman
Route 2 Box J
Jane Lew, WV 26378

Marge Chavooshian
222 Morningside Drive
Trenton, NJ 08618

Cheng-Khee Chee
1508 VermilionRoad
Duluth, MN 55812

Celia Clark
RD #2, Box 228A
Delhi, NY 13753

Ruth Cobb
38 Devon Road
Newton, MA 02159

Ruth Cocklin
5923 South Willow Way
Englewood, CO 80111

Judi Coffey
10602 Cypresswood Drive
Houston, TX 77070

Loring W. Coleman
39 Poor Farm Road
Harvard, MA 01451

Joseph J. Correale Jr.
25 Dock Square
Rockport, MA 01966

Laurel Covington-Vogel
333 Northeast Circle
Durango, CO 81301

Maxine Custer
2083 Trevino Avenue
Oceanside, CA 92056

Dorothy B. Dallas
378 Eastwood Court
Englewood, NJ 07631

Mickey Daniels
4010 E. San Juan Avenue
Phoenix, AZ 85018

Ratindra K. Das
1938 Berkshire Place
Wheaton, IL 60187

Pat Deadman
105 Townhouse Lane
Corpus Christi, TX 78412

Gayle Denington-Anderson
661 South Ridge East
Geneva, OH 44041

D. Gloria Devereaux
49 Lester Avenue
Freeport, NY 11520

Robert Di Marzo
7124 Hartwell
Dearborn, MI 48126

Henry W. Dixon
8000 E. 118th Terrace
Kansas City, MD 64134

Donald L. Dodrill
Suite C
17 Aldrich Road
Columbus, OH 43214

Liz Donovan
4035 Roxmill Court
Glenwood, MD 21738

J. Everett Draper
20 Ponte Vedra Circle,
P.O. Box 12
Ponte Vedra Beach, FL 32004

Neil Drevitson
Church Hill Road,
P.O. Box 515
Woodstock, VT 05091

Lois Duitman
2373 Hanover Drive
Dunedin, FL 34698

Cal Dunn
Route 9 Box 86L
Santa Fe, NM 87505

Janice Edelman
3505 Hale Road
Huntingdon Valley, PA 19006

J.A. Eiser
372 Hawthorn Court
Pittsburgh, PA 15237-2618

Jerry M. Ellis
Route 66 Studio
Route 1, Box 382
Carthage, MO 64836

Rich Ernsting
6024 Birchwood Avenue
Indianapolis, IN 46220

Renée Faure
600 Second Street
Neptune Beach, FL 32266

Mary Lou Ferbert
334 Parklawn Drive
Cleveland, OH 44116

Jill Figler
2230 Rising Hill Road
Placerville, CA 95667

Pat Fortunato
70 Southwick Drive
Orchard Park, NY 14127

Ellen Fountain
1909 N. Westridge Avenue
Tucson, AZ 85745-1557

Michael Frary
3409 Spanish Oak Drive
Austin, TX 78731

Elaine Frederickson
1602 McKusick Lane
Stillwater, MN 55082

Jane Frey
518 W. Franklin
Taylorville, IL 62568

Karen Frey
1781 Brandon Street
Oakland, CA 94611

Gerald J. Fritzler
1051 50 Road, Box 253
Mesa, CO 81643-0253

Carolyn Grossé Gawarecki
7018 Vagabond Drive
Falls Church, VA 22042

Karen George
2131 Winn
Kemah, TX 77565

Edythe Solberg Ghen
42 E. Corning Street
Beverly, MA 01915

George Gibson
1449 Santa Maria Avenue
Los Osos, CA 93402

T. Thomas Gilfilen
6469 Amblewood NW
Canton, OH 44718

Nellie Gill
318 Madrid Drive
Universal City, TX 78148

Joyce Gow
901 11th Avenue
Two Harbors, MN 55616

Jean H. Grastorf
6049 4th Avenue N.
St. Petersburg, FL 33710

Dick Green
4617 Southmore Drive
Bloomington, MN 55437-1847

Irwin Greenberg
17 W. 67th Street
New York, NY 10023

Ellna Gregory-Goodrum
7214 Lane Park Drive
Dallas, TX 75225

Joseph E. Grey II
19100 Beverly Road
Beverly Hills, MI 48025-3901

Mary Griffin
1002 Oakwood Street Ext.
Holden, MA 01520

Jeannie Grisham
10044 Edgecombe Place NE
Bainbridge Island, WA 98110

Marilyn Gross
374 MacEwen Drive
Osprey, FL 34229

Carmela C. Grunwaldt
772 Linda Vista Avenue
Pasadena, CA 91103

Elaine Hahn
8823 Lake Hill Drive
Lorton, VA 22079

Becky Haletky
128 Liberty Street
Rockland, MA 02370

Revelle Hamilton
131 Mockingbird Circle
Bedford, VA 24523

Ken Hansen
241 JB Drive
Polson, MT 59860

S.J. Hart
846 Lookout Mountain Road
Golden, CO 80401

Noriko Hasegawa
3105 Burkhart Lane
Sebastopol, CA 95472

Anne Hayes
7505 River Road #11G
Newport News, VA 23607

Janet N. Heaton
1169 Old Dixie Highway
Lake Park, FL 33403

Phyllis Hellier
2465 Pinellas Drive
Punta Gorda, FL 33983-3317

Patricia A. Hicks
506 Sheridan
Marquette, MI 49855

Sharon Hildebrand
5959 Saint Fillans Court W.
Dublin, OH 43017

Allan Hill
2535 Tulip Lane
Langhorne, PA 19053

Lorraine Hill
295 Gilmour Street P.H. 2
Ottawa K2P 0P7
CANADA

Judy A. Hoiness
1840 NW Vicksburg Avenue
Bend, OR 97701

John R. Hollingsworth
15426 Albright Street
Pacific Palisades, CA 90272

Martha House
962 N. Lakeshore Circle
Port Charlotte, FL 33952

Margaret Hoybach
101 Grayson Lane
Summerville, SC 29485

Margaret Huddy
105 N. Union Street #313
Alexandria, VA 22314

Paula B. Hudson
24364 Paragon Place
Golden, CO 80401

Mary Sorrows Hughes
1045 Erie Street
Shreveport, LA 71106

Howard Huizing
145 S. Olive Street
Orange, CA 92666

Sandra Humphries
3503 Berkeley Place NE
Albuquerque, NM 87106

Bill James
15840 S.W. 79th Court
Miami, FL 33157

George James
340 Colleen
Costa Mesa, CA 92627

Philip Jamison
104 Price Street
West Chester, PA 19382

Joe Jaqua
300 Stony Point Road
Santa Rosa, CA 95401

Astrid E. Johnson
14423 Ravenswood Drive
Sun City West, AZ 85375-5629

Bruce G. Johnson
953 E. 173rd Street
South Holland, IL 60473-3529

Donal Jolley
P.O. Box 156
Rimforest, CA 92378

Carole Pyle Jones
275 Upland Road
West Grove, PA 19390

Jack Jones
391 Maple Street
Danvers, MA 01923

Joyce H. Kamikura
6651 Whiteoak Drive
Richmond, BC V7E 4Z7
CANADA

M.C. Kanouse
6346 Tahoe Lane SE
Grand Rapids, MI 49546

Karen Mueller Keswick
9707 Creek Bridge Circle
Pensacola, FL 32514-1676

Kim Seng Ong
Block 522, Hougang
Avenue 6 #10-27
SINGAPORE 1953

Dong Kingman
21 W 58th Street
New York, NY 10019

Sandy Kinnamon
3928 New York Drive
Enon, OH 45323

Everett Raymond Kinstler
15 Gramercy Park S.
New York, NY 10003

Frances Kirsh
P.O. Box 10767
Pensacola, FL 32524

Judith Klausenstock
94 Reed Ranch Road
Tiburon, CA 94920

George W. Kleopfer, Jr.
2110 Briarwood Boulevard
Arlington, TX 76013

George Kountoupis
5523 E. 48th Place
Tulsa, OK 74135

Lynne Kroll
3917 NW 101 Drive
Coral Springs, FL 33065

Chris Krupinski
10602 Barn Swallow Court
Fairfax, VA 22032

Frederick Kubitz
12 Kenilworth Circle
Wellesley, MA 02181

Kuo Yen Ng
4514 Hollyridge Drive
San Antonio, TX 78228

Frank La Lumia
P.O. Box 3237
Pojoaque Station
Santa Fe, NM 87501-0237

Jerome Land
S.W. 730 Crestview
Pullman, WA 99163

John A. Lawn
200 Hulls Highway
Southport, CT 06490

Incha Lee
713 W. Jacker Avenue
Houghton, MI 49931

Barbara Leites
18 Lehmann Drive
Rhinebeck, NY 12572

Monroe Leung
1990 Abajo Drive
Monterey Park, CA 91754

Arne Lindmark
101 Forbus Street
Poughkeepsie, NY 12603

Gregory Litinsky
253 W 91 Street #4C
New York, NY 10024

Mary Lizotte
P.O. Box 93
Norwell, MA 02061

Sherry Loehr
1580 Garst Lane
Ojai, CA 93023

Carolyn Lord
1993 De Vaca Way
Livermore, CA 94550-5609

John L. Loughlin
124 Angell Road
Lincoln, RI 02865

Betty Lynch
1500 Harvard
Midland, TX 79701

Mary Britten Lynch
1505 Wood Nymph Tr
Lookout Mountain, TN 37350

David Maddern
6492 SW 22nd Street
Miami, FL 33155

Joseph Manning
5745 Pine Terrace
Plantation, FL 33317

Margaret C. Manter
1328 State Street
Veazie, ME 04401

Daniel J. Marsula
2828 Castleview Drive
Pittsburgh, PA 15227

Margaret M. Martin
69 Elmwood Avenue
Buffalo, NY 14201

Ophelia B. Massey
2610 Carriage Place
Birmingham, AL 35223

Anne Adams Robertson
Massie
3204 Rivermont Avenue
Lynchburg, VA 24503

Karen Mathis
9400 Turnberry Drive
Potomac, MD 20854

Benjamin Mau
1 LaTeer Drive
Normal, IL 61761

Marija Pavlovich McCarthy
6413 Western Avenue NW
Washington, DC 20015

Laurel Lake McGuire
1914 Blueridge Rd
Ridgecrest, CA 93555

John McIver
1208 Greenway Drive
High Point, NC 27262

Geraldine McKeown
227 Gallaher Road
Elkton, MD 21921

Mark E. Mehaffey
5440 Zimmer Road
Williamston, MI 48895

Paul G. Melia
3121 Atherton Road
Dayton, OH 45409

Joanna Mersereau
4290 University Avenue #14
Riverside, CA 92501

Fred L. Messersmith
726 N. Boston Avenue
DeLand, FL 32724

Mary Lou Metcalf
227 Ravenhead
Houston, TX 77034-1521

Anita Meynig
6335 Brookshire Drive
Dallas, TX 75230-4017

Carl Vosburgh Miller
334 Paragon Avenue
Stockton, CA 95210

Barbara Millican
5709 Wessex
Fort Worth, TX 76133

Edward Minchin
54 Emerson Street
Rockland, MA 02370

Lance R. Miyamoto
53 Smithfield Road
Waldwick, NJ 07463

Mary T. Monge
78 Allenwood Lane
Laguna Hills, CA 92656

Robert Eric Moore
111 Cider Hill Road
York, ME 03909-5213

Judy Morris
2404 E. Main Street
Medford, OR 97504

Sybil Moschetti
1024 11th Street
Boulder, CO 80302

Donald A. Mosher
5 Atlantic Avenue
Rockport, MA 01966

Linda L. Stevens Moyer
9622 Zetland Drive
Huntington Beach, CA 92646

Jean Munro
7622 Simonds Road NE
Bothell, WA 98011-3924

Carol Myers
15806 Horse Creek Drive
San Antonio, TX 78232-1710

Jean R. Nelson
1381 Dow Street NW
Christiansburg, VA 24073

Lael Nelson
600 Lakeshore Drive
Scroggins, TX 75480

Mary Field Neville
307 Brandywine Drive
Old Hickory, TN 37138-2105

Georgia A. Newton
1032 Birch Creek Drive
Wilmington, NC 28403

Tom Nicholas
7 Wildon Hgts
Rockport, MA 01966

Beverly Nichols
11816 W. 78th Terrace
Lenexa, KS 66214

Louise Nobili
14 Donovan Place
Grosse Pointe, MI 48230

Nathalie J. Nordstrand
384 Franklin Street
Reading, MA 01867

Bea Jae O'Brien
34 Sea Pines
Moraga, CA 94556

Don O'Neill
3723 Tibbetts Street
Riverside, CA 92506

Jane Oliver
20 Park Avenue
Maplewood, NJ 07040

Robert S. Oliver
4111 E. San Miguel
Phoenix, AZ 85018

Carol Orr
Box 371
La Conner, WA 98257

Belle Osipow
3465 Wonderview Drive
Los Angeles, CA 90068

Doug Pasek
12405 W. Pleasant Valley Road
Parma, OH 44130-5030

Gloria Paterson
9090 Barnstaple Lane
Jacksonville, FL 32257

Carolyn H. Pedersen
119 Birch Lane
New City, NY 10956

Ann Pember
14 Water Edge Road
Keeseville, NY 12944

Cynthia Peterson
7777 E. Heatherbrae #225
Scottsdale, AZ 85251

Don Phillips
1755 49th Avenue
Capitola, CA 95010

Ann T. Pierce
545 W. Shasta Avenue
Chico, CA 95926

Peggy Pipkin
716 Grovewood Drive
Cordova, TN 38018

Carlton B. Plummer
10 Monument Hill Road
Chelmsford, MA 01824

Pomm
4865 Hartwick Street
Los Angeles, CA 90041

Eloise Pope
426 Wingrave Drive
Charlotte, NC 28270-5928

Mary Ann Pope
1705 Greenwyche Road SE
Huntsville, AL 35801

Alex Powers
401 72nd Avenue N. #1
Myrtle Beach, SC 29577

Elizabeth H. Pratt
P.O. Box 238
Eastham, MA 02642

Heide E. Presse
15914 Farringham Drive
Tampa, FL 33647

Bonnie Price
2690 E. Villa Street
Pasadena, CA 91107

Judithe Randall
2170 Hollyridge Drive
Hollywood, CA 90068

Nancy Rankin
4704 35th Street NW
Gig Harbor, WA 98335

Herb Rather
Route 1 Box 89
Lampasas, TX 76550

Edward Reep
8021 Crowningshield Drive
Bakersfield, CA 93311

Pat Regan
120 W. Brainard
Pensacola, FL 32501

Judith S. Rein
10064 W Greenlawn Drive
La Porte, IN 46350

Ruth L. Reinel
17 W. 049 Washington Street
Bensenville, IL 60106

Patricia Reynolds
390 Point Road
Willsboro, NY 12996

Lou Rizzolo
P.O. Box 62
Glenn, MI 49416

Jean Rolfe
P.O. Box 51
East Wilton, ME 04234

Jerry Rose
700 SW 31st Street
Palm City, FL 34990

Joan Ashley Rothermel
221 46th Street
Sandusky, OH 44870

Sara Roush
2801 Coleen Court
Louisville, KY 40206

Jada Rowland
438 W 116 Street #73
New York, NY 10027

Ruth Rush
2418 Helen Road
Fallbrook, CA 92028

Sandra Saitto
61 Carmel Lane
Feeding Hills, MA 01030

Robert G. Sakson
10 Stacey Avenue
Trenton, NJ 08618-3421

John Salchak
18220 S. Hoffman Avenue
Cerritos, CA 90703

Ann Salisbury
7300 Tanbark Way
Raleigh, NC 27615

Pat San Soucie
68 Dortmunder Drive
Manalapan, NJ 07726

Joseph Santoro
158 Lovell Road
Watertown, MA 02172

Janice Ulm Sayles
4773 Tapestry Drive
Fairfax, VA 22032

Margaret Scanlan
1501 Campbell Station Road
Knoxville, TN 37932

J. Luray Schaffner
14727 Chermoore Drive
Chesterfield, MO 63017-7901

Betty Lou Schlem
19 Caleb's Lane
Rockport, MA 01966

Michael Schlicting
3465 NE Davis Street
Portland, OR 97232

Aida Schneider
31084 East Sunset Drive N.
Redlands, CA 92373

Carol Ann Schrader
113 East Harbor Drive
Hendersonville, TN 37075-3400

Ruth Hickok Schubert
2462 Senate Way
Medford, OR 97504

Marie Shell
724 Nature's Hammock
Road West
Jacksonville, FL 32259

Leona Sherwood
615 Burtonwood Drive
Longboat Key, FL 34228

Donna Shuford
716 Water Oak Drive
Plano, TX 75025

Edwin C. Shuttleworth
3216 Chapel Hill Boulevard
Boynton Beach, FL 33435

Sherry Silvers
405 Shallow Brook Drive
Columbia, SC 29223

William Vasily Singelis
25801 Lakeshore Boulevard
#132
Euclid, OH 44132-1132

Dorothy Sklar
6612 Colgate Avenue
Los Angeles, CA 90048

Edith Hill Smith
6940 Polo Fields Parkway
Cumming, GA 30130-5730

Gayle Fulwyler Smith
P.O. Box 56
Embudo, NM 87531

Jean Snow
4 Charlotte Drive
New Orleans, LA 70122

Phyllis Solcyk
20223 Labrador Street
Chatsworth, CA 91311

Peter L. Spataro
44 Hickory Lane
Whitinsville, MA 01588

Linda L. Spies
919 Coulter Street
Fort Collins, CO 80524

Cory Staid
P.O. Box 592A
Kennebunkport, ME 04046

Colleen Newport Stevens
8386 Meadow Run Cove
Germantown, TN 38138

David L. Stickel
1201 Hatch Road
Chapel Hill, NC 27516

Donald Stoltenberg
947 Satucket Rd
Brewster, MA 02631

Don Stone
P.O. Box 305
Monhegan Island, ME 04852

Paul Strisik
123 Marmion Way
Rockport, MA 01966

Betsy Dillard Stroud
620 Street onewall Street
Lexington, VA 24450

Hilda Stuhl
10559A Lady Palm Lane
Boca Raton, FL 33498

Janet Swanson
702 N. 5th Avenue
Ann Arbor, MI 48601

Roy E. Swanson
10409 E. Watford Way
Sun Lakes, AZ 85248

Fredi Taddeucci
Route 1, Box 262
Houghton, MI 49931

Nancy Meadows Taylor
6431 E. Lake Anne Drive
Raleigh, NC 27612

Paula Temple
P.O. Box 1935
University, MS 38677

Janis Theodore
274 Beacon Street
Boston, MA 02116

Theodora T. Tilton
8010 Hamilton Lane
Alexandria, VA 22308

Ron Tirpak
10541B Lakeside Drive S.
Garden Grove, CA 92640

Greg Tisdale
35 Briarwood Place
Grosse Point Farms, MI 48236

Linda Tompkin
4780 Medina Road
Copley, OH 44321-1141

Lois Salmon Toole
561 North Street
Chagrin Falls, OH 44022

Nedra Tornay
2131 Salt Air Drive
Santa Ana, CA 92705

Sharon Towle
2417 John Street
Manhattan Beach, CA 90266

Thomas V. Trausch
2403 Mustang Trail
Woodstock, IL 60098

Susan Webb Tregay
470 Berryman Drive
Snyder, NY 14226

Doris O. Turnbaugh
194 Valhalla Drive
Eaton, OH 45320

Linda J. Chapman Turner
Route 2 Box J
Jane Lew, WV 26378

Mary Unterbrink
3998 NW 7th Place
Deerfield Beach, FL 33442

James D. Vance
Route 1, Box 165A
Carmel, CA 93923-9803

Diane Van Noord
5072 N. Lakeshore Drive
Holland, MI 49424

Ted Vaught
1527 NE Hancock Street
Portland, OR 97212

Janet B. Walsh
130 W. 80 2R
New York, NY 10024

Jean Warren
22541 Old Santa Cruz
Highway
Los Gatos, CA 95030

Ben Watson III
3506 Brook Glen
Garland, TX 75044

Kitty Waybright
1390 Baily Road
Cuyahoga Falls, OH 44221

Michael J. Weber
12780 59th Street N.
Royal Palm Beach, FL 33411

Larry Webster
116 Perkins Row
Topsfield, MA 01983

Murray Wentworth
132 Central Street
Norwell, MA 02061

Dee Wescott
165 Devonshire
Branson, MO 65616

E. Gordon West
2638 Waterford
San Antonio, TX 78217

Arne Westerman
711 SW Alder #313
Portland, OR 97205

Eileen Monaghan Whitaker
1579 Alta La Jolla Drive
La Jolla, CA 92037

Eric Wiegardt
Box 1114
Ocean Park, WA 98640

Marjean Willett
4141 N. Henderson Road #701
Arlington, VA 22203

Joyce Williams
Box 192
Tenants Harbor, ME 04860

Cynthia L. Wilson
2 Side Hill Road
Westport, CT 06880

Sharon Wooding
Box 992
Lawrence Academy
Groton, MA 01450

Eudoxia Woodward
24 Kenmore Road
Belmont, MA 02178

Patricia Wygant
10 Winhurst Drive
Rochester, NY 14618

Ruth Wynn
30 Oakledge Road
Waltham, MA 02154

Marvin Yates
1457 Highway 304
Hernando, MS 38632

Yee Wah Jung
5468 Bloch Street
San Diego, CA 92122

Maxine Yost
915 West B
North Platte, NE 69101

Zheng-Ping Chen
8139 S. Wood Drive #102A
Garrettsville, OH 44231

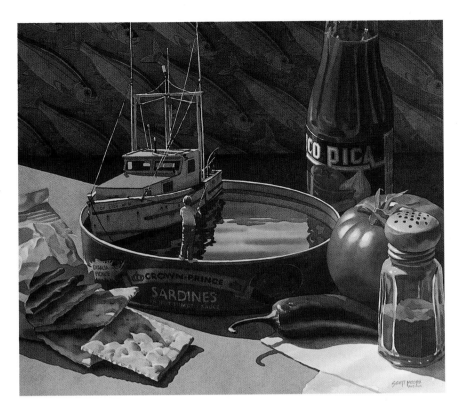

SCOTT MOORE
Fish in a Can
24" x 28" (61 cm x 71 cm)
Arches 140 lb. cold press

NORIKO HASEGAWA
Bizen Teabowl
18" x 24" (46 cm x 61 cm)
Waterford 300 lb. cold press

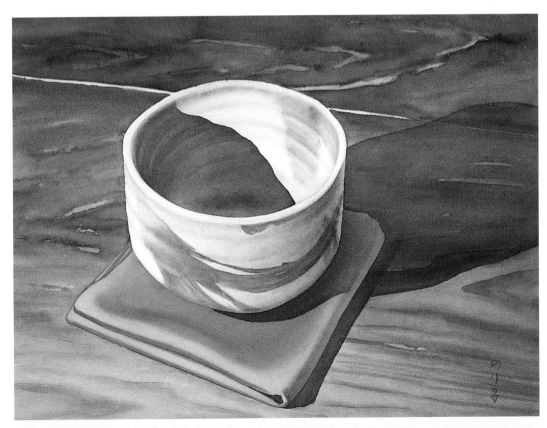

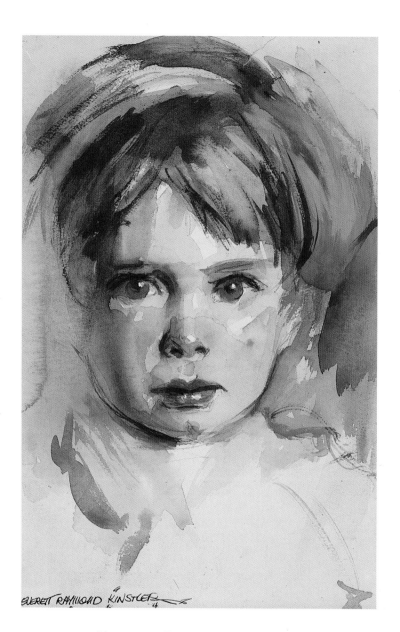

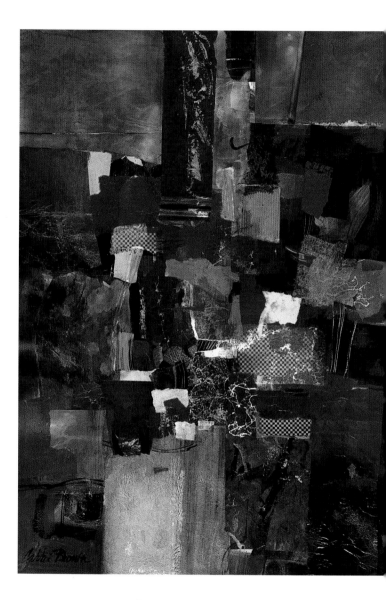

EVERETT RAYMOND KINSTLER
Dana
8" x 10" (20 cm x 25 cm)
Arches hot press
Watercolor and gouache

CARRIE BURNS BROWN
Jubilee
30" x 22" (76 cm x 56 cm)
Arches cold press
Watercolor inks acrylic and collage

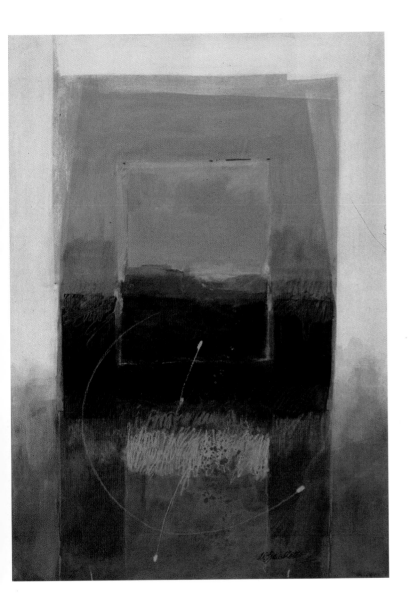

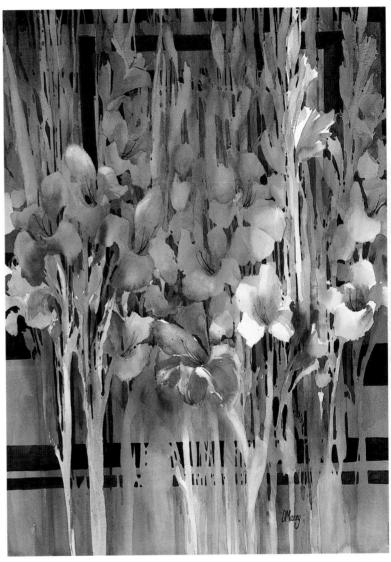

AL BROUILLETTE
Passages II
27" x 19.5" (69 cm x 50 cm)
Fabriano Classico 140 lb.
Watercolor, acrylic color pencils,
and Caran D'Ache crayons

DIANE MAXEY
Intertwined
30" x 22" (76 cm x 56 cm)
Arches 140 lb. cold press

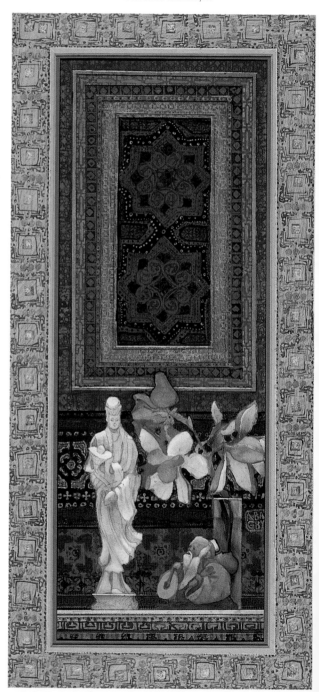

Anne Bagby
Old Man and the Goddess
40" x 10" (102 cm x 25cm)
Arches 140 lb. cold press
Watercolor and acrylic

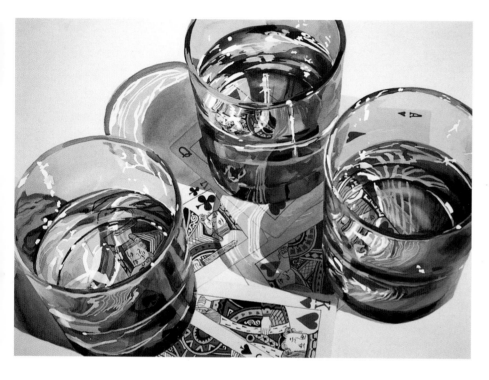

Suzanne McWhinnie
Playing Cards and Glasses
22" x 30" (56 cm x 76 cm)
Arches 140 lb. hot press

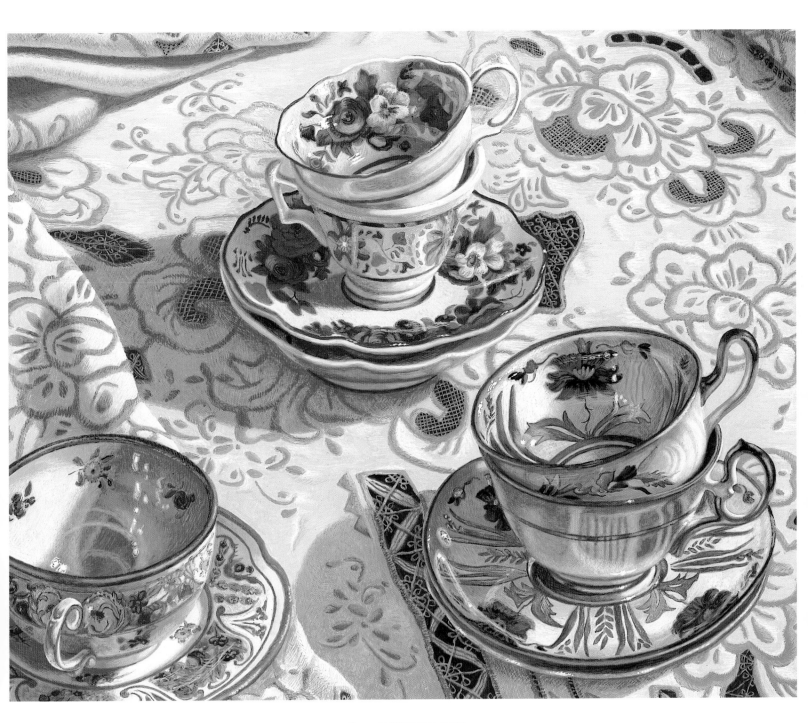

JANIS THEODORE

Five Floral Teacups

10" x 12" (25 cm x 30 cm)

Strathmore museum board

Watercolor and gouache

9

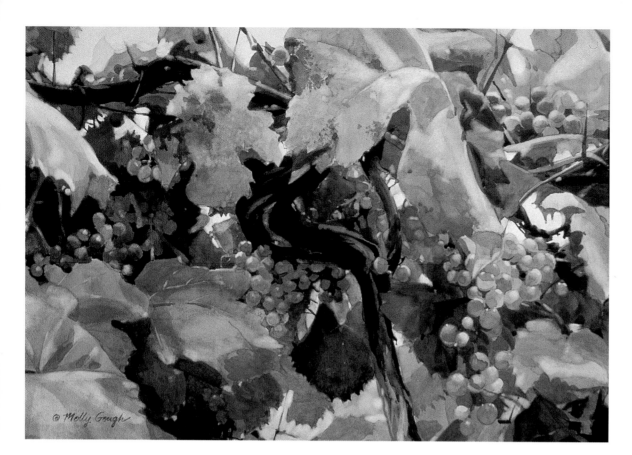

MOLLY GOUGH
Generations
12" x 18" (30 cm x 46 cm)
Strathmore 4-ply bristol
Watercolor and gouache

JANICE ULM SAYLES
The Glass Hat
19" x 29" (48 cm x 74 cm)
Arches 140 lb. cold press

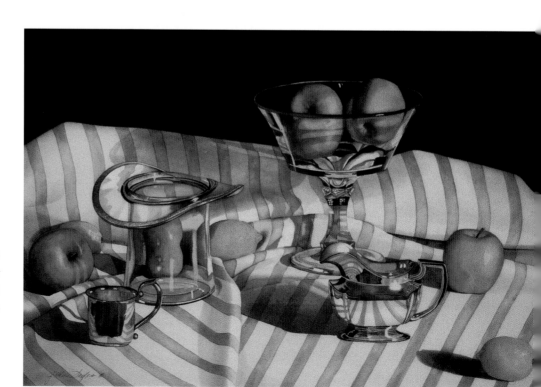

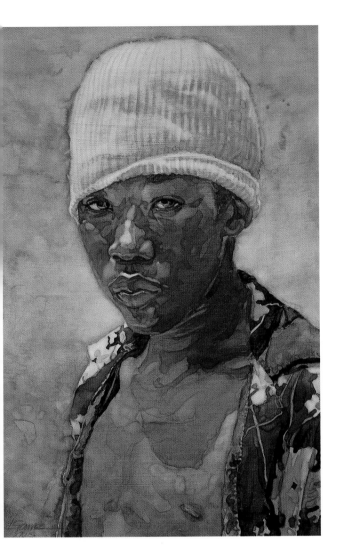

BILL JAMES
Stocking Cap
17" x 11" (43 cm x 28 cm)
Crescent
Watercolor and gouache

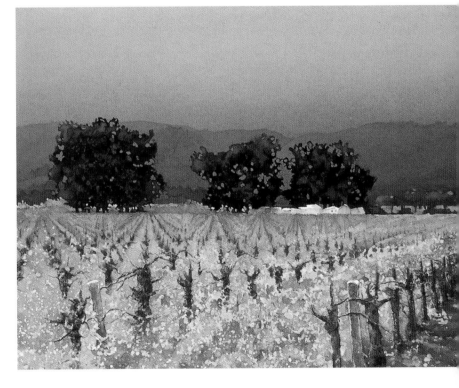

CATHERINE ANDERSON
Fields of Gold
22" x 30" (56 cm x 76 cm)
300 lb. hot press

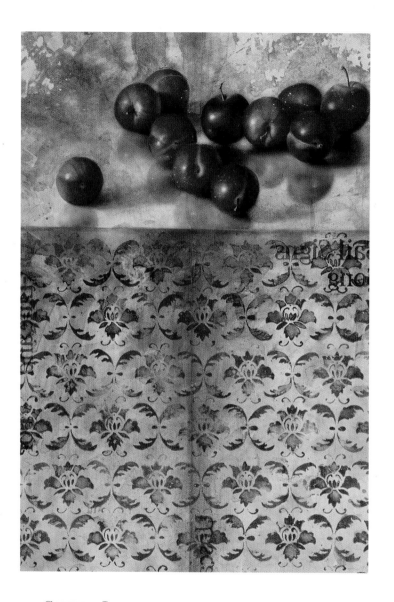

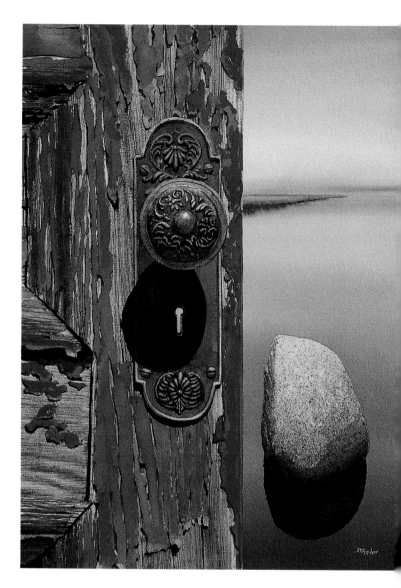

SHERRY LOEHR
Black Plum
26" x 20" (66 cm x 51 cm)
Arches 140 lb. hot press
Watercolor and acrylic

GREGORY STRACHOV
Afterthought
24" x 18" (61 cm x 46 cm)
Arches 140 lb. cold press

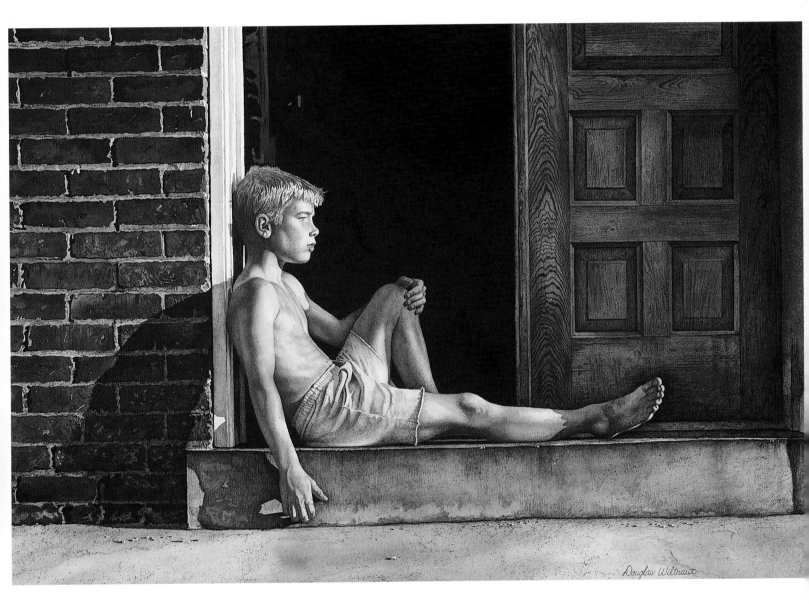

DOUGLAS WILTRAUT

Setting Son

26.5" x 39" (67 cm x 99 cm)

Arches Double Elephant 300 lb.

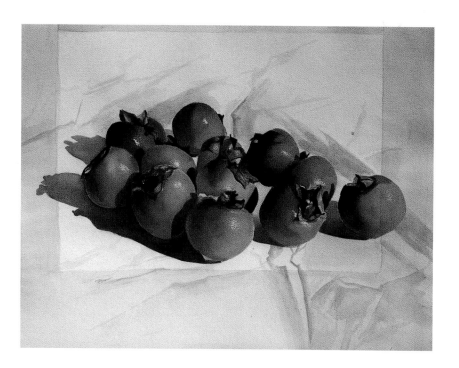

JUDITH KLAUSENSTOCK
A Dozen Persimmons
18" x 25" (46 cm x 64 cm)
Arches 140 lb. cold press

KATHERINE CHANG LIU
Token II
18" x 20" (46 cm x 51 cm)
Lanaquarelle 300 lb. cold press
Watercolor, gouache, acrylic, and collage

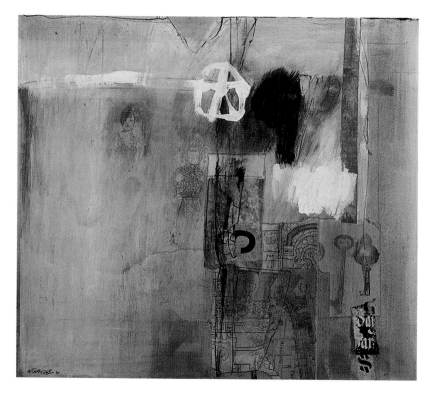

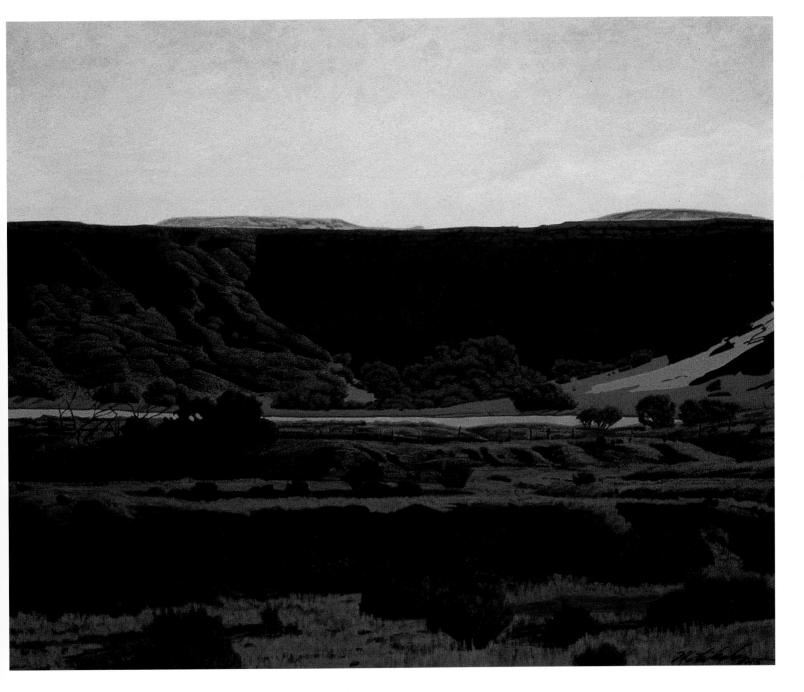

MICHAEL L. NICHOLSON
Selenite Sunrise
14" x 17" (36 cm x 43 cm)
2-ply bristol with gesso
Watercolor, acrylic, and graphite

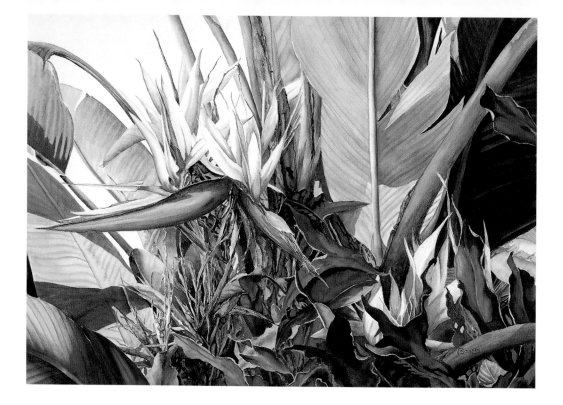

JUNE Y. BOWERS
Bird of Paradise
29.5" x 41" (75 cm x 104 cm)
Arches 555 lb. cold press

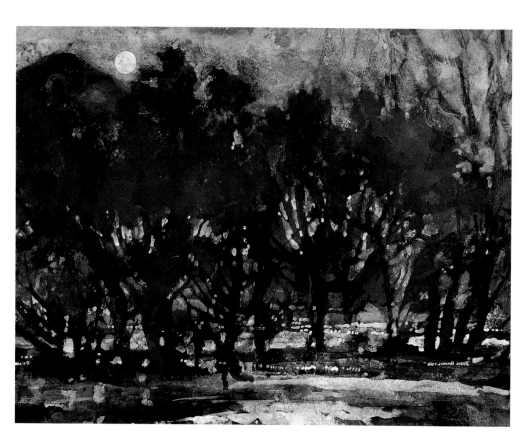

DODIE HAMILTON
October Moon
22" x 28" (56 cm x 71 cm)
Morilla
Watercolor, acrylic, and gouache
Special Technique: Used plastic
wrap and applied pressure
while printing.

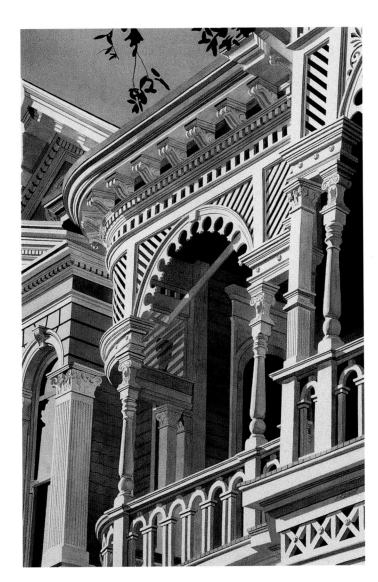

L. Herb Rather, Jr.
Victorian Galveston
30" x 22" (76 cm x 56 cm)
Arches 140 lb. rough

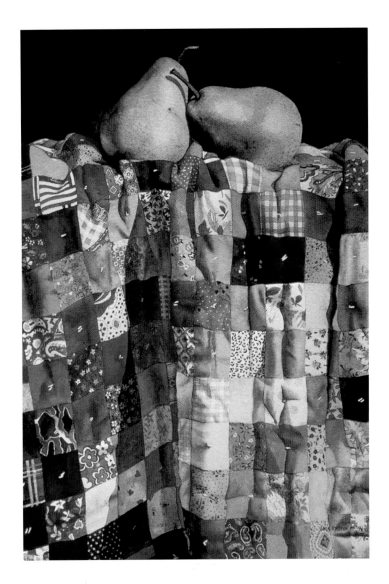

Chris Krupinski
A Pair
30" x 22" (76 cm x 56 cm)
Arches 300 lb. rough

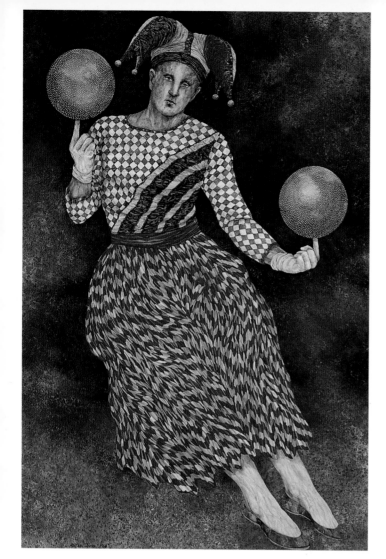

ALETHA A. JONES
To Rise Above the Level of the Fool II
40" x 27" (102 cm x 69 cm)
Crescent smooth
Watercolor and water-soluble painting
crayons

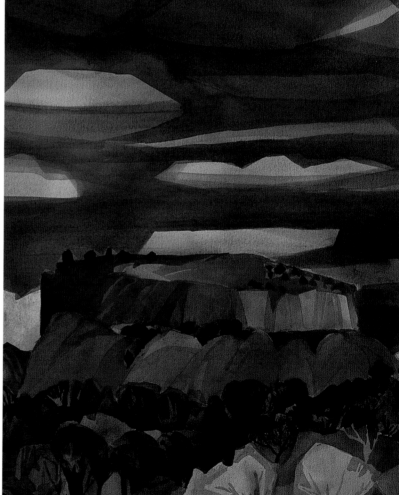

SANDRA HUMPHRIES
New Mexico Sky
30" x 22" (76 cm x 56 cm)
Arches 300 lb. cold press

18

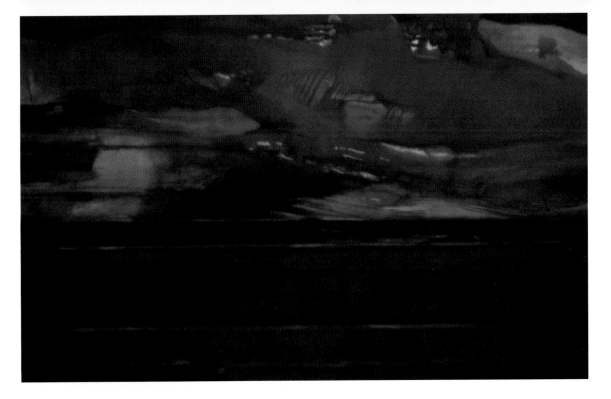

ROBERT HALLETT
Crescendo
30" x 44" (76 cm x 112 cm)
Arches 140 lb. cold press
Watercolor and acrylic

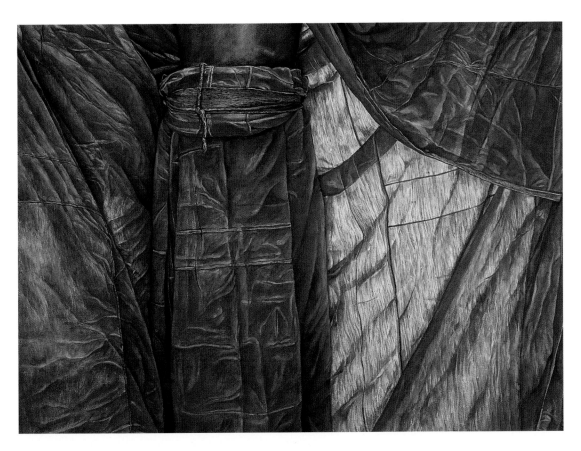

CHANG FEE-MING
In This Earth, In That Wind
22" x 30" (56 cm x 76 cm)
Schut 300 gsm

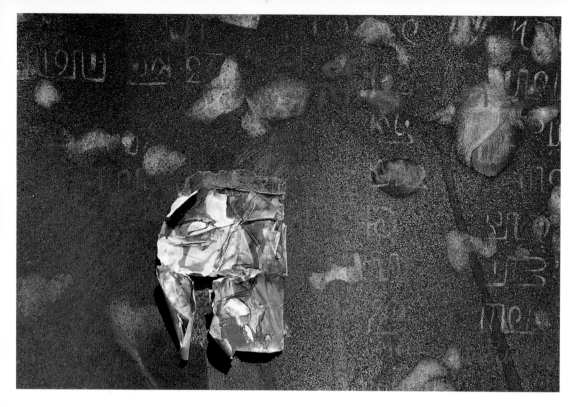

AÏDA SCHNEIDER
Ancient Rituals XII
11" x 14" (28 cm x 36 cm)
Arches 140 lb.
Watercolor, water-soluble pencil, and collage
Special Technique: Underpainted various colors
and sprayed dark colors. Lifted and wiped off
shapes and picked out details with water-soluble
pencil. Used collage for other imagery.

MARY JANE COX
Family Outing
22" x 30" (56 cm x 76 cm)
Winsor & Newton 140 lb. hot press
Watercolor, acrylic, and gouache

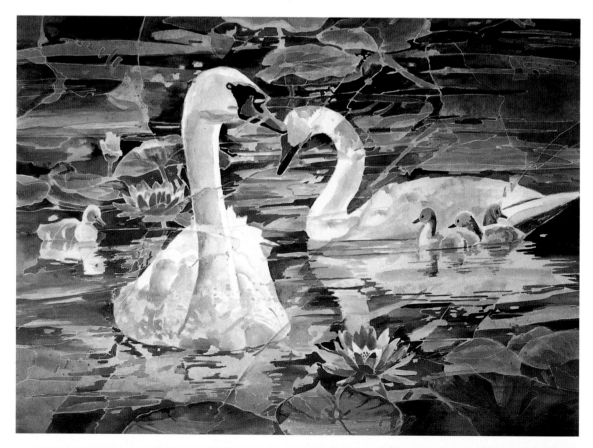

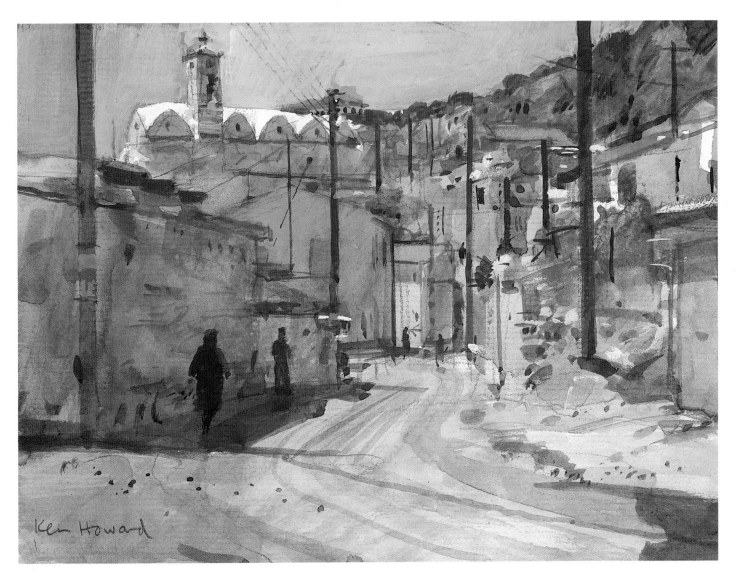

KEN HOWARD
Pissouri Village, Afternoon
7" x 9" (18 cm x 23 cm)
Canson pastel paper
Watercolor and Chinese white

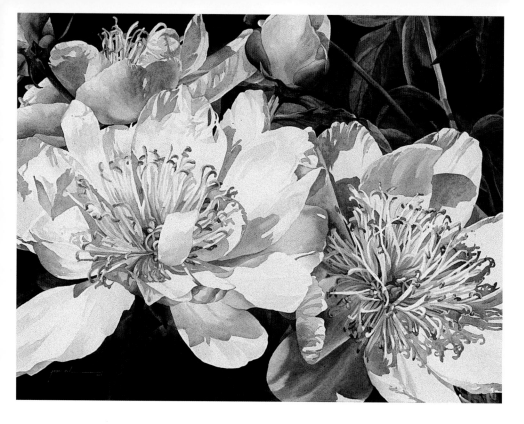

JEAN COLE
Never Bashful
22" x 30" (56 cm x 76 cm)
Fabriano Artistico 300 lb. rough

NAT LEWIS
Maine Mansard
22" x 28" (56 cm x 71 cm)
Arches 300 lb. hot press

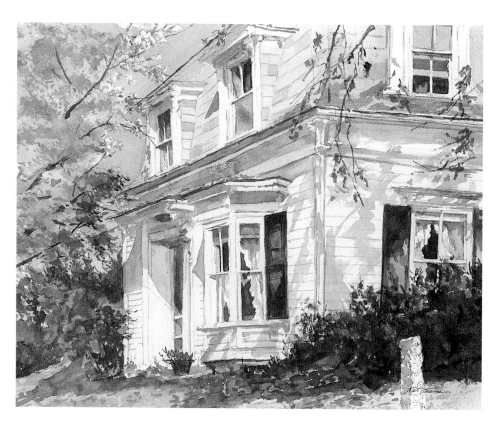

22

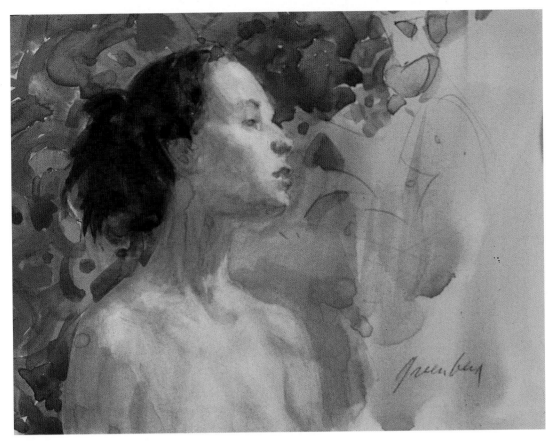

IRWIN GREENBERG
Chrissy
5" x 7" (13 cm x 18 cm)
3-ply bristol

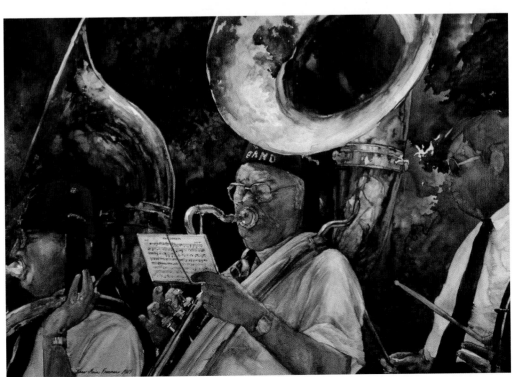

KASS MORIN FREEMAN
Boys in the Band
19" x 27" (48 cm x 69 cm)
5-ply bristol vellum

23

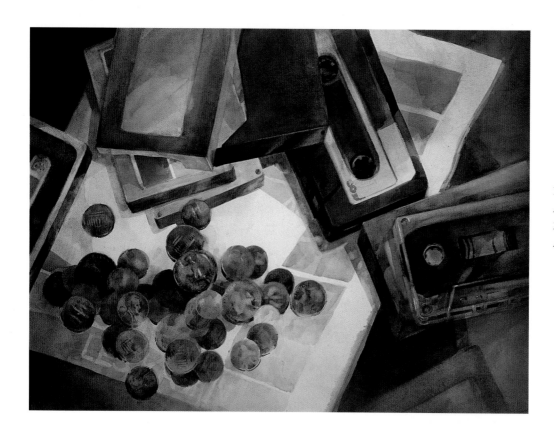

EDWARD MINCHIN
Money and Music
29" x 36" (74 cm x 91 cm)
Arches 140 lb. cold press

LOUIS STEPHEN BADAL
Nightlights—Marina Del Rey
20" x 28" (51 cm x 71 cm)
Arches 300 lb. cold press

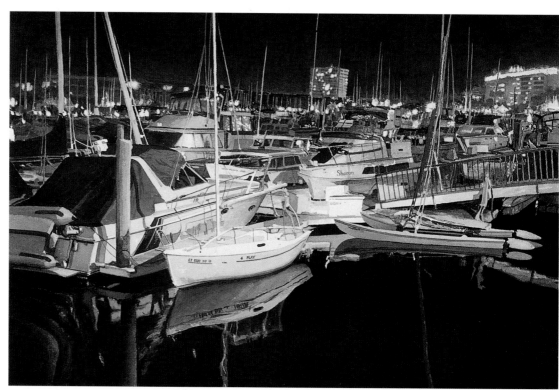

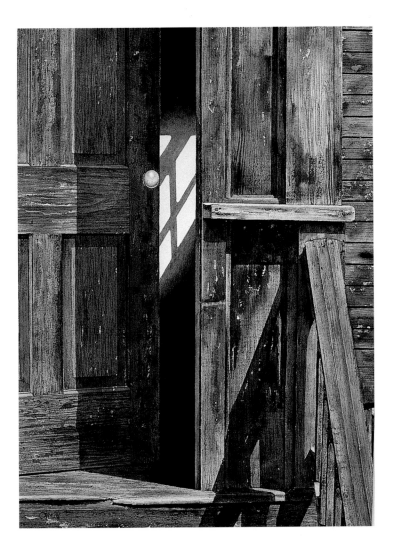

RUDOLPH OHRNING
Inside Shadow
19.25" x 14" (48 cm x 36 cm)
Arches 300 lb. cold press

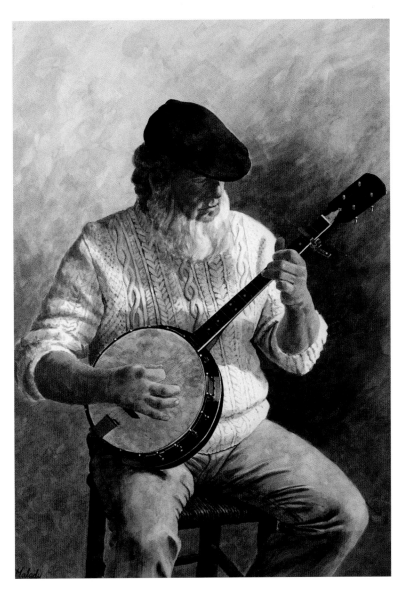

JAMES MALADY
Roger Redmond on the Banjo
28" x 20" (71 cm x 51 cm)
Waterford 140 lb. cold press
Watercolor and gouache

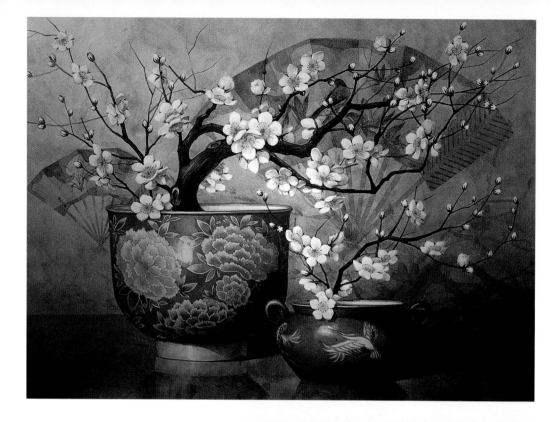

YUMIKO ICHIKAWA
Plum Flowers
18" x 24" (46 cm x 61 cm)
Strathmore 80 lb. cold press

JERRY LITTLE
Magical Forest II
30" x 38" (76 cm x 97 cm)
Arches 300 lb. cold press
Watercolor, acrylic, ink, and collage

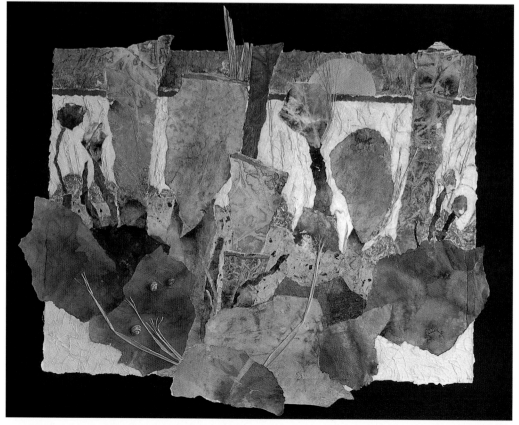

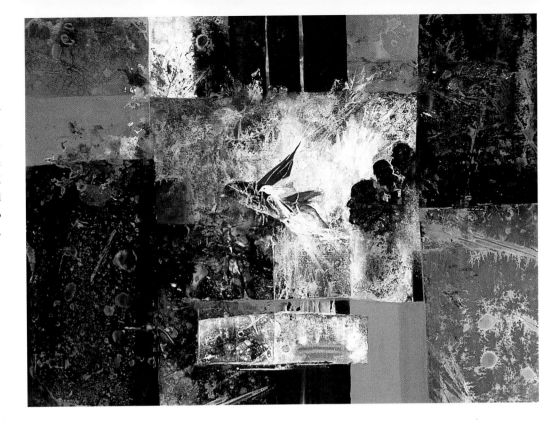

KAREN BECKER BENEDETTI
Autumn Song
22" x 30" (56 cm x 76 cm)
Strathmore Aquarius II cold press
Watercolor and acrylic
Special Technique: Paint is poured, sprayed
with water, and printed with cut plastic and
pine needles; brushes are then used to
simplify and define.

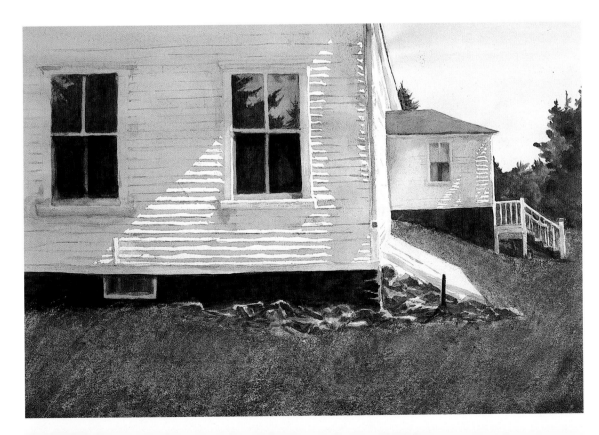

NAT LEWIS
House at Harts Neck
24" x 30" (61 cm x 76 cm)
Arches 300 lb. hot press

27

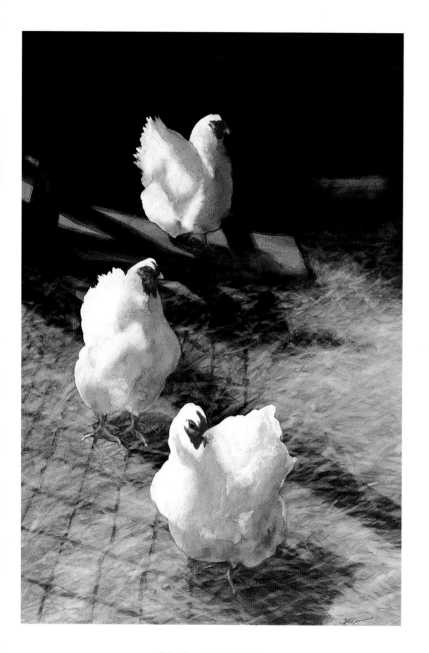

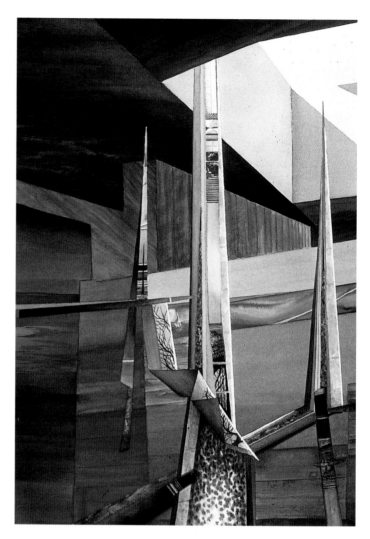

M. C. KANOUSE
Three Chickens
32" x 23" (81 cm x 58 cm)
Lanaquarelle 300 lb. cold press

H. C. DODD
Trident
30" x 22" (76 cm x 56 cm)
300 lb. cold press

28

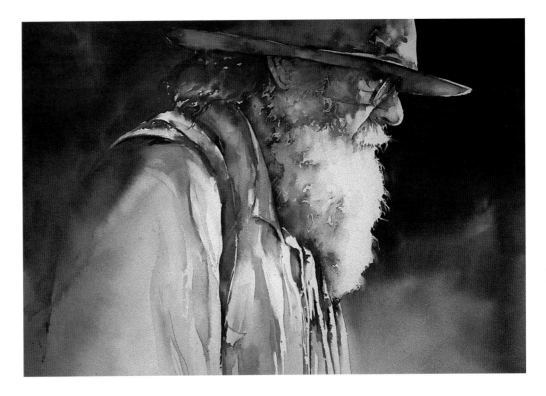

JOSEPH FETTINGIS
The Light on his Face
22" x 28" (56 cm x 71 cm)
300 lb. cold press

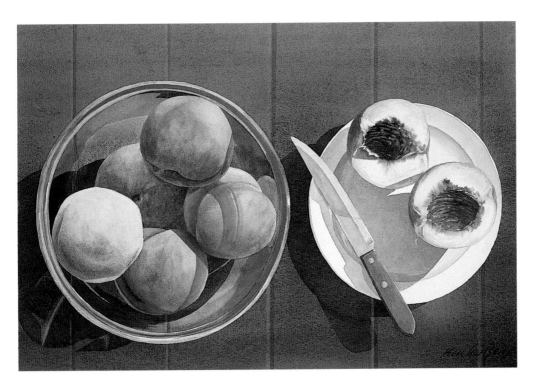

KEN HANSEN
Golden Albertas
15" x 22" (38 cm x 56 cm)
Arches 300 lb. cold press

29

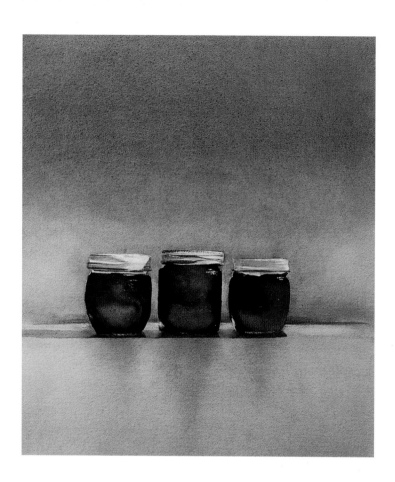

JUDITH KLAUSENSTOCK
Cherry Jam
13" x 15" (33 cm x 38 cm)
Arches 140 lb. cold press

JACK R. BROUWER
Egyptian Tea
19" x 29" (48 cm x 74 cm)
Strathmore Crescent 114 lb. cold press

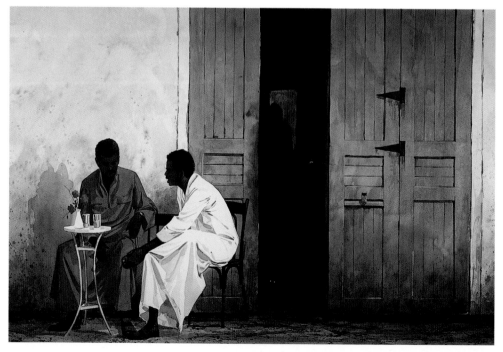

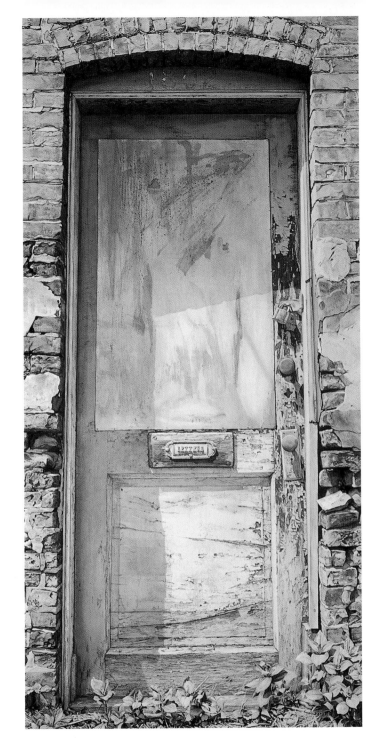

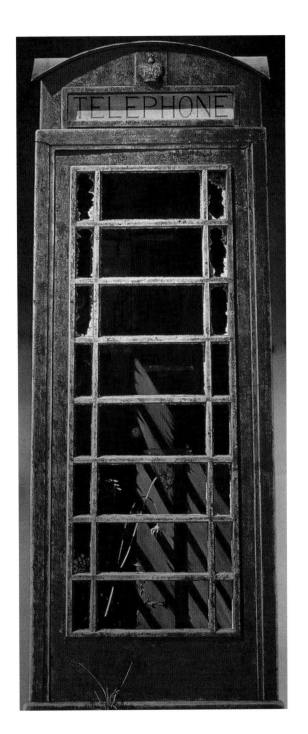

MARY LOU FERBERT

Old Door

86.5" x 42.5" (220 cm x 108 cm)

Tycore

Special Technique: Printing with wax paper.

MARY LOU FERBERT

Queen Anne's Lace and English Telephone Booth

87" x 35.75" (221 cm x 91 cm)

Tycore

Special Technique: Utilized printing to simulate
the patina of the metal booth.

PAUL W. NIEMIEC, JR.
Sea Jewels
18" x 30" (46 cm x 76 cm)
Lanaquarelle 140 lb. cold press

ROBERT SAKSON
Artist's Table
22" x 30" (56 cm x 76 cm)
Arches 140 lb. rough

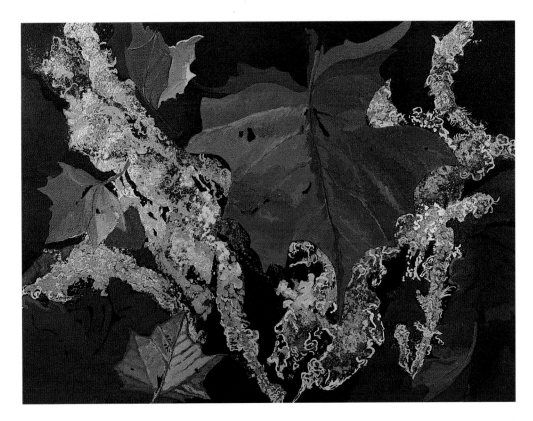

MARILYNN R. BRANHAM
Sycamore Seasons IV
22" x 30" (56 cm x 76 cm)
Arches 300 lb.
Watercolor, acrylic, and metallic
watercolor powders

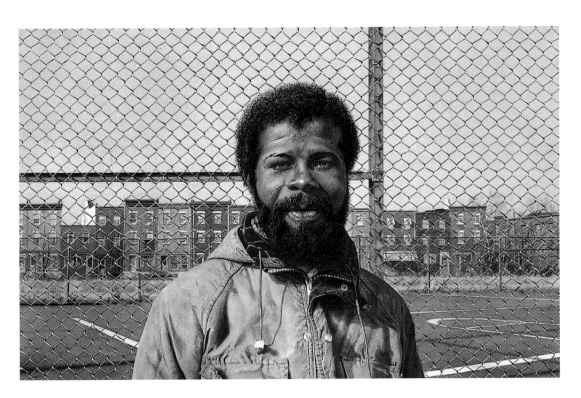

JAMES TOOGOOD
Kindred Spirit
14.5" x 20.5" (37 cm x 51 cm)
Arches 140 lb. cold press

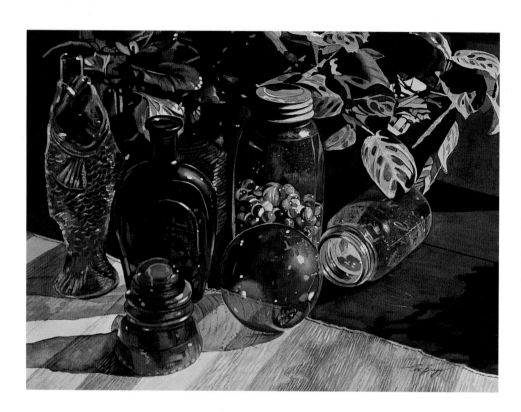

EVE BRAGG
Glass Menagerie
22" x 30" (56 cm x 76 cm)
Arches 300 lb.

MARLENE A. BOONSTRA
Collective Input
19" x 29" (48 cm x 74 cm)
Cold press

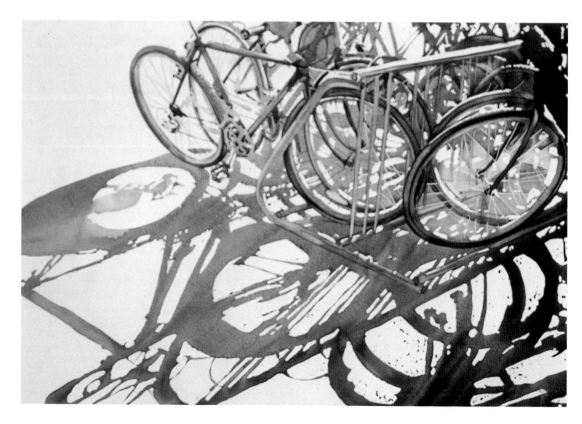

GEORGIA A. NEWTON
Orchid
30" x 22" (76 cm x 56 cm)
Very soft paper
Watercolor and acrylic

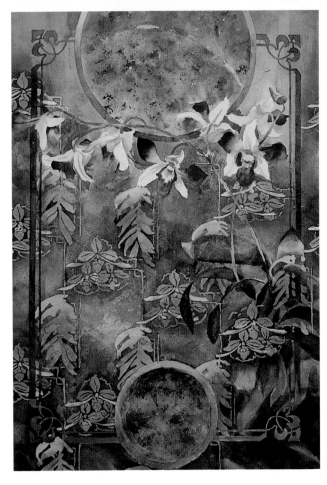

ALICE W. WEIDENBUSCH
Lancaster Cottage
3.5" x 5" (9 cm x 13 cm)
Arches 140 lb. cold press

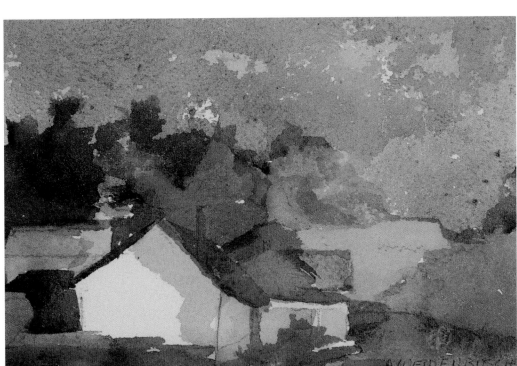

35

JOSEPH MANNING
Lady in Red
10.5" x 10.5" (27 cm x 27 cm)
Arches 140 lb. hot press
Watercolor, gouache, and egg-mixed pigment

ALEXIS LAVINE
Barnside
11" x 30" (28 cm x 76 cm)
140 lb. cold press
Watercolor and watercolor pencils

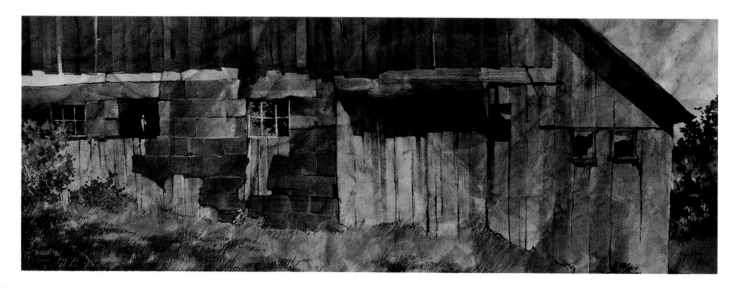

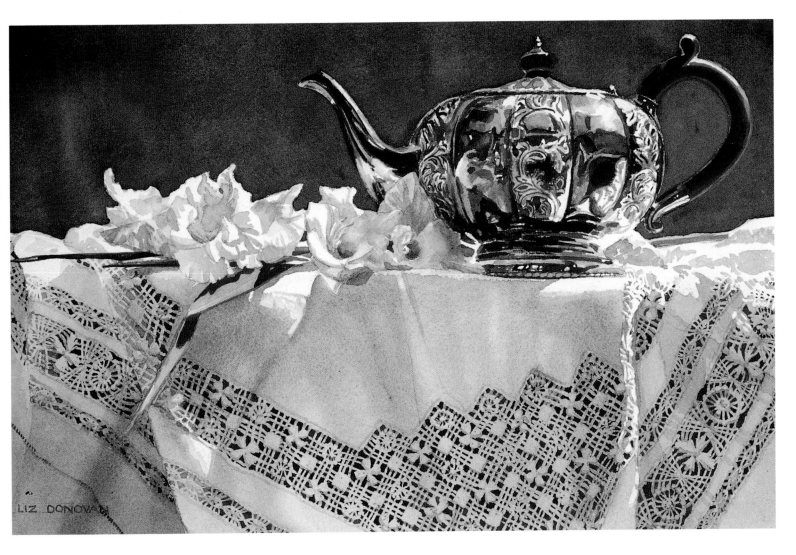

LIZ DONOVAN
Teapot with Gladiola
10.5" x 16" (27 cm x 41 cm)
Arches 300 lb. cold press

ALLAN HILL
Spirit Dance
13" x 30" (33 cm x 76 cm)
Arches 140 lb. hot press
Watercolor and acrylic collage

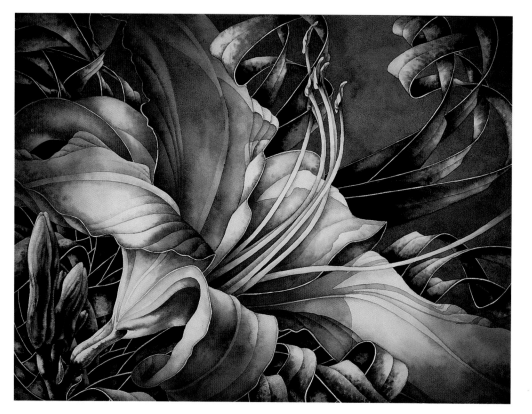

JOHN POLLOCK
Day Lily with a Twist
22.5" x 30" (57 cm x 76 cm)
Winsor & Newton 260 lb. cold press
Special Technique: Colors were glazed over one
another to achieve the final result; none of the
colors were mixed on the palette.

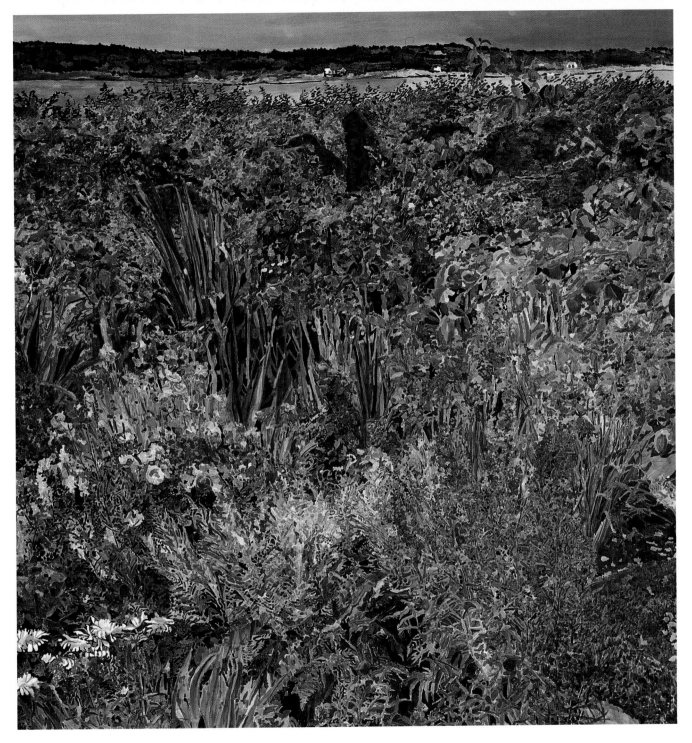

Judith Steele Gaitemand
Ceilia Beaux'
42" x 42" (107 cm x 107 cm)
Silk
Watercolor and silk dyes

39

DEBORAH KAPLAN EVANS
Chrysalis
30" x 23" (76 cm x 58 cm)
Arches 300 lb. hot press

CONNIE LUCAS
The Hideaway
29.5" x 21.5" (75 cm x 55 cm)
Arches 140 lb. cold press

JORENE NEWTON
Behold the Awe of Our Being
19" x 27" (48 cm x 69 cm)
Strathmore hot press 100% rag
Watercolor and acrylic

MICHAEL WHITTLESEA
The Walking Frame
16" x 17" (41 cm x 43 cm)
Arches Aquarelle 90 lb. rough

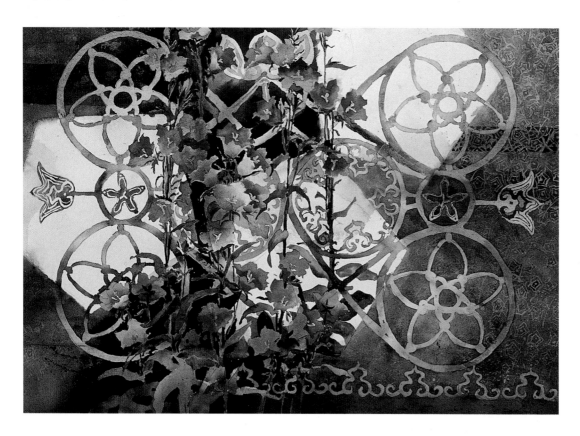

GEORGIA A. NEWTON
Campanula
22" x 30" (56 cm x 76 cm)
140 lb. cold press

GERALDINE MCKEOWN
Winnowing Basket
20.5" x 28" (52 cm x 71 cm)
140 lb. cold press

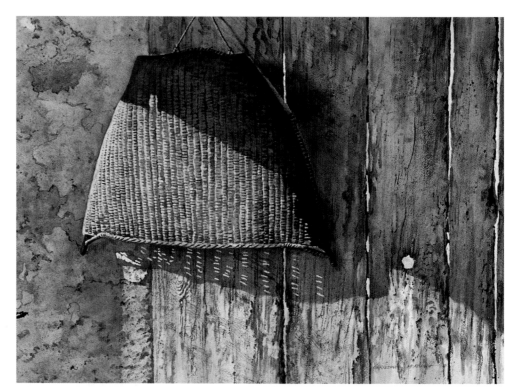

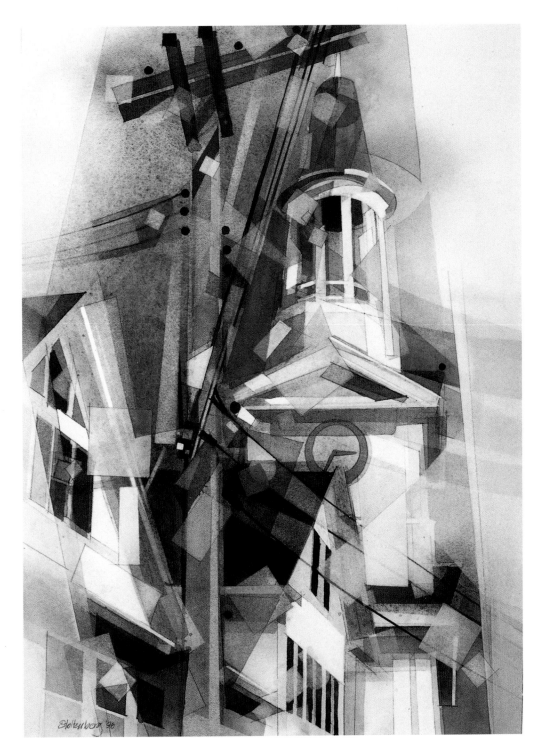

DONALD STOLTENBERG

Wellfleet Sky

Arches 140 lb. cold press

Watercolor and Chinese white

43

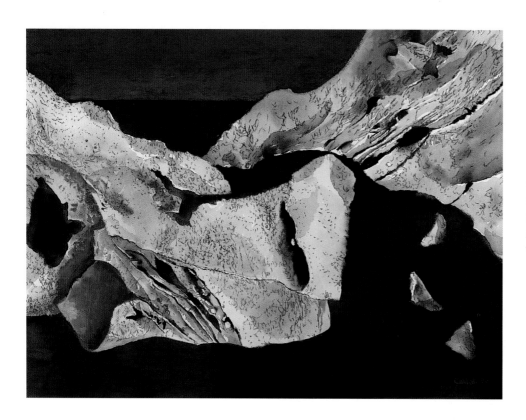

JUDY CASSAB
Rill—Rainbow Valley
29" x 40" (74 cm x 102 cm)
Arches
Watercolor and gouache

GLORIA BAKER
The Dedicated
32" x 40" (81 cm x 102 cm)
Arches 140 lb. cold press

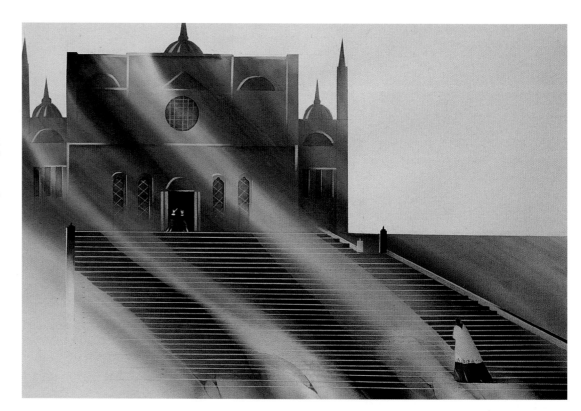

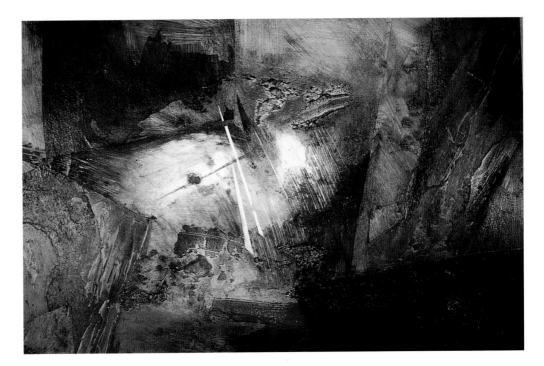

BETTY CARMELL SAVENOR
Inner Vision
30" x 40" (76 cm x 102 cm)
3-ply board
Watercolor and acrylic textures
Special Technique: Surface layer of board
was torn for varied levels of texture
and then glazed. Linear effects
were acheived by scratching wet paint.

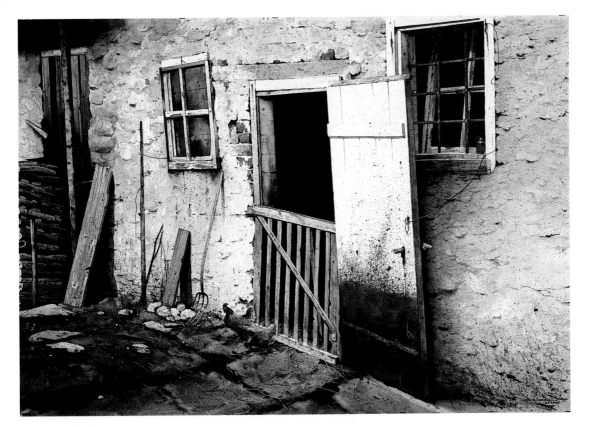

LORING W. COLEMAN
16th Century Farm—Austria
26.5" x 39" (67 cm x 99 cm)
Arches 110 lb. cold press
Watercolor and acrylic

45

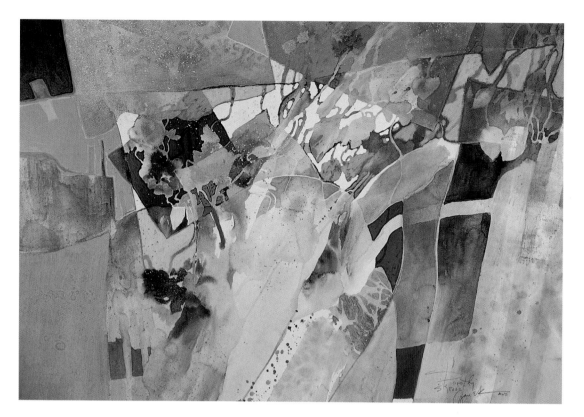

Dorothy Ganek
Breaking Away
36" x 42" (91 cm x 107 cm)
Arches 260 lb. hot press
Watercolor and acrylic
Special Technique: Wax paper was
laid into wet pigment and left to dry.

John T. Salminen
Lake & Wells, Chicago, Illinois
25" x 35" (64 cm x 89 cm)
Arches 140 lb. cold press

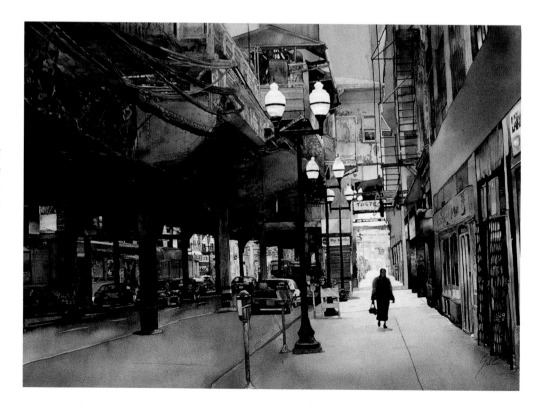

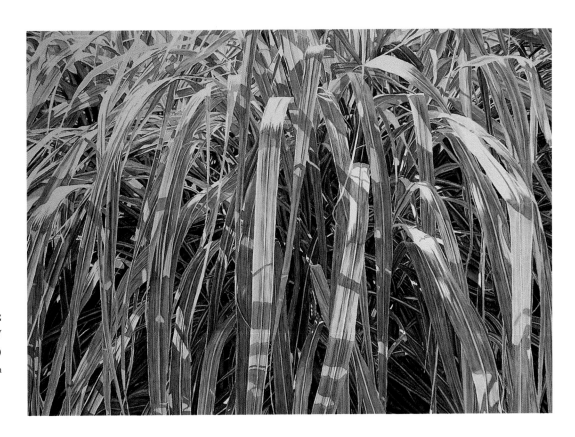

DOROTHY D. GREENE
Citronella II
29" x 41" (74 cm x 104 cm)
Arches 300 lb. rough

BENJAMIN MAU
Night Flower
30" x 40" (76 cm x 102 cm)
Arches 140 lb. cold press

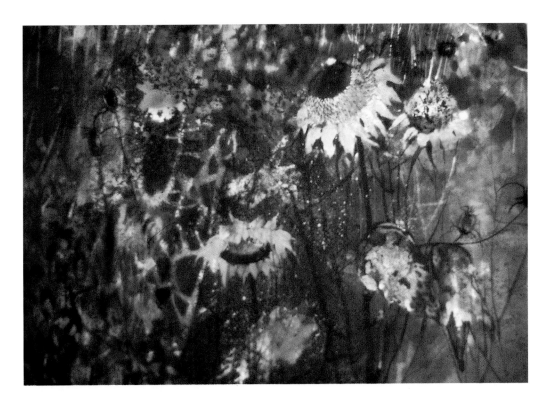

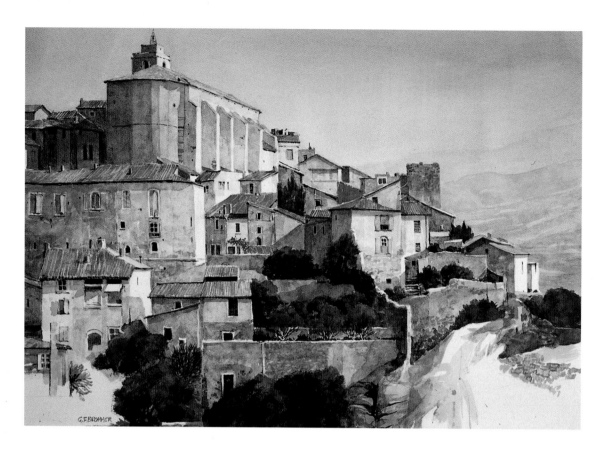

GERALD F. BROMMER
View of Gordes
22" x 30" (56 cm x 76 cm)
Lanaquarelle 300 lb. rough

HELEN GARRETSON
Clean Sweep at the Railroad Museum
13" x 21" (33 cm x 53 cm)
Arches 140 lb.

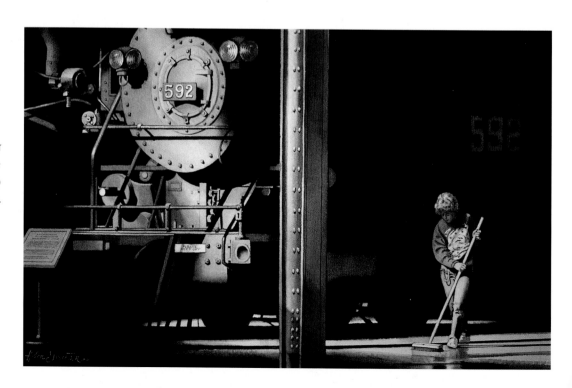

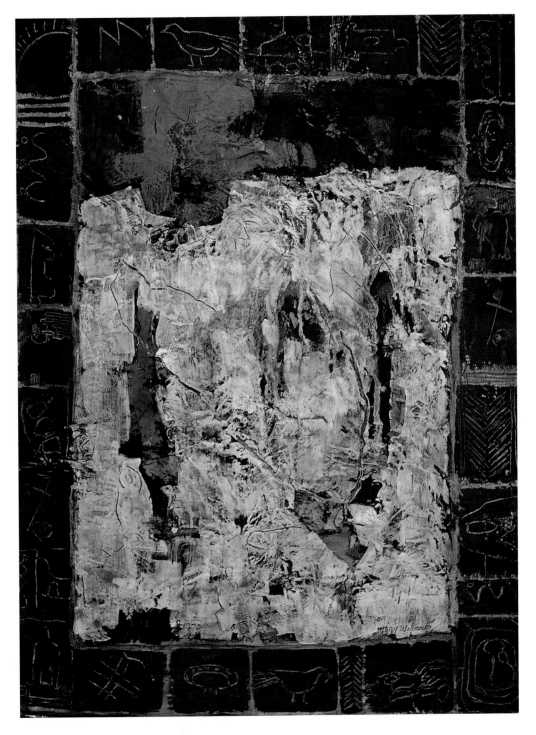

MARY WILBANKS

Visible Mystery

34" x 25" (86 cm x 64 cm)

Handmade paper

Watercolor, acrylic, collage, and watercolor pencils

49

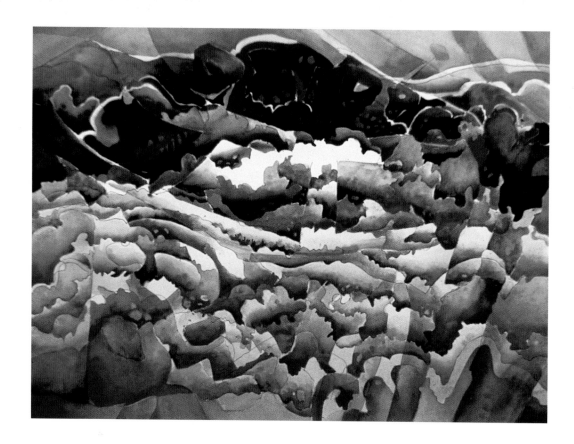

JANE E. JONES
Hawaii Scape I
22" x 30" (56 cm x 76 cm)
Arches 140 lb. cold press

GREG TISDALE
Medusa Challenger
17" x 27.5" (43 cm x 70 cm)
140 lb. medium

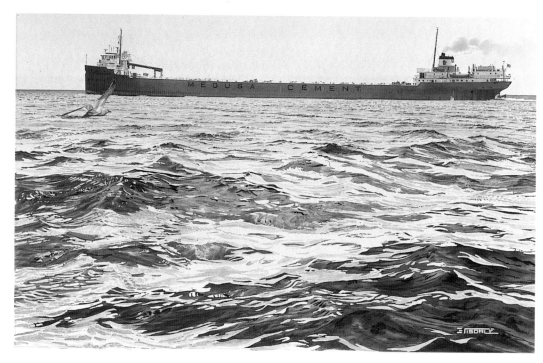

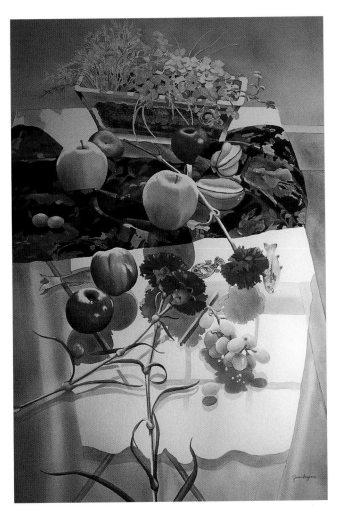

JANE FREY
Herb Garden and Red Carnations
36" x 26" (91 cm x 66 cm)
Arches Double Elephant cold press

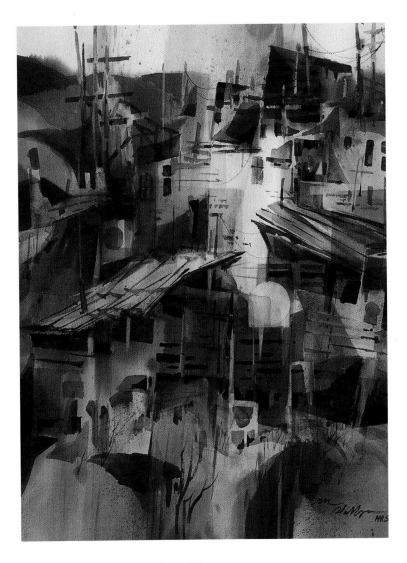

DICK PHILLIPS
In Search of El Dorado
29" x 21" (74 cm x 53 cm)
Arches 140 lb. cold press

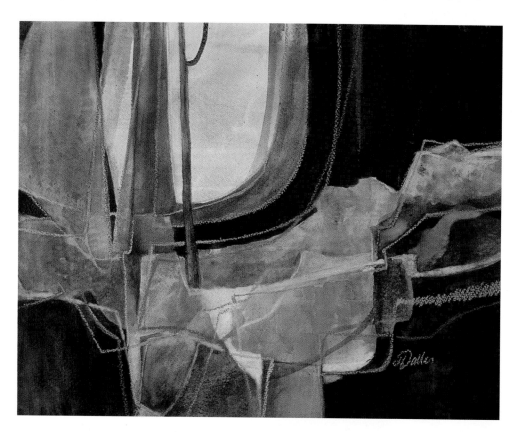

DOROTHY B. DALLAS
New Forest II
15" x 19" (38 cm x 48 cm)
Arches 140 lb. cold press
Watercolor, gouache, and watercolor crayon

SCOTT MOORE
T.V. Dinner
22" x 30" (56 cm x 76 cm)
Arches 140 lb. cold press

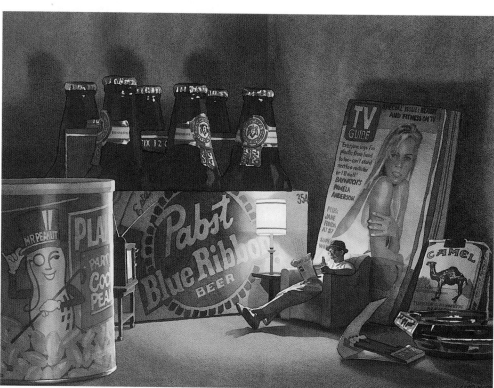

DOUGLAS WILTRAUT
Mare's Tail
38" x 29" (97 cm x 74 cm)
Arches Double Elephant 300 lb.

EDWIN L. JOHNSON
Grandma's Quilt
19" x 13" (48 cm x 33 cm)
Crescent 114 lb. cold press

MICHAEL L. NICHOLSON
On Stage at the Kiamichi
11" x 14" (28 cm x 36 cm)
2-ply bristol with gesso
Watercolor, acrylic, and graphite

WILL BULLAS
Fool's Time...
20" x 20" (51 cm x 51 cm)
Illustration board

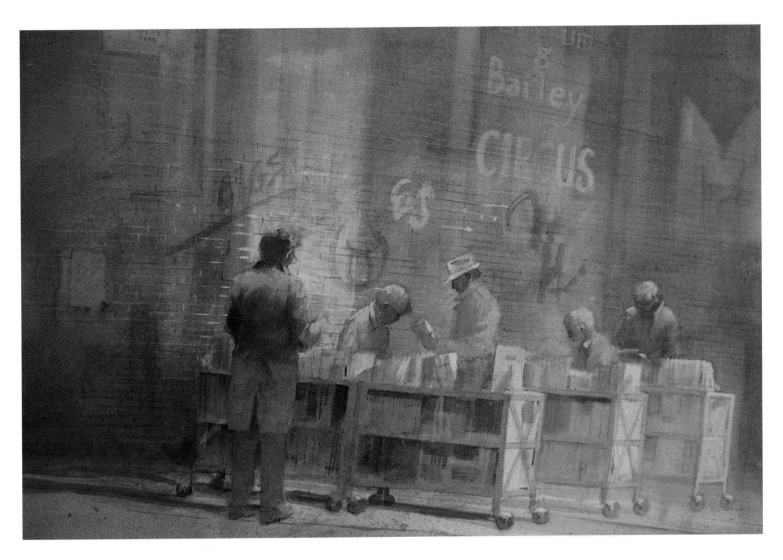

GEORGE SHEDD
Bookworms
22" x 30" (56 cm x 76 cm)
Bainbridge cold press
Watercolor and gouache

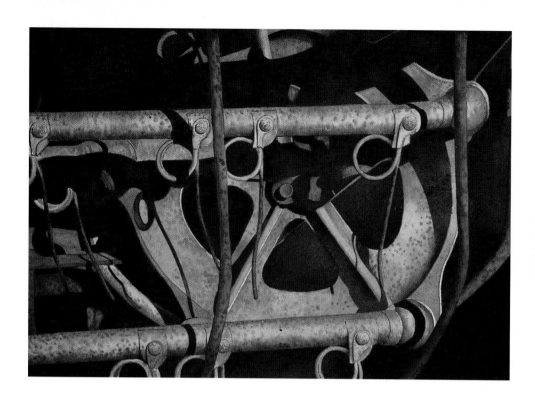

JOHN BRYANS
Rural Power
29.5" x 40" (75 cm x 102 cm)
Arches 115 lb. rough

MILES G. BATT, SR.
Indifferent Love
17" x 23" (43 cm x 58 cm)
Arches 140 lb. hot press

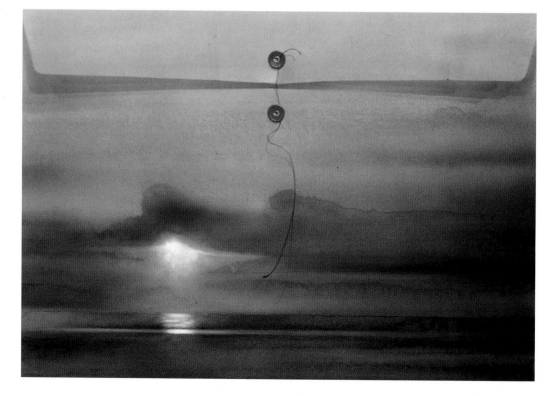

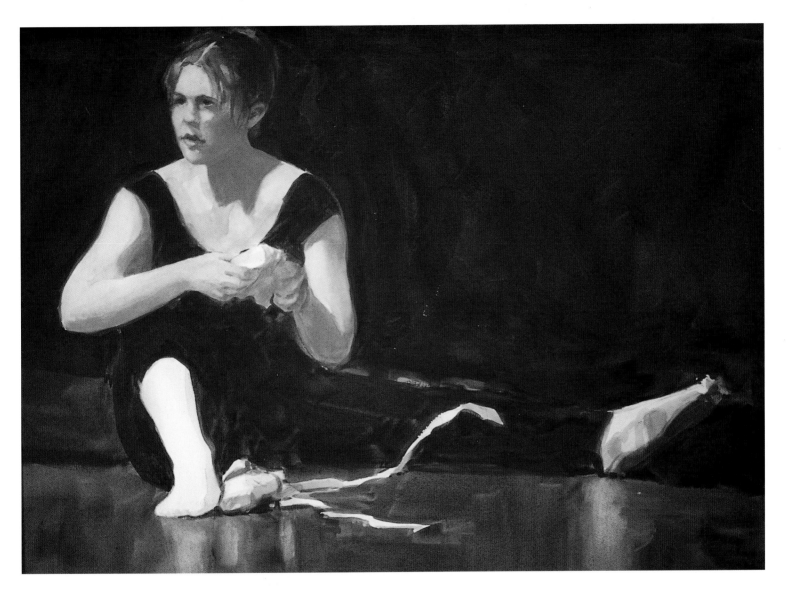

MARTHA MANS
Backstage
20" x 26" (51 cm x 66 cm)
Arches 300 lb. hot press

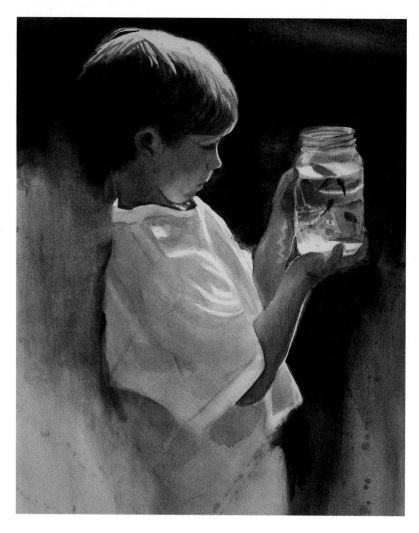

PAT CAIRNS
Pollywog Jar
30" x 22" (76 cm x 56 cm)
Arches 140 lb. hot press

JOHN MCIVER
Sequences 43
32" x 24" (81 cm x 61 cm)
Arches 260 lb. cold press
Watercolor and acrylic

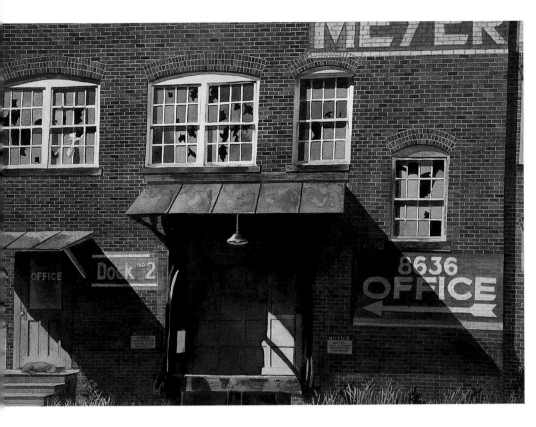

MORRIS MEYER
Dock 2
20" x 28" (51 cm x 71 cm)
Arches 300 lb.

KEN SCHULZ
Over Still Waters
14" x 18.5" (36 cm x 47 cm)
Arches 300 lb. cold press
Watercolor and opaque

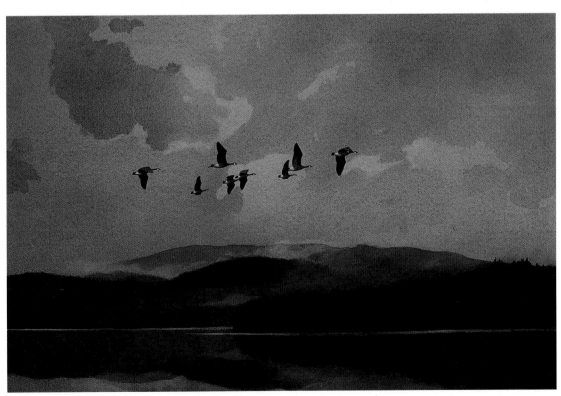

ROBERT S. OLIVER
Cardinal's Table
10.5" x 13.5" (27 cm x 34 cm)
Crescent 100 lb.
Watercolor, liquid acrylic, gesso,
modeling paste, and particle collage
in paste

BARBARA BURWEN
Heavenly Body
12" x 17" (30 cm x 43 cm)
140 lb. rough
Watercolor, water-based ink, mica,
sand patterns, and ink overlays

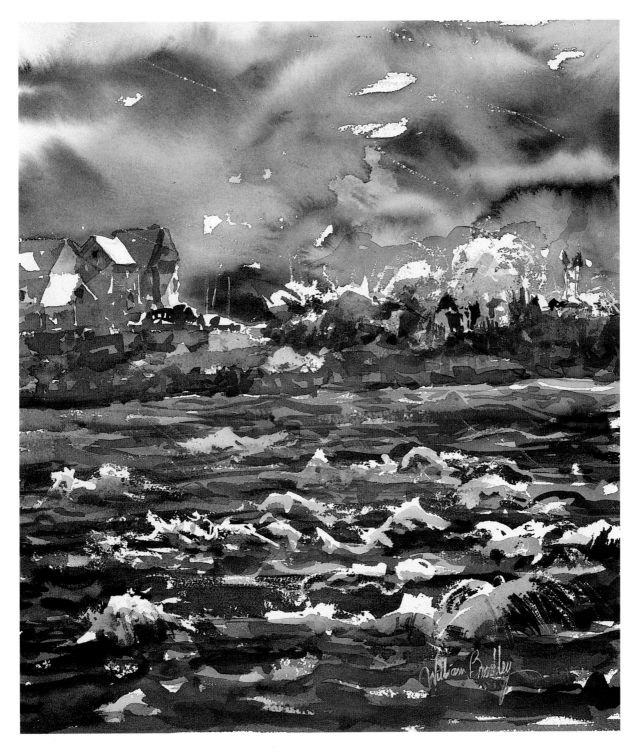

WILLIAM BRADLEY

Nor'easter—Rockport Harbor

22" x 15.5" (56 cm x 38 cm)

Arches 300 lb.

61

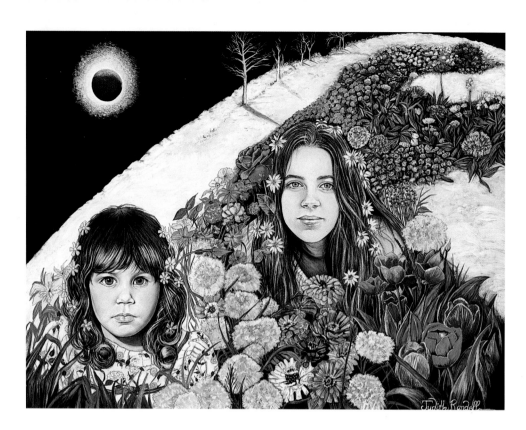

JUDITHE RANDALL
Les Soeurs En Blume
20" x 26" (51 cm x 66 cm)
Crescent
Watercolor, acrylic, and ink

BARBARA SORENSON RAMBADT
Fresh from the Garden
21" x 29" (53 cm x 74 cm)
Arches 300 lb.

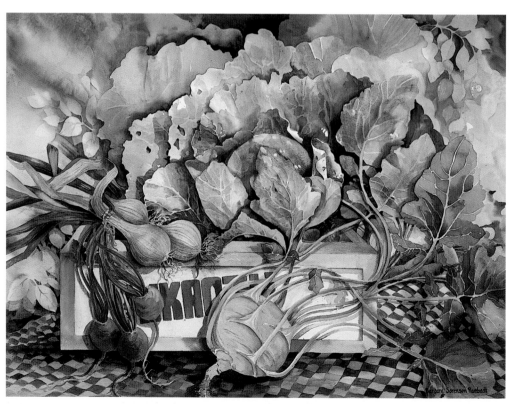

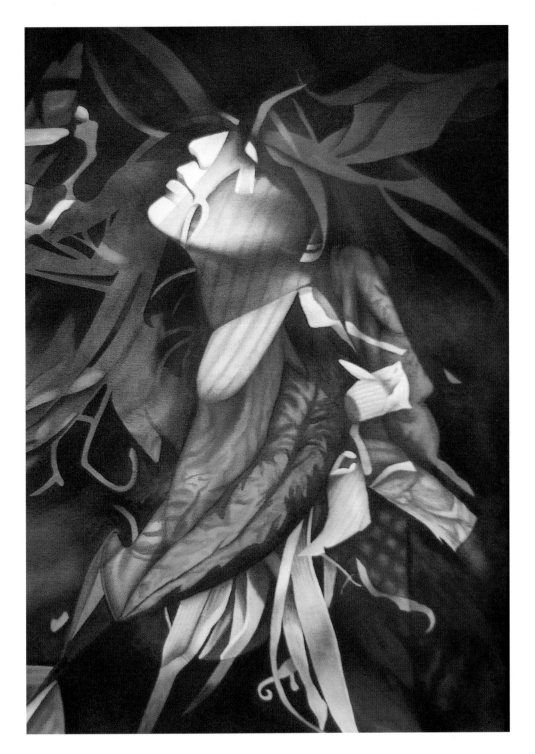

RICH ERNSTING

Spirits of the Past

25" x 37" (94 cm x 64 cm)

Arches 555 lb. cold press

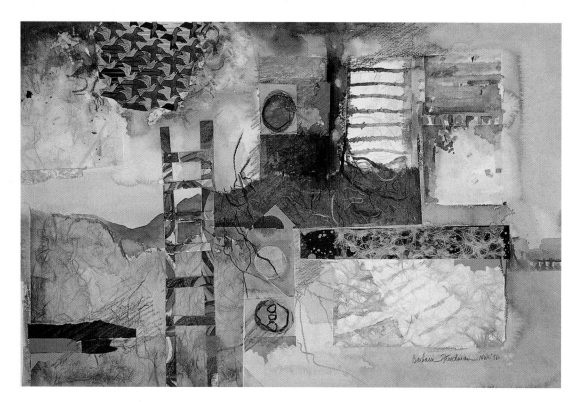

BARBARA FREEDMAN
Ladder on the Left
22" x 30" (56 cm x 76 cm)
Fabriano 300 lb.
Watercolor, oriental rice papers,
prepainted watercolor paper for
collage, watercolor, gouache,
watercolor pencils, and
watercolor crayons

RANULPH BYE
Reconstruction—Union Mills
22" x 38" (56 cm x 97 cm)
Arches cold press
Watercolor and oil

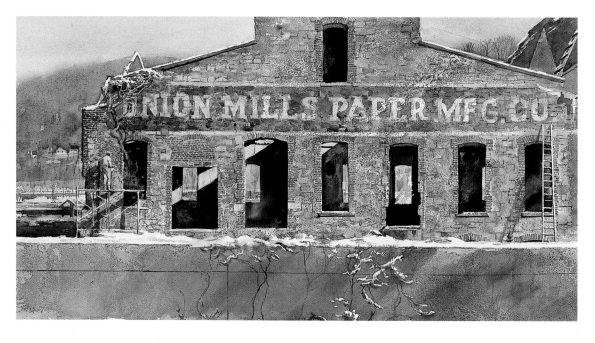

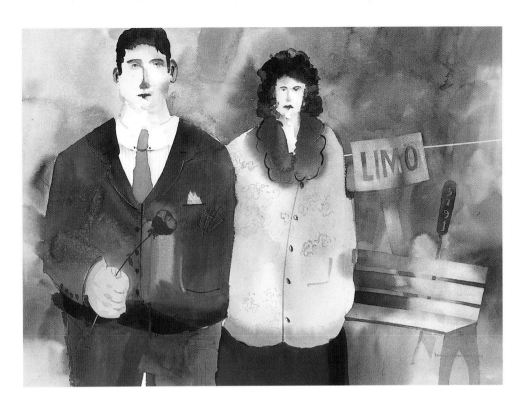

HAROLD WALKUP
On the Town
22" x 30" (56 cm x 76 cm)
Arches 140 lb. rough

SANDRA HENDY
Broken Hill Outback
40" x 34" (102 cm x 86 cm)
Arches 600 gsm hot press

65

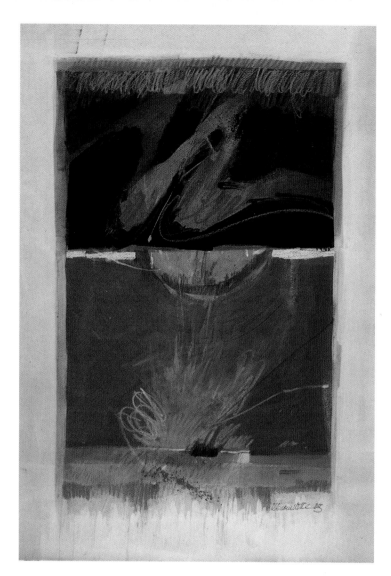

AL BROUILLETTE
Building Blocks VI
27.5" x 19.5" (70 cm x 50 cm)
Fabriano Classico 140 lb.
Watercolor, acrylic color pencils, and
Caran D'Ache crayons

JOHN POLLOCK
Pattern of Eight
42" x 30" (107 cm x 76 cm)
Arches 555 lb. cold press
Special Technique: Colors were
glazed over one another to achieve
the final result; none of the colors
were mixed on the palette.

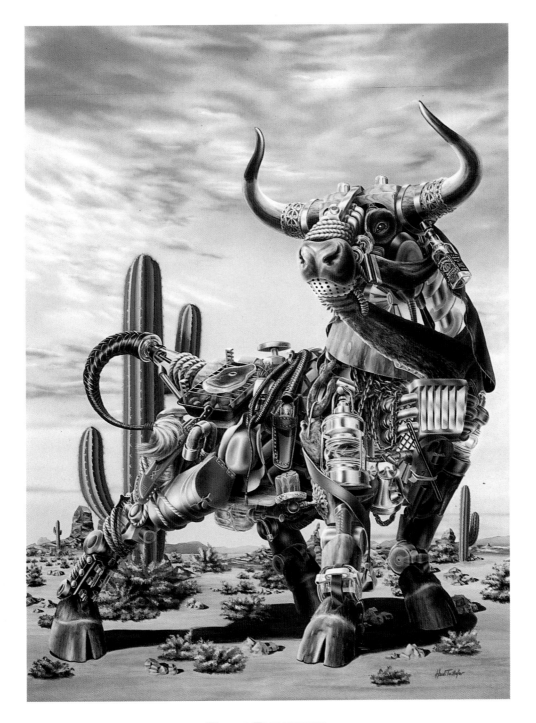

HEIDI TAILLEFER

Harbinger's Tail

30" x 40" (76 cm x 102 cm)

High-Art 27 lb.

Watercolor and acrylic

Special Technique: The metal and clouds were airbrushed with liquid acrylics to soften the surfaces.

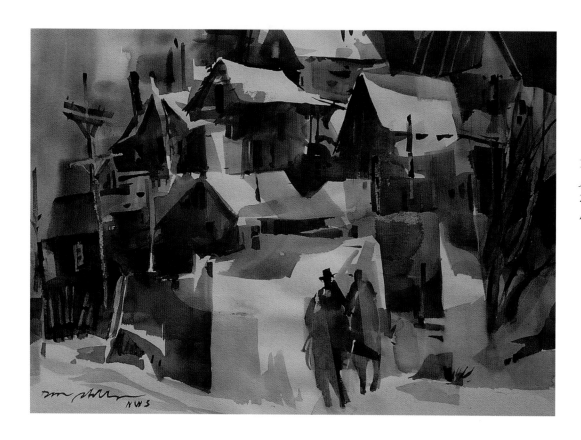

DICK PHILLIPS
Jerome Stack
21" x 29" (53 cm x 74 cm)
Arches 140 lb. cold press

PAUL W. NIEMIEC, JR.
Pines and Straw
20" x 30" (51 cm x 76 cm)
Strathmore 3-ply bristol plate finish

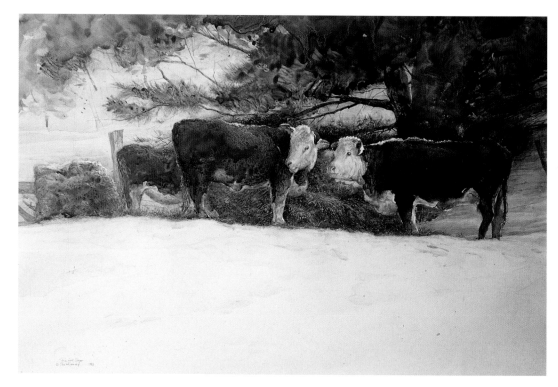

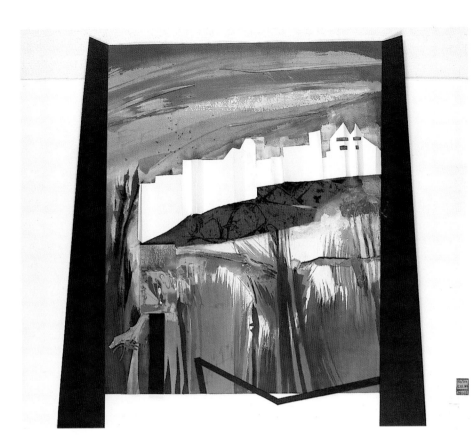

RUTH L. ERLICH
Watercolors: Third Dimensions VI
32.5" x 38" (83 cm x 97 cm)
140 lb. rough
Watercolor and diluted fabric dye

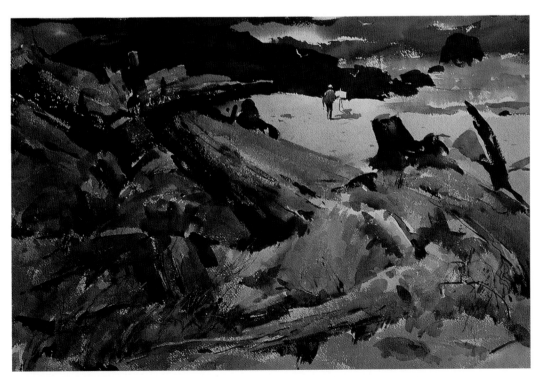

VERNON NYE
East of Terrebon
22" x 30" (56 cm x 76 cm)
Arches 400 lb. rough

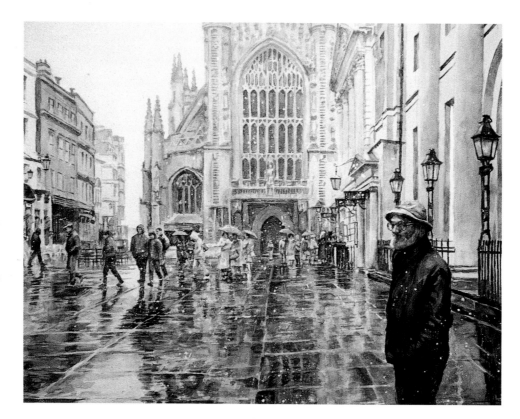

JONATHAN BLATT
Snowfall at Bath Abbey
24.5" x 27.5" (62 cm x 70 cm)
Arches 140 lb. cold press

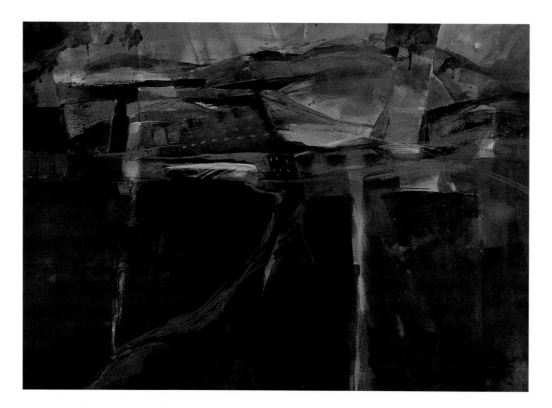

BEVERLY GROSSMAN
Born of Stone
22" x 30" (56 cm x 76 cm)
140 lb. cold press
Watercolor, acrylic pigment, and pastel

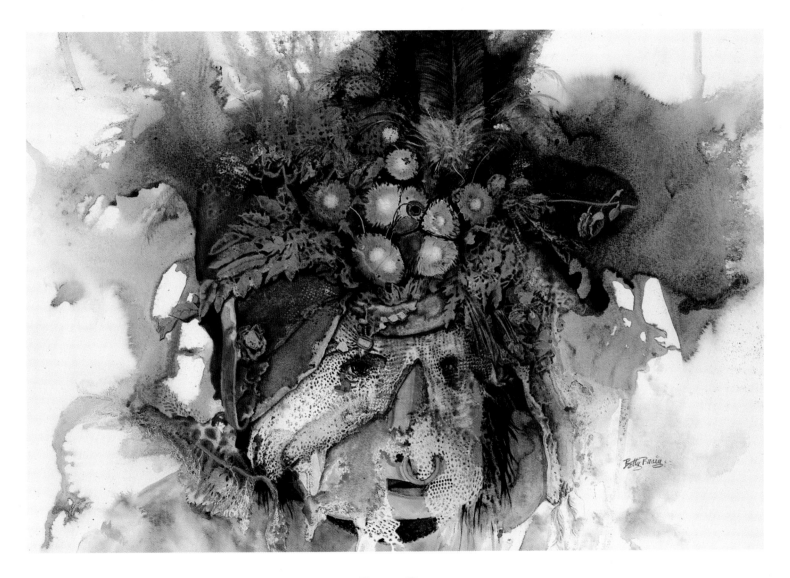

BETTY BRAIG

The Mask

30" x 40" (76 cm x 102 cm)

2-ply hot press 100% rag

Watercolor and acrylic

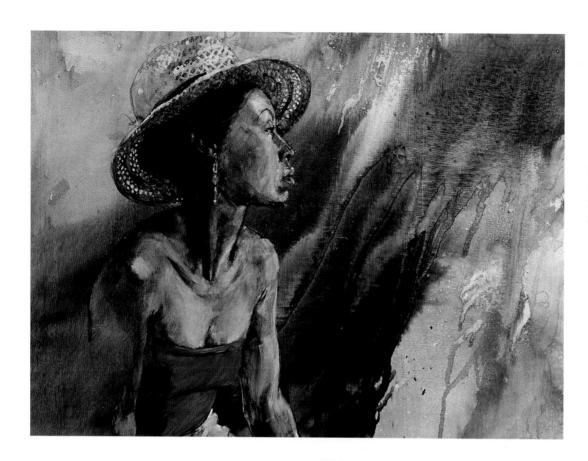

SUSAN HOLEFELDER
Gwen
20" x 25" (56 cm x 64 cm)
Crescent 100 lb. cold press

MARGARET LAURIE
My Kwan Chow Period
21" x 29" (53 cm x 74 cm)
Arches 260 lb. cold press

DELL KEATHLEY
Apples and Copper
14" x 19" (36 cm x 48 cm)
Arches 140 lb. cold press

DAN BURT
English Dreamscape
22" x 30" (56 cm x 76 cm)
Arches 300 lb. cold press

JOHN BARNARD
Oso Flaco
20" x 28" (51 cm x 71 cm)
Strathmore Aquarius II 80 lb. cold press
Watercolor, ink, and pastel

GAYLE DENINGTON-ANDERSON
Metal I: Ben
22" x 30" (56 cm x 76 cm)
Arches 300 lb. rough

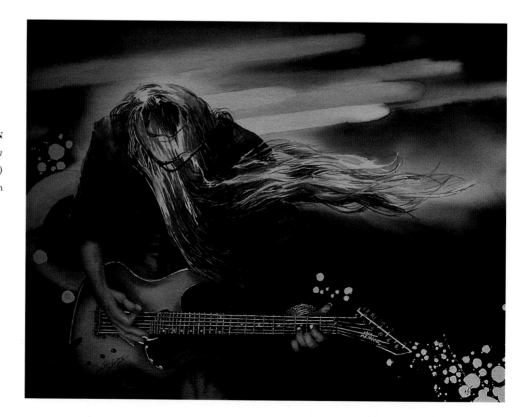

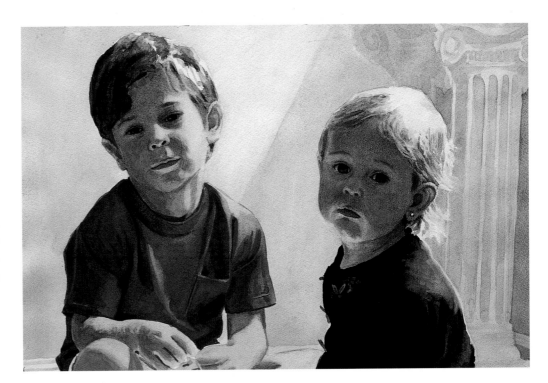

MARGARET CROWLEY-KIGGINS
Saturday Morning
15" x 22" (38 cm x 56 cm)
Lanaquarelle 140 lb. cold press

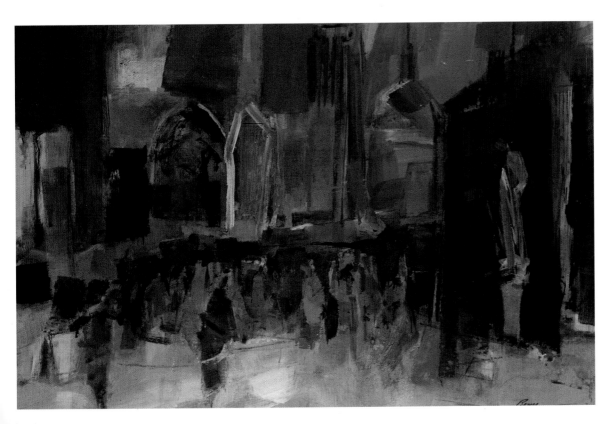

BETTY M. BOWES
Rome
20" x 24" (50 cm x 61 cm)
Masonite
Watercolor and acrylic

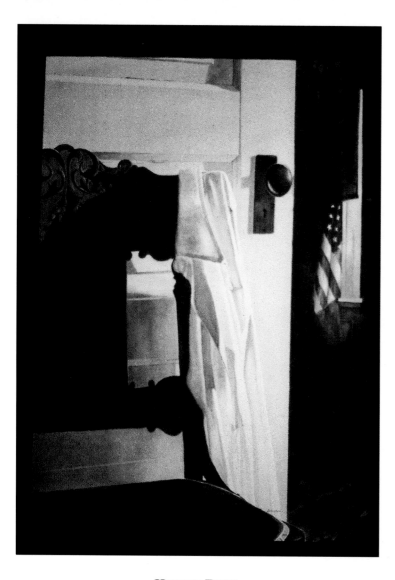

HENRY BELL
Opened to the Morning
28" x 36" (71 cm x 91 cm)
Arches 260 lb. hot press

MARIANNE K. BROWN
Up Tight
30" x 22" (76 cm x 56 cm)
Arches 140 lb. cold press
Special Technique: Textures were made using plastic
wrap, salt, and bubble plastic. Small lines were created
with watercolor and a ruling pen.

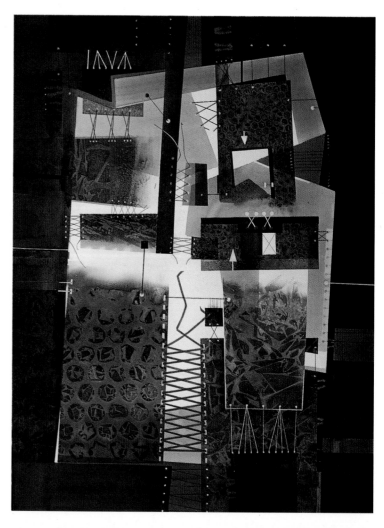

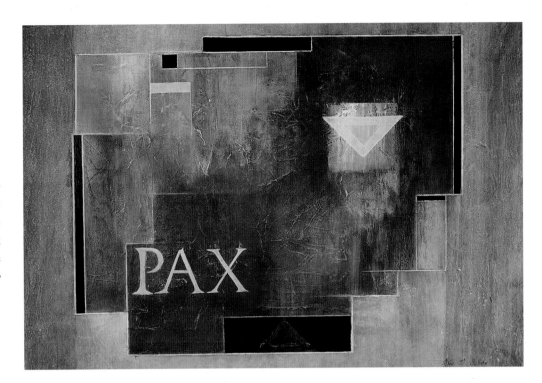

ANNE D. SULLIVAN
Pax I (Connections XVII series)
28" x 36" (71 cm x 91 cm)
Strathmore Aquarius II
Watercolor, acrylic ink, acrylic
paint, and gesso

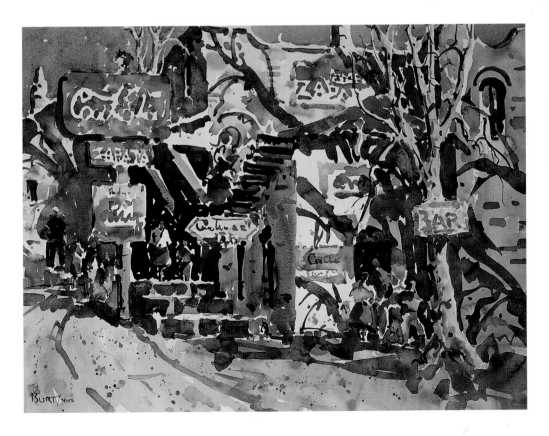

DAN BURT
Signs of the Times
22" x 30" (56 cm x 76 cm)
Arches 140 lb. cold press

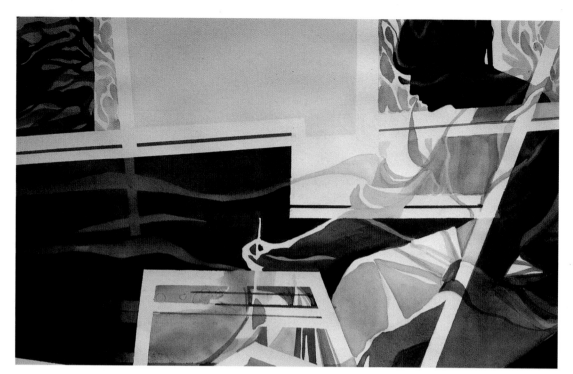

LUCIJA DRAGOVAN
The Work We Choose Should Be Our Own
22" x 30" (56 cm x 76 cm)
Arches 140 lb. cold press

KEN HANSEN
Bags and Oranges
15" x 21" (38 cm x 53 cm)
Arches 300 lb. cold press

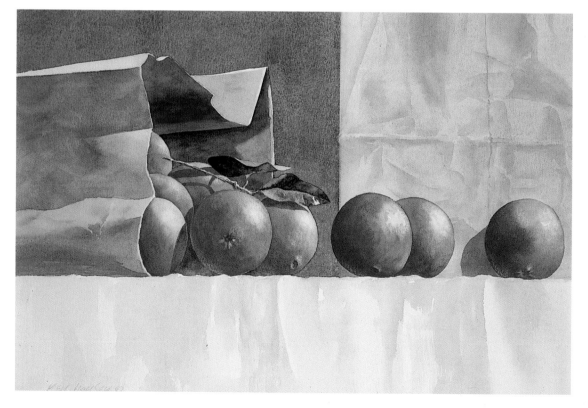

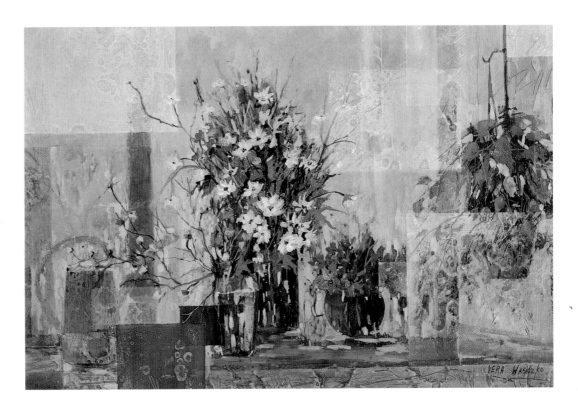

WOLODIMIRA VERA WASICZKO
A Summer Moment
26" x 36" (66 cm x 91 cm)
Crescent 100% rag
Watercolor, acrylic, and gesso

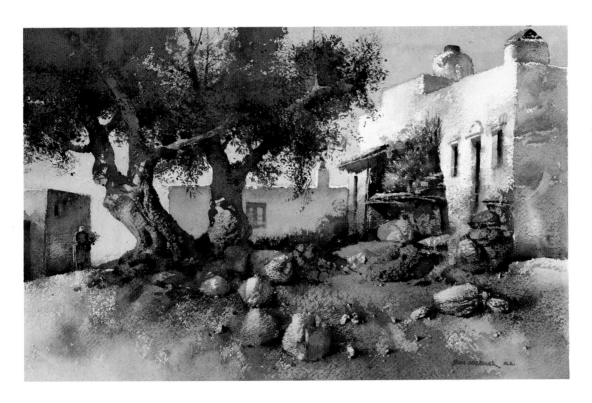

TOM NICHOLAS
Morning Light—Sianna, Greece
12" x 19" (30 cm x 48 cm)
Fabriano 300 lb. cold press

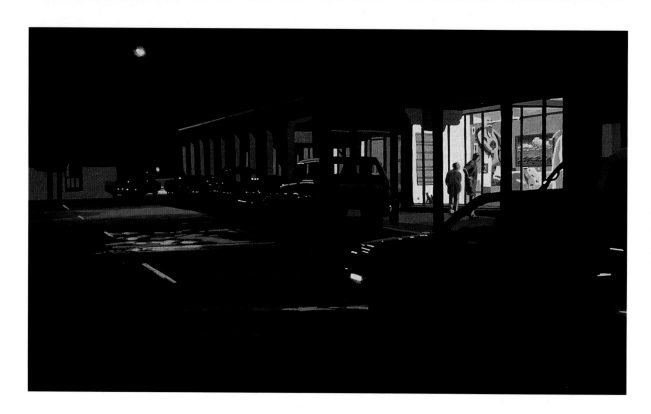

JAMES FARRAH
Window Shopping
15" x 22" (38 cm x 56 cm)
Winsor & Newton 260 lb.
cold press
Watercolor and gouache

ELENA ZOLOTNITSKY
Sepia Dreams
22.5" x 30" (57 cm x 76 cm)
Strathmore

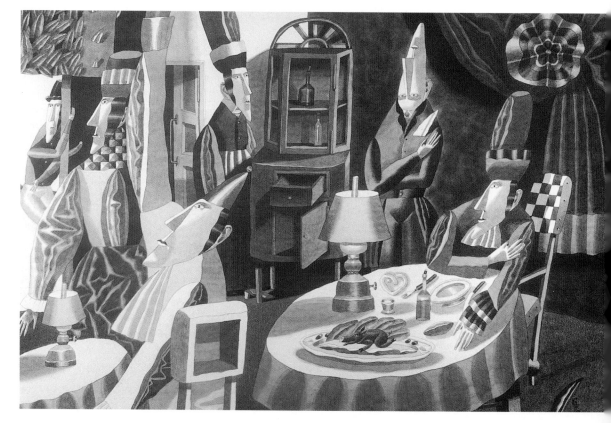

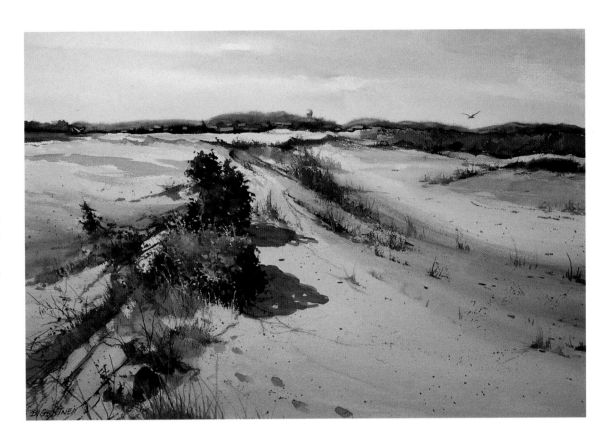

BERNARD GERSTNER
Plum Island Dunes
22" x 29" (56 cm x 74 cm)
Arches 300 lb. cold press

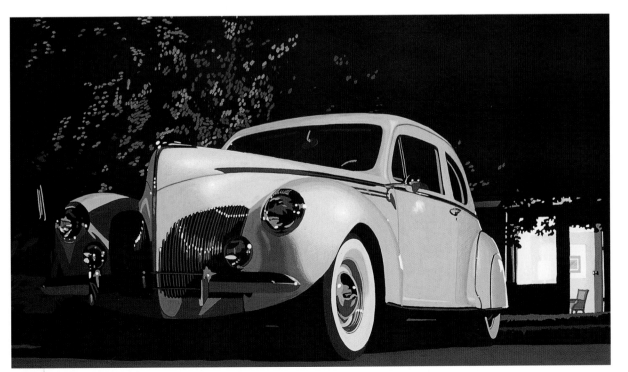

JAMES FARRAH
Rendezvous
15" x 22" (38 cm x 56 cm)
Lanaquarelle 260 lb.
cold press
Watercolor and gouache

RUTH L. ERLICH
Watercolor: Third Dimension VII
32" x 43" (81 cm x 109 cm)
140 lb. rough
Watercolor and diluted fabric dye

JUDITHE RANDALL
Covenant
20" x 29" (51 cm x 74 cm)
Crescent
Watercolor, acrylic, and ink

LINDA TOMPKIN
Lemonade
20" x 24" (51 cm x 61 cm)
Strathmore 500 series
Watercolor and acrylic

SANDRA THRUBER KUNZ
Harbour Down East
30" x 40" (76 cm x 102 cm)
Rives BFK

83

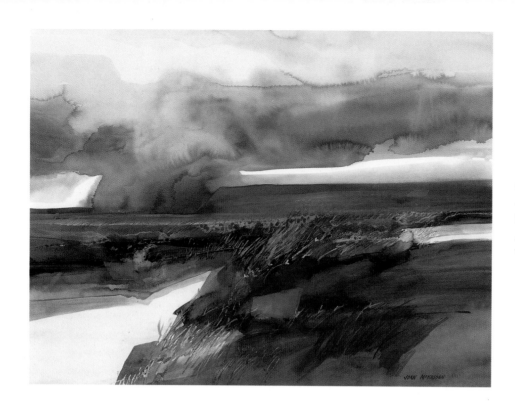

JOAN MCKASSON
Southwest Sunset
22" x 30" (56 cm x 76 cm)
Arches 140 lb. cold press
Watercolor and gouache

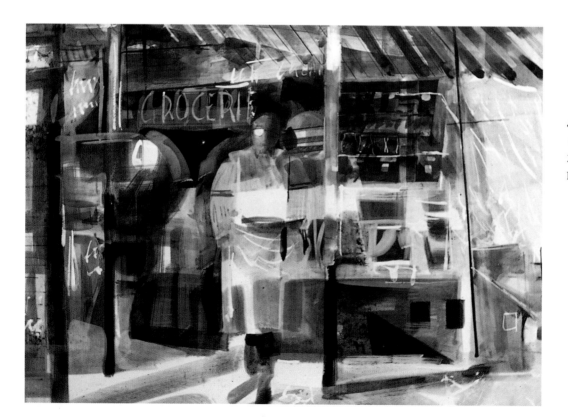

JANE OLIVER
Grocer
25" x 30" (64 cm x 76 cm)
Hot press

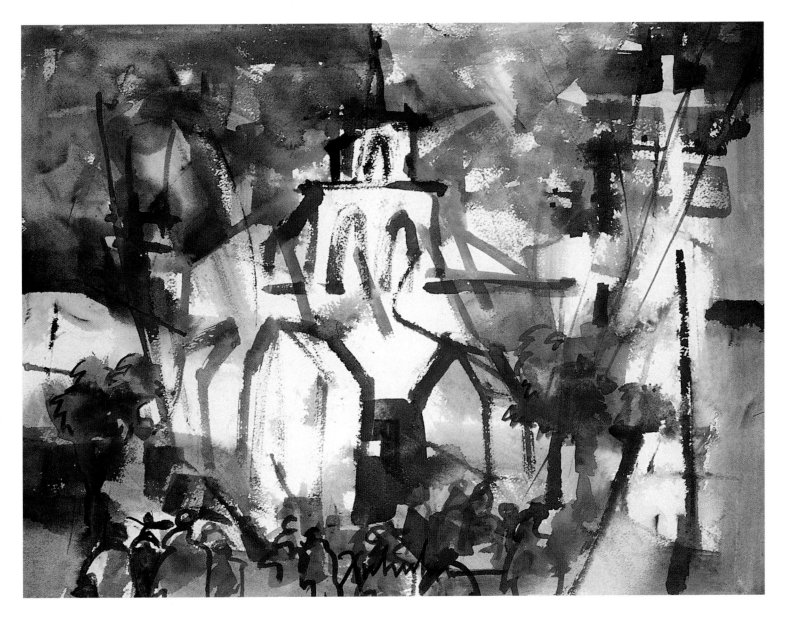

HENRY FUKUHARA

Iglesia San Antonio

18" x 24" (46 cm x 61 cm)

Waterford 140 lb. rough

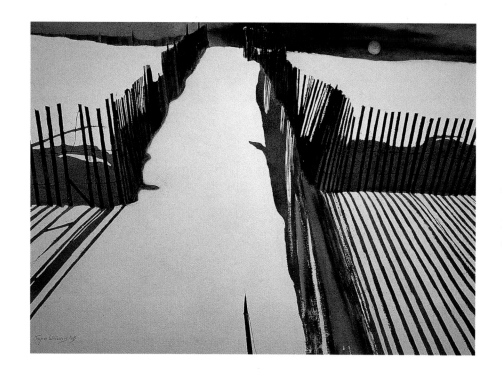

JOYCE WILLIAMS
Winter Moon
22" x 30" (56 cm x 76 cm)
Arches 300 lb. cold press

ANITA MEYNIG
Air Borne
22" x 28" (56 cm x 71 cm)
Arches 140 lb. cold press
Watercolor and gouache

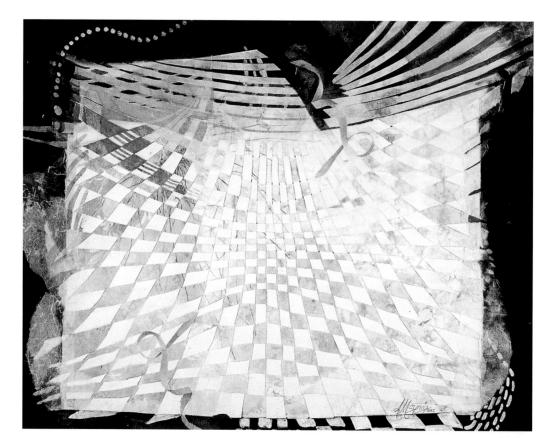

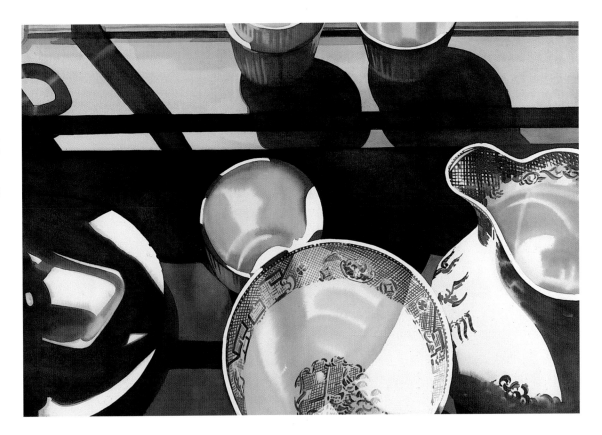

DEBORAH ELLIS
Red Counter White Dishes I
30" x 41" (76 cm x 104 cm)
Arches 555 lb. cold press

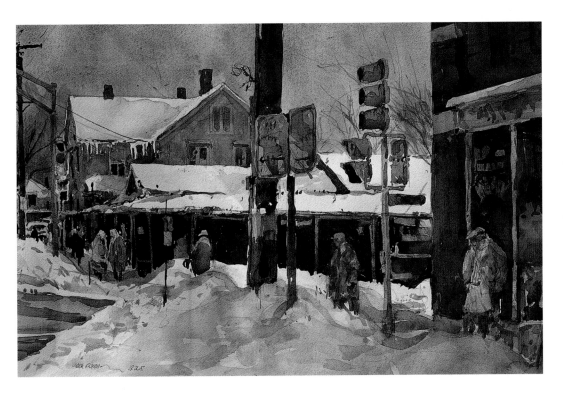

JACK FLYNN
Closed Tyler Market
15" x 22" (38 cm x 56 cm)
Arches 140 lb. cold press

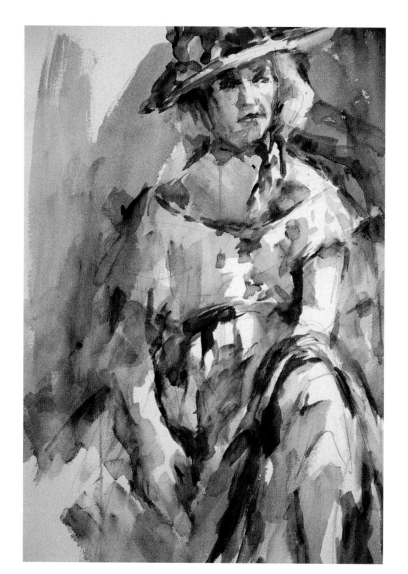

JONATHAN BLATT
The Flowered Hat
13" x 21" (33 cm x 53 cm)
Arches 140 lb. cold press

JIM PITTMAN
Shadow People—Wallmark Series
30" x 22" (76 cm x 56 cm)
Strathmore Aquarius
Watercolor, acrylic, watercolor
pencil, and watercolor crayon

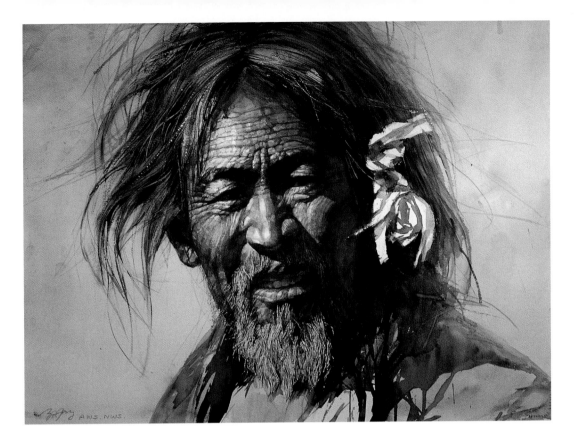

Z. L. FENG
Mountain Man
22" x 30" (56 cm x 76 cm)
Arches 140 lb. cold press

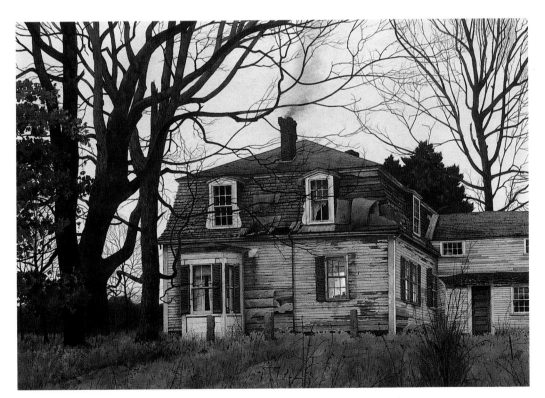

LORING W. COLEMAN
November Evening
21" x 29" (53 cm x 74 cm)
Waterford 300 lb. cold press

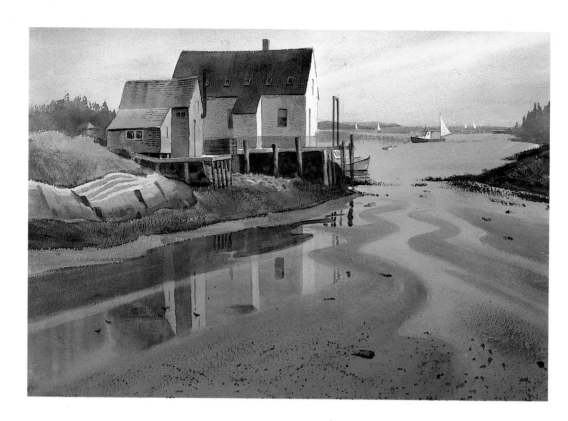

MARTIN R. AHEARN
Ebb Tide—Orr's Island, ME
21" x 29" (53 cm x 74 cm)
300 lb. cold press

JANE DESTRO
Claire
17" x 19" (43 cm x 48 cm)
Fabriano Artistico 140 lb.

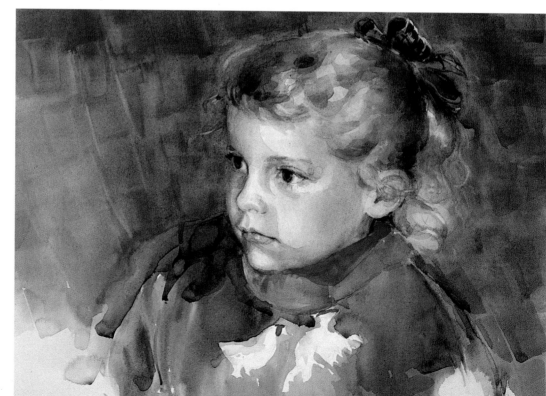

SHERRY LOEHR
Random Play
28" x 20" (71 cm x 51 cm)
Arches 140 lb. hot press
Watercolor and acrylic

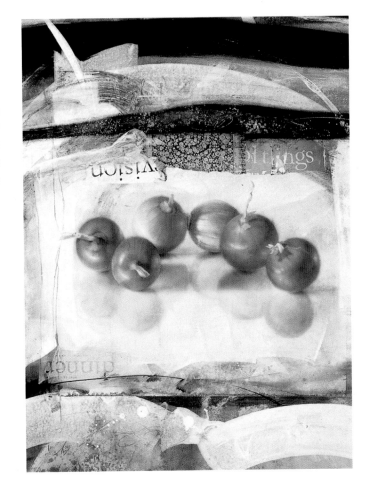

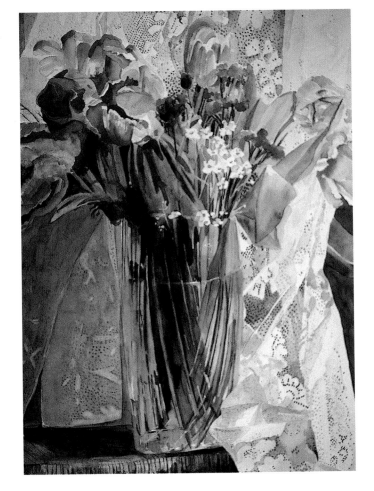

PAT FORTUNATO
Betty's Gift #2
30" x 22" (76 cm x 56 cm)
Waterford 140 lb. cold press

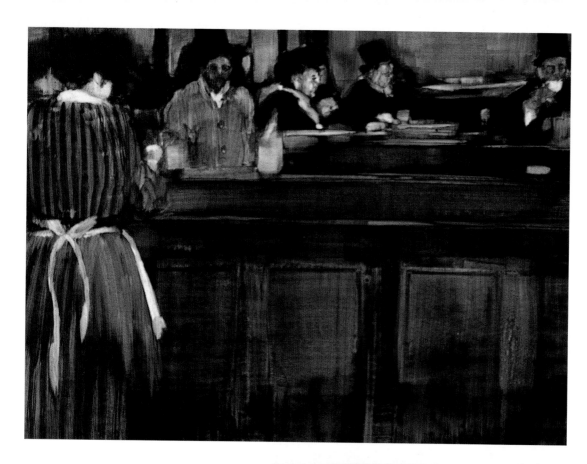

ALFRED CHRISTOPHER
Café Marcel
8" x 11" (20 cm x 28 cm)
Strathmore 500 series 140 lb.

BARBARA SCULLIN
Nature's Harmony
30" x 40" (76 cm x 102 cm)
Arches 300 lb. cold press

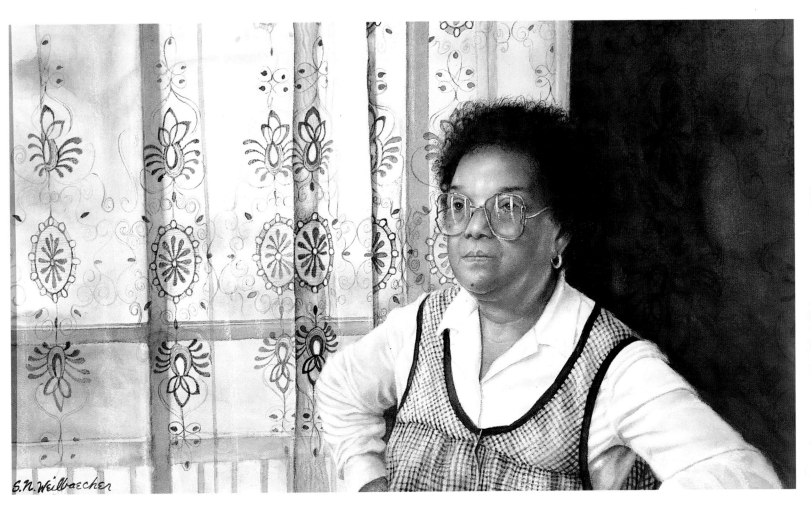

SHARON WEILBAECHER

Thelma and Lace

13.5" x 23" (34 cm x 58 cm)

Arches 300 lb. cold press

STELLA DOBBINS
Foreign Resonances, VI
50.5" x 40" (128 cm x 102 cm)
Arches 140 lb. cold press

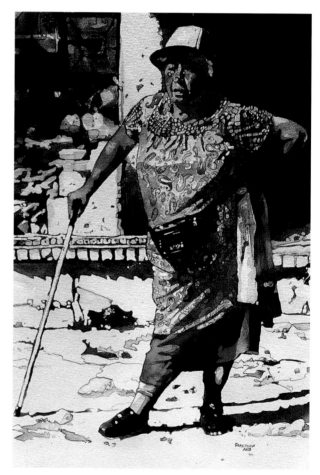

JEAN GRASTORF
Chichen Itza
28" x 20" (71 cm x 51 cm)
Waterford 300 lb. cold press

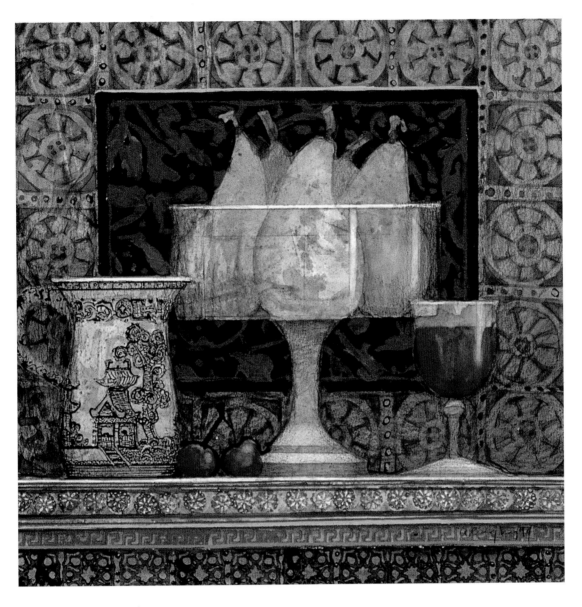

ANNE BAGBY
French Pears
13" x 13" (33 cm x 33 cm)
Watercolor board
Watercolor and acrylic

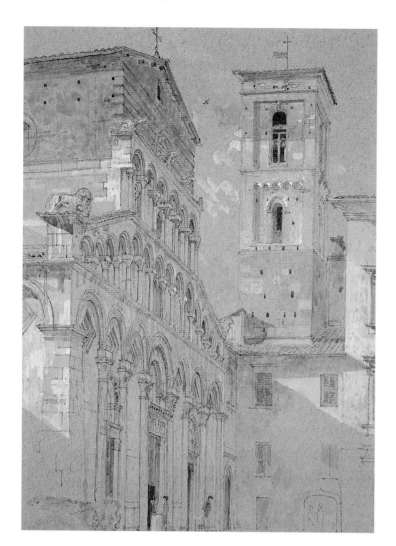

CHARLOTTE HALLIDAY
Santa Maria Forisportam—Lucca
15" x 12" (38 cm x 30 cm)
Ingres 160 gsm
Watercolor and pencil

NICK SCALISE
Staying Warm—Vendor, Santa Fe, NM
28" x 22" (71 cm x 56 cm)
140 lb. cold press

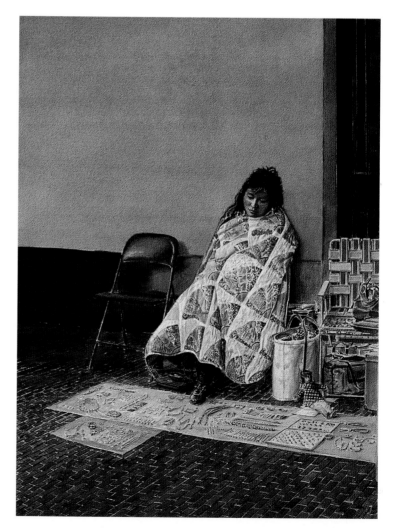

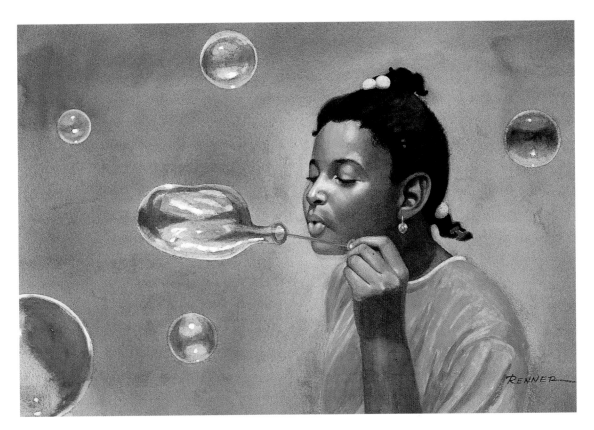

DONALD G. RENNER
Bubbles
13" x 19" (33 cm x 48 cm)
Arches 140 lb. cold press

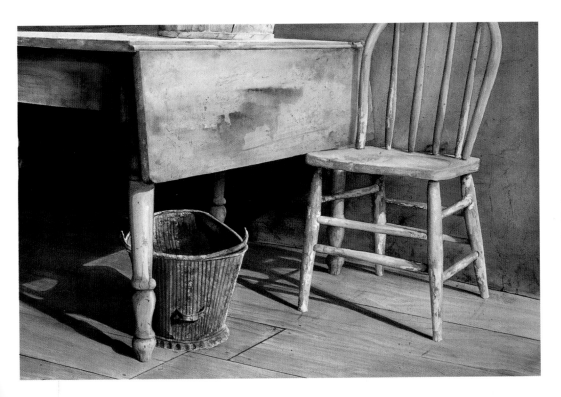

DAVID S. DeMarco
In the Waning Hours
20" x 30" (51 cm x 76 cm)
Cold press

97

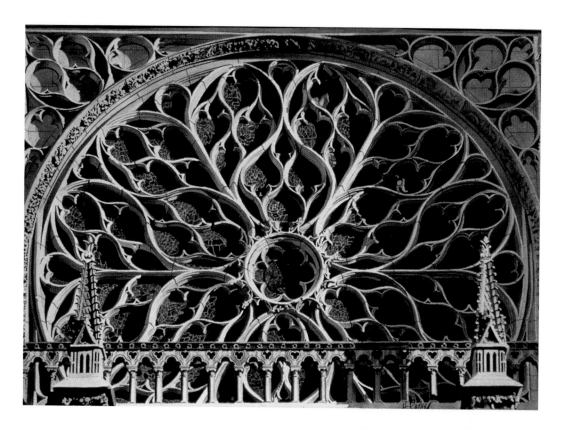

L. HERB RATHER, JR.
Rose Window—Sainte Chapelle
30" x 22" (76 cm x 56 cm)
Arches 140 lb. rough

BRUCE G. JOHNSON
School's Out
21" x 29" (53 cm x 74 cm)
Arches 300 lb. rough

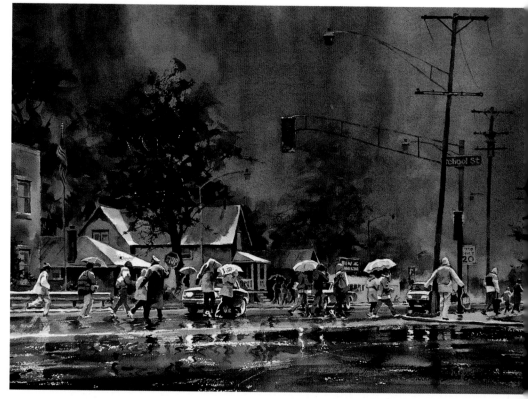

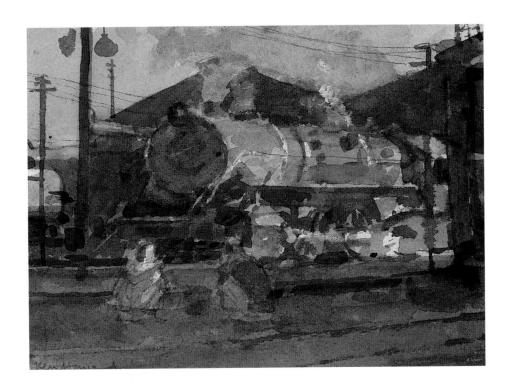

KEN HOWARD
Jhansi Loco—India
5" x 7" (13 cm x 18 cm)
Arches 300 lb. rough
Watercolor and Chinese white

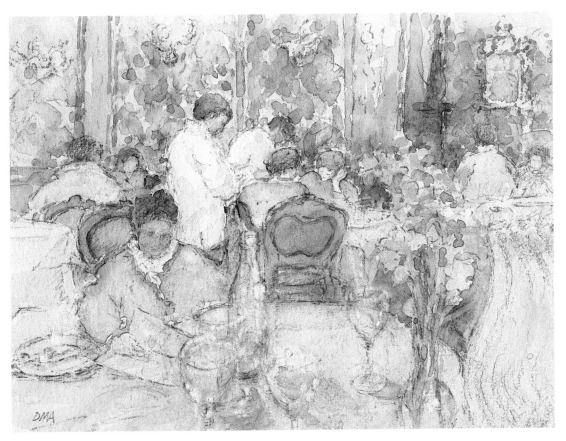

DIANA ARMFIELD
Ristorante Il Giglio—Venice
6" x 8" (15 cm x 20 cm)
Sanderson 140 lb.

99

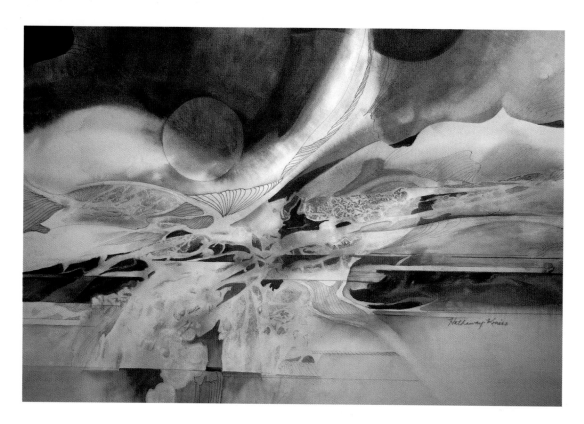

SHIRLEY KRUISE HATHAWAY
Indecisive I
32" x 40" (81 cm x 102 cm)
300 lb. cold press
Watercolor and white opaque ink

SUSAN SPENCER
Oriental Lilies
28" x 36" (71 cm x 91 cm)
Fabriano 140 lb. hot press

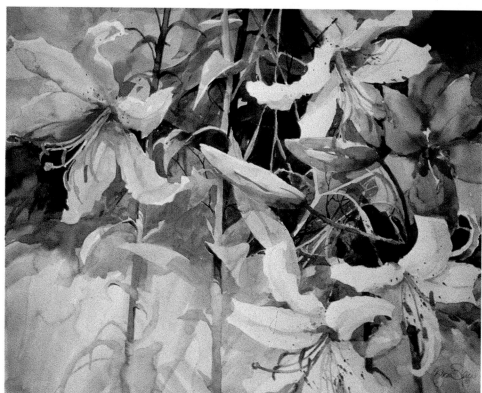

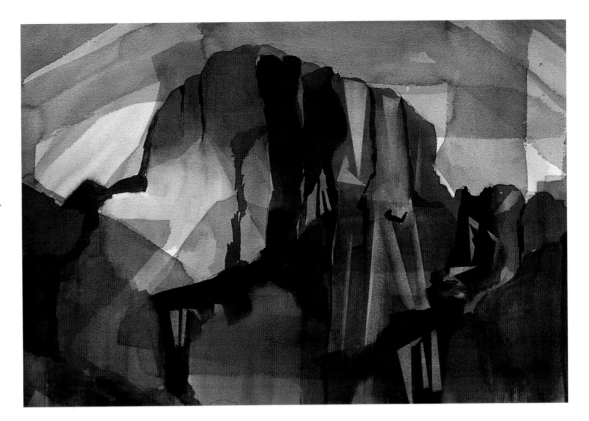

ROWENA FRANCIS
Sugar Loaf
22" x 30" (56 cm x 76 cm)
Arches 300 lb. cold press

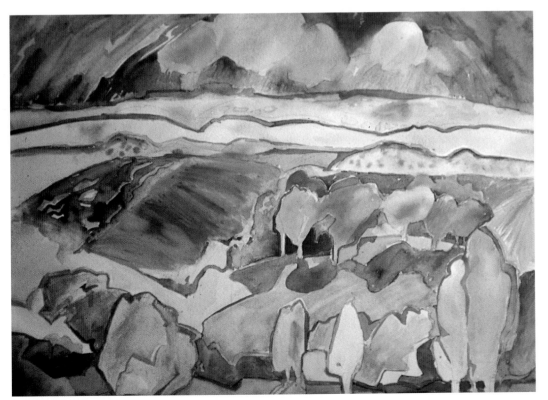

SUSAN AMSTATER SCHWARTZ
Rio Grande Valley
20" x 25" (51 cm x 64 cm)
Arches 140 lb.

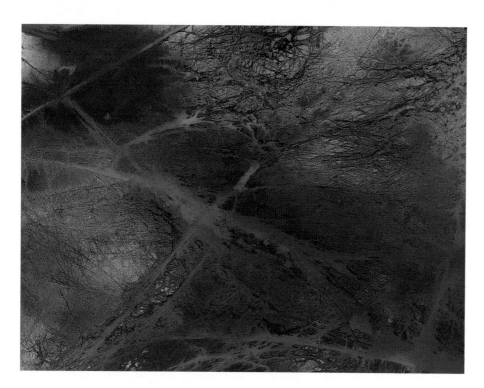

MARY ANN BECKWITH
Sunrise, Sunset
22" x 30" (56 cm x 76 cm)
Arches 140 lb. hot press
Watercolor and ink
Special Technique: Halloween cobwebs are
stretched over the paper, water is then poured
over the surface, and diluted W.C.I. is sprayed
onto the surface.

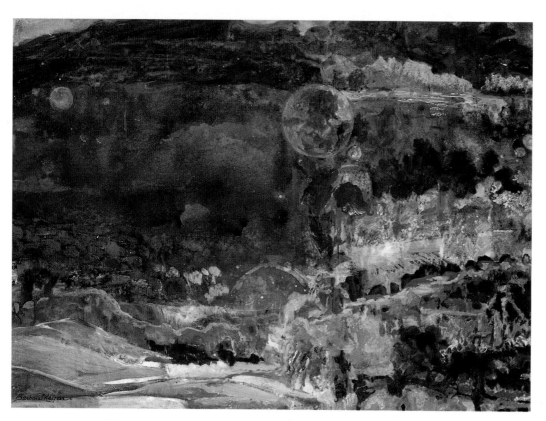

BARBARA KEYSER
Santa Fe II
22" x 17" (56 cm x 43 cm)
Arches 140 lb. cold press
Watercolor and acrylic

H. C. DODD
One Half Three
30" x 22" (76 cm x 56 cm)
300 lb. cold press

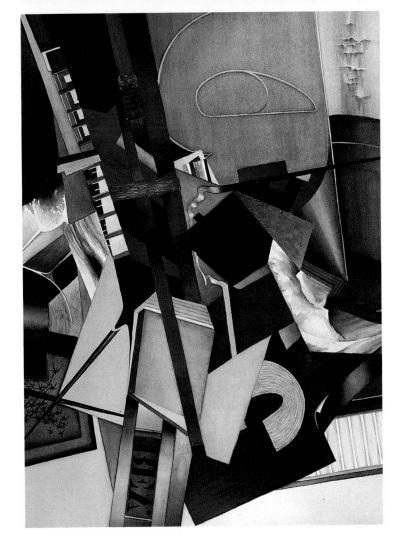

CHRISTINE FORTNER
Hot Tomatoes
13" x 21" (33 cm x 53 cm)
Arches 140 lb. cold press

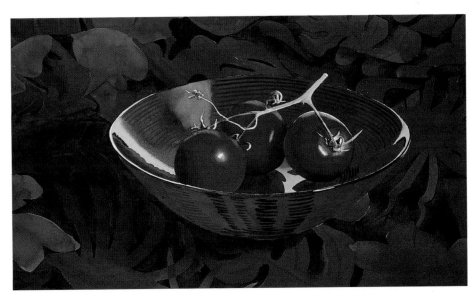

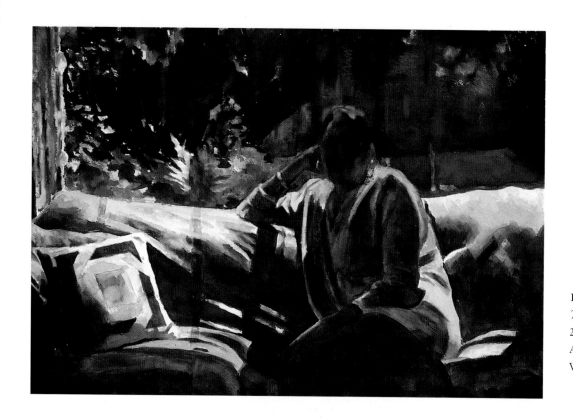

PAT BERGER
The End of the Day
29" x 36" (74 cm x 91 cm)
Arches 300 lb. cold press
Watercolor and pastel

RALPH BUSH
Northern Exposure
20" x 25" (51 cm x 64 cm)
Strathmore 500 series 140 lb.
Watercolor and white gouache

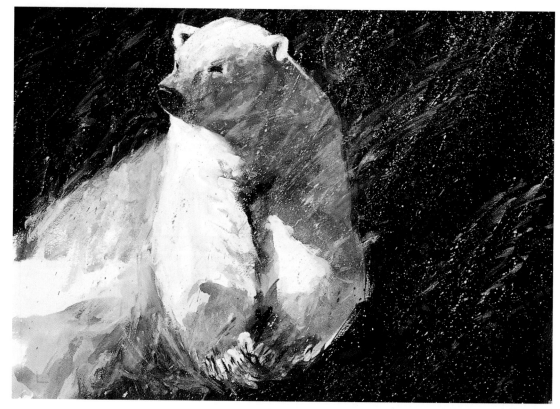

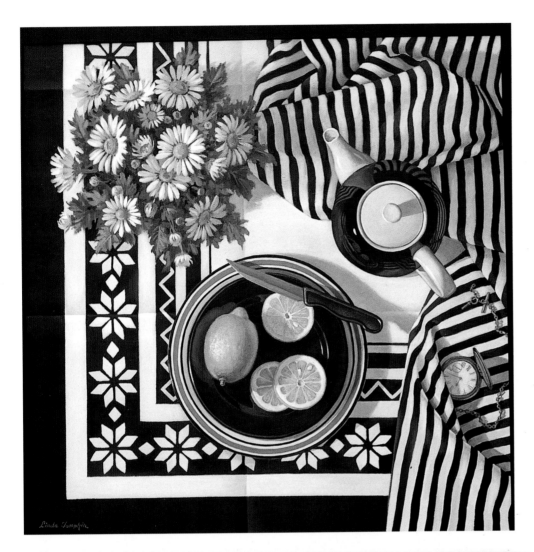

LINDA TOMPKIN
Lemon Delight
22" x 22" (56 cm x 56 cm)
Strathmore 500 series
Watercolor and acrylic

CARRIE BURNS BROWN
Wrappings
12" x 22" (30 cm x 56 cm)
100% rag mat board
Watercolor, acrylic, ink stained silk,
and collage

105

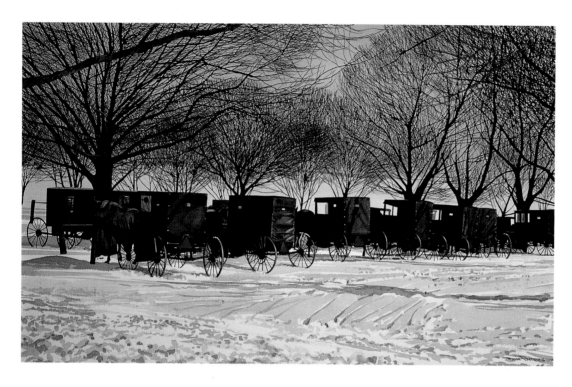

DONALD W. PATTERSON
The Sabbath
16" x 28" (41 cm x 71 cm)
300 lb. cold press

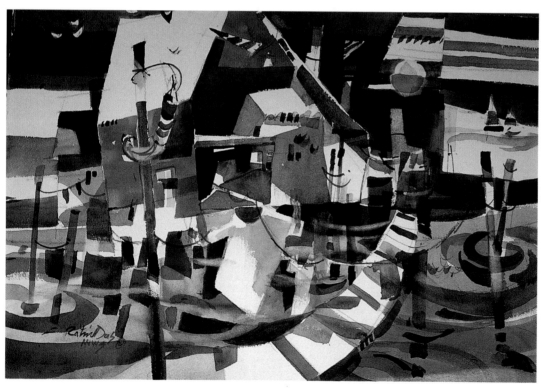

RATINDRA DAS
Fun by the Bay
15" x 22" (38 cm x 56 cm)
Arches 140 lb. cold press

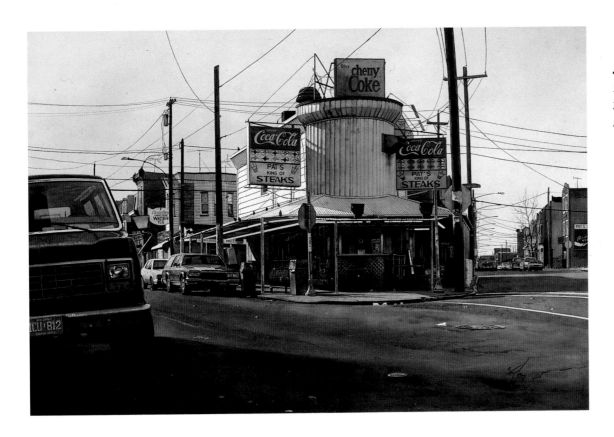

JAMES TOOGOOD
Pat's
21" x 29.5" (53 cm x 74 cm)
Arches 140 lb. cold press

MARTIN R. AHEARN
Island Man
21" x 29" (53 cm x 74 cm)
300 lb. cold press

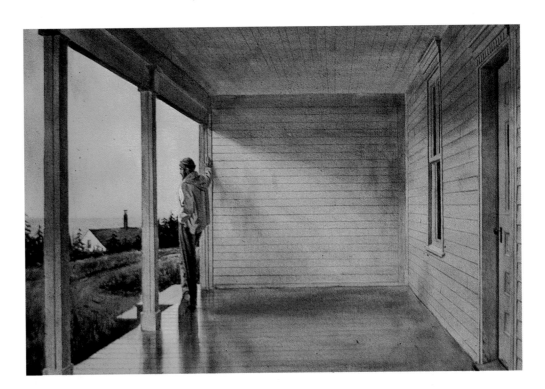

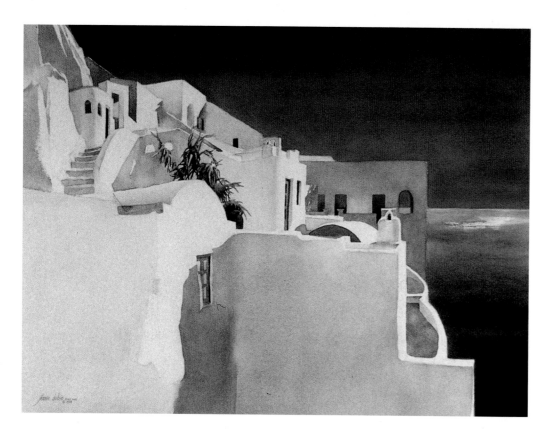

JEANNE DOBIE
Aegean Shadows
22" x 30" (56 cm x 76 cm)
Arches 140 lb. cold press

KAY REBBER FOOTE
Fishin'
22" x 29.5" (56 cm x 75 cm)
Fabriano 300 lb. cold press

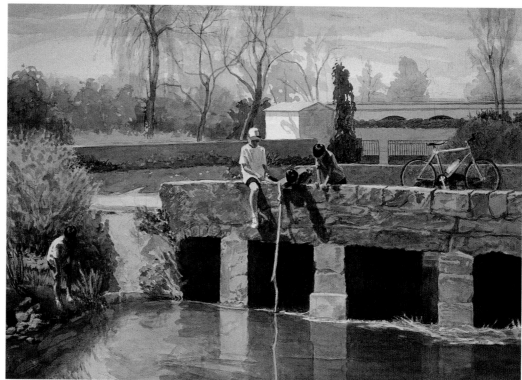

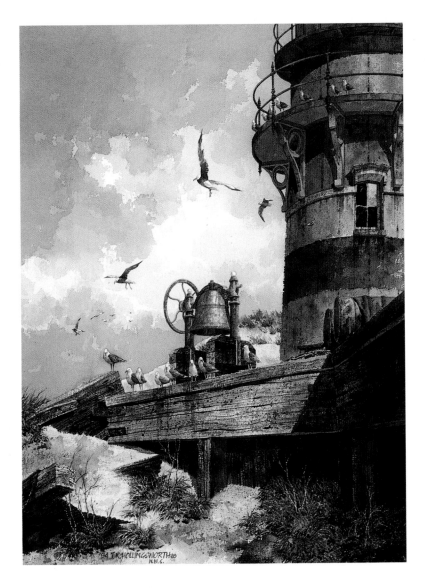

JOHN R. HOLLINGSWORTH

Tenants in Common
29" x 21" (74 cm x 53 cm)
300 lb. rough
Special Technique: White lines scraped with
razor, no white paint used.

JIM BROWER

Unexpected Downpour
29.5" x 19.5" (75 cm x 50 cm)
300 lb. cold press

PAULA K. ARTAC
Wolf Eyes
28" x 32" (71 cm x 61 cm)
Arches 300 lb. rough

PAUL STRISIK
Ebb Tide
20" x 28" (51 cm x 71 cm)
Green's 300 lb. rough

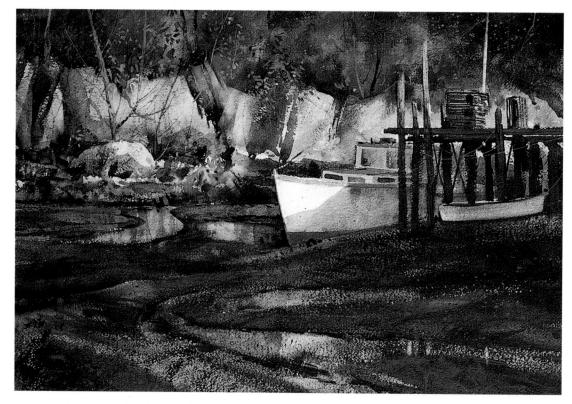

110

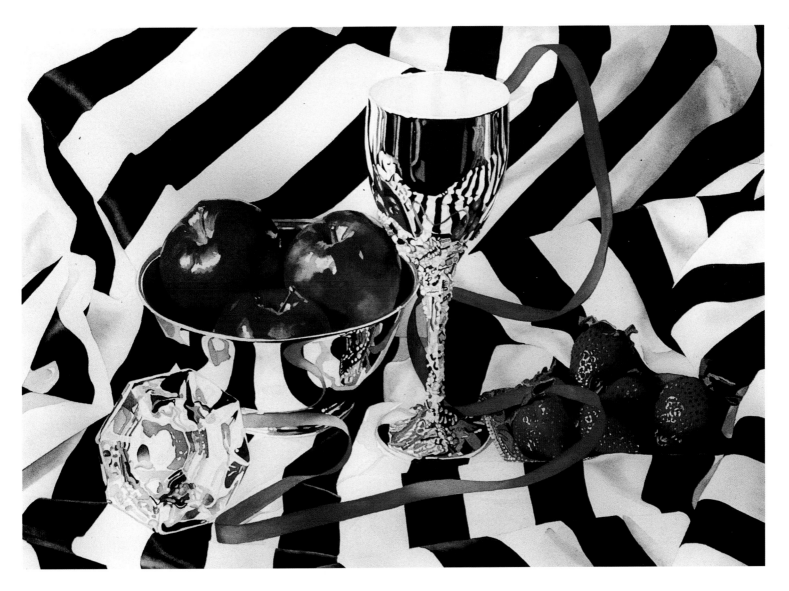

TERRY O'MALEY

Red Ribbon

29.5" x 35.5" (75 cm x 90 cm)

Arches 300 lb. cold press

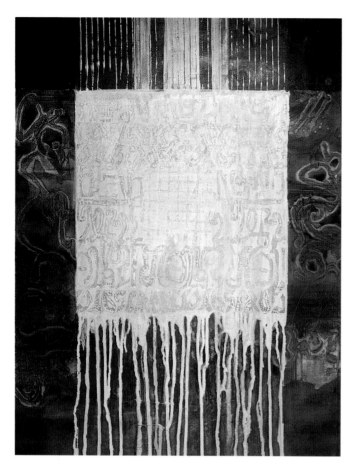

DELDA SKINNER
Dialogue with the Tabernacle
26" x 20" (66 cm x 51 cm)
Arches 300 lb. hot press
Watercolor casein and acrylic

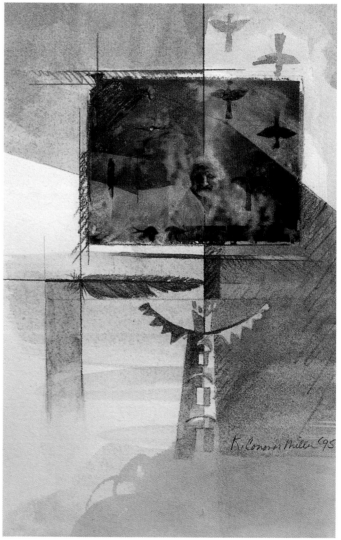

KATHLEEN CONOVER
Contemplation of Flight
8" x 10" (20 cm x 25 cm)
Arches 140 lb. hot press
Watercolor and water-soluble
colored pencils
Special Technique: Polaroid photo images
were transferred from slides directly onto
the watercolor paper.

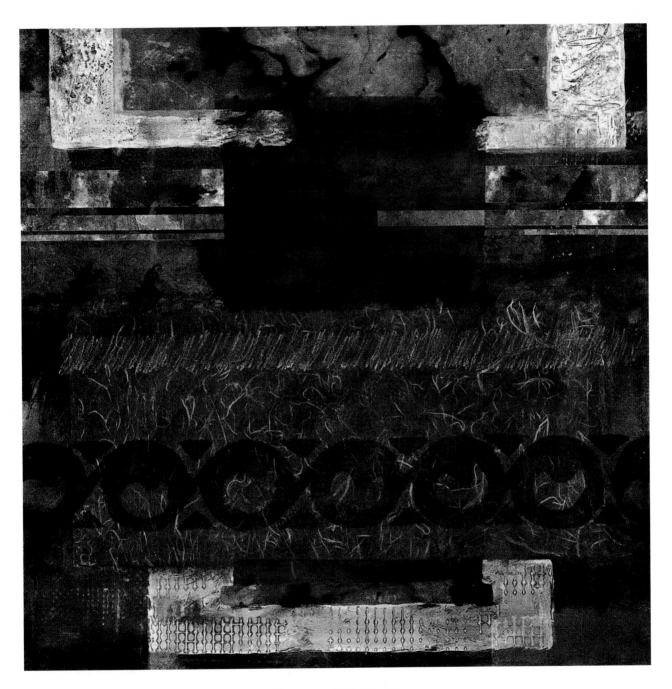

GERRIE L. BROWN
Southwest Images
30" x 30" (76 cm x 76 cm)
Strathmore Aquarius II 80 lb.
Watercolor, acrylics, watercolor crayon, watermedia inks, and collage

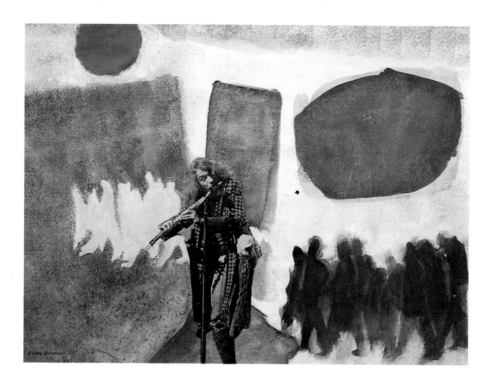

BELLE OSIPOW
Pied Piper (Modern Style)
17.5" x 23.5" (44 cm x 60 cm)
Arches 140 lb.
Watercolor, acrylic, and collage

JOHNNIE CROSBY
Petroglyph Wall—Canyon de Chelle
27" x 34" (69 cm x 86 cm)
Arches 140 lb.

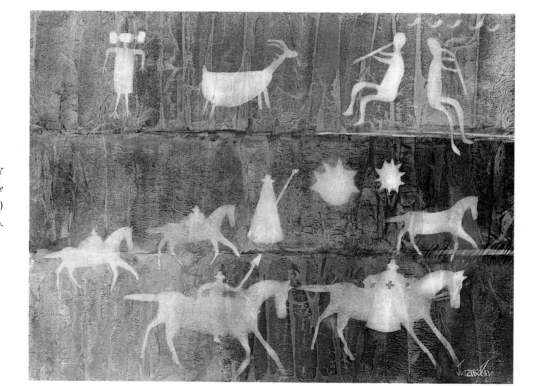

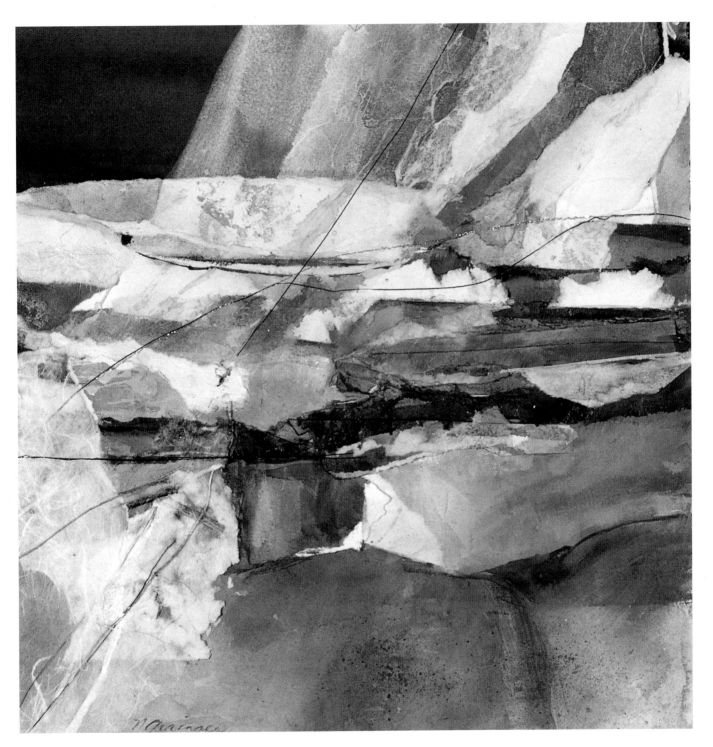

NESSA GRAINGER
Lightshaft
15" x 14" (38 cm x 36 cm)
Arches 140 lb. cold press

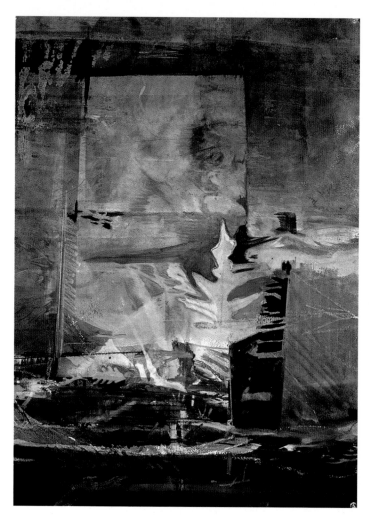

LYNNE KROLL
An Early Frost
36" x 28" (91 cm x 71 cm)
Arches 140 lb. cold press
Watercolor, wax crayon, water-soluble
Craypas, gouache, golden liquid acrylic,
and watercolor pencils

BARBARA BURWEN
Notes
30" x 22" (76 cm x 56 cm)
140 lb. hot press
Watercolor, acrylic, ink, and charcoal powder

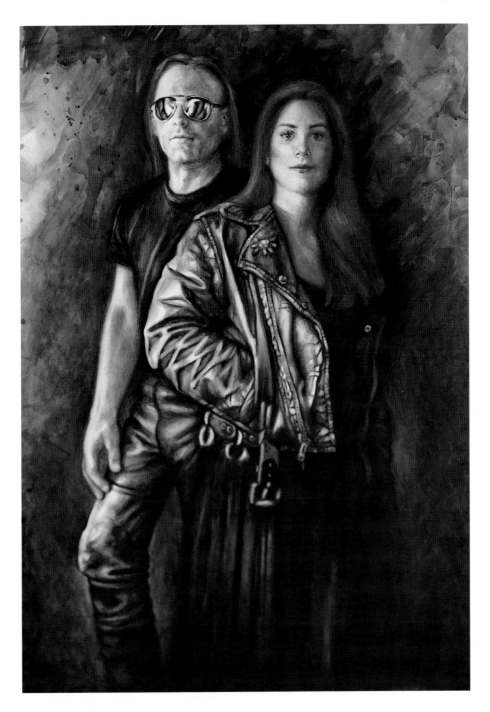

JANE BREGOLI

Crepuscule in Black and Brown: Wendy and Chris

40" x 28" (102 cm x 71 cm)

Strathmore 4-ply bristol

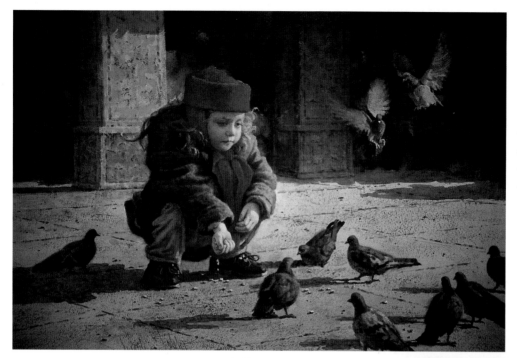

JOSEPH BOHLER
Morning Sunshine—Piazza San Marco
21.5" x 29.5" (55 cm x 75 cm)
Arches 300 lb. cold press

RUTH WYNN
Melissa's Menagerie
28" x 22" (71 cm x 56 cm)
Strathmore plate finish
Special Technique: Doll's face was
patted with cloth while damp to give
smooth appearance.

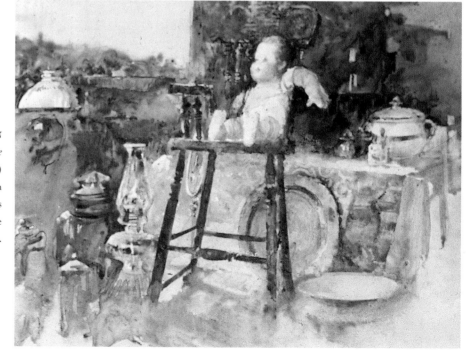

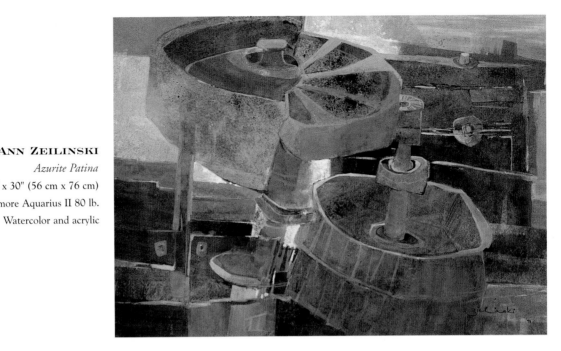

ANN ZEILINSKI
Azurite Patina
22" x 30" (56 cm x 76 cm)
Strathmore Aquarius II 80 lb.
Watercolor and acrylic

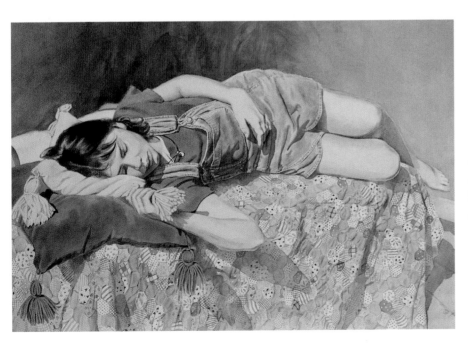

JEAN KALIN
Summertime
17.5" x 28" (44 cm x 71 cm)
Arches 140 lb. cold press

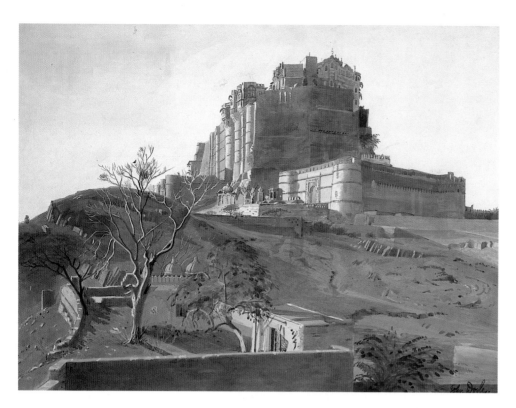

JOHN DOYLE
The Fort—Jodhpur, India
18" x 24" (46 cm x 61 cm)
Ingres Zirkall
Watercolor and gouache

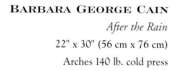

BARBARA GEORGE CAIN
After the Rain
22" x 30" (56 cm x 76 cm)
Arches 140 lb. cold press

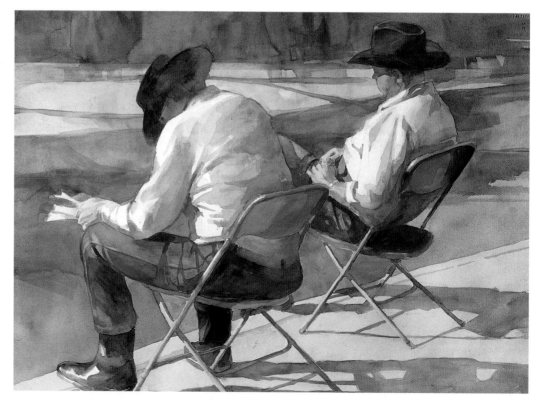

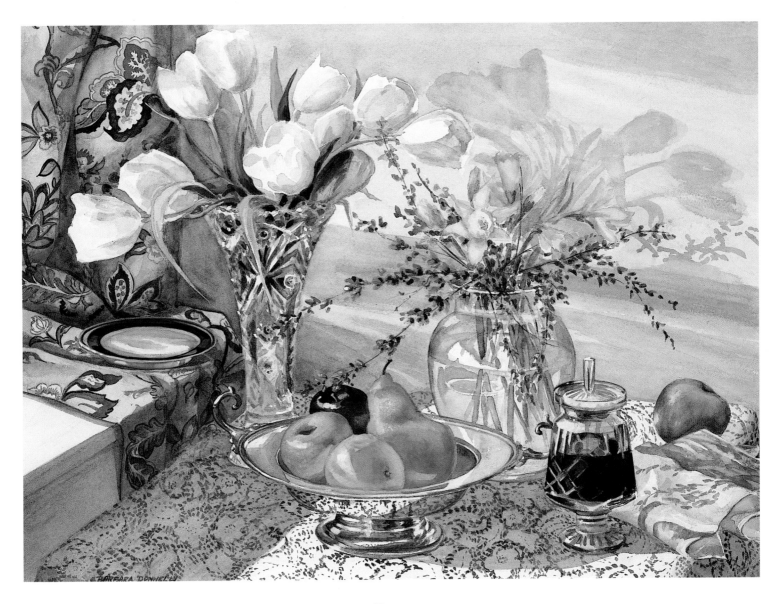

BARBARA DONNELLY

Promise of Spring

22" x 30" (56 cm x 76 cm)

Arches 300 lb. cold press

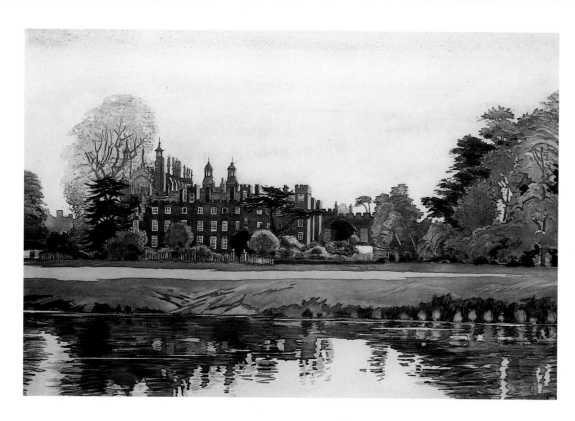

JOHN DOYLE
Eton College—Windsor
18" x 12" (46 cm x 30 cm)
Ingres Zirkall

MURRAY WENTWORTH
August Mist
22" x 30" (56 cm x 76 cm)
Waterford 300 lb. cold press
Watercolor and gouache

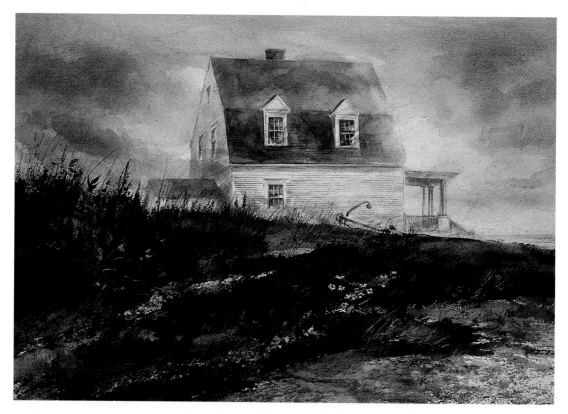

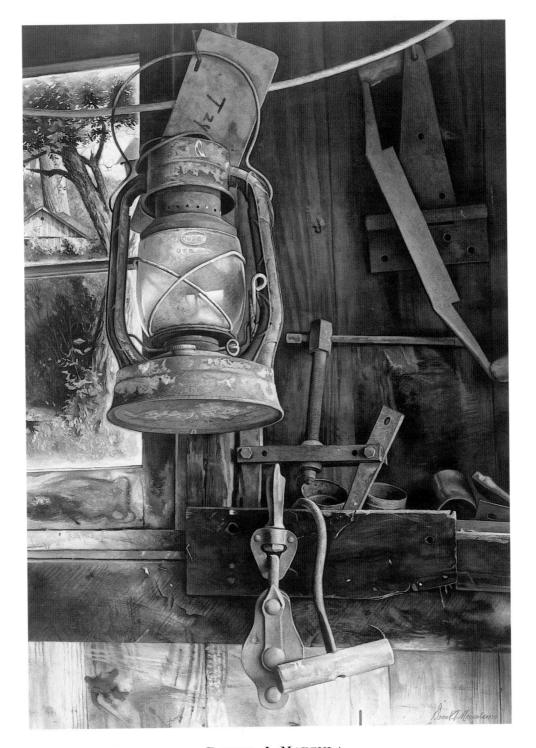

DANIEL J. MARSULA

Lantern II

28" x 20" (71 cm x 51 cm)

Arches 140 lb. cold press

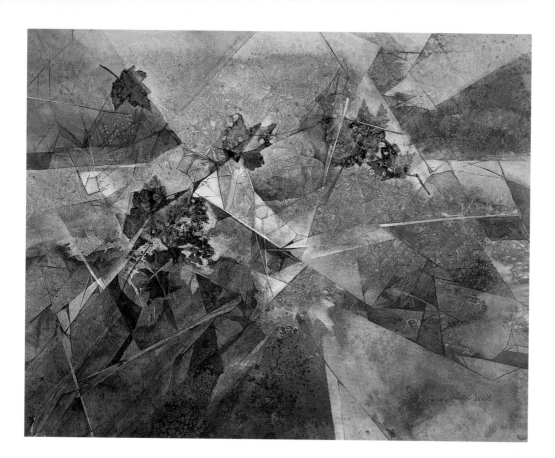

KATHLEEN CONOVER
Winter Fragments
22" x 30" (56 cm x 76 cm)
Arches 140 lb. hot press
Special Technique: Water, liquefied watercolor, and paper were exposed to outdoor temperatures of 10°–20°F, producing fragile crystal patterns and lacy frost textures that were painted, printed, and stenciled to develop the composition.

MORRIS SHUBIN
One-Way Downtown
30" x 40" (76 cm x 102 cm)
Crescent 112 lb. rough

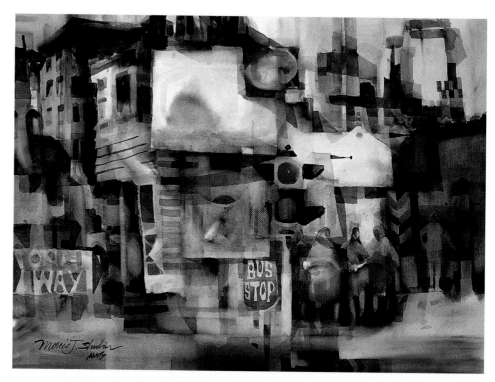

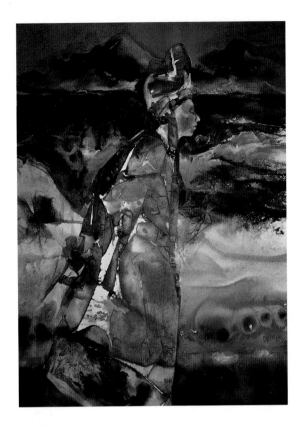

PAT REGAN
Katmandu
30" x 22" (76 cm x 56 cm)
140 lb. cold press

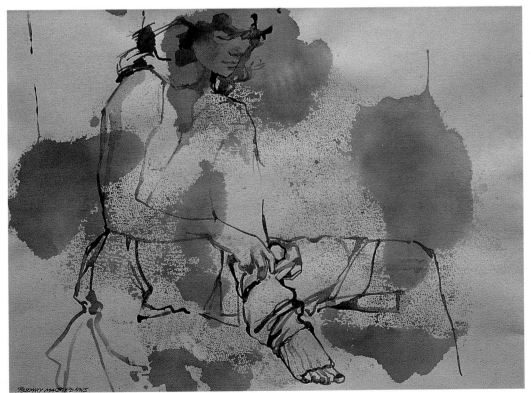

ROSEMARY MACBIRD
Dancer's Leg Warmer
22" x 30" (56 cm x 76 cm)
Arches 140 lb. rough

125

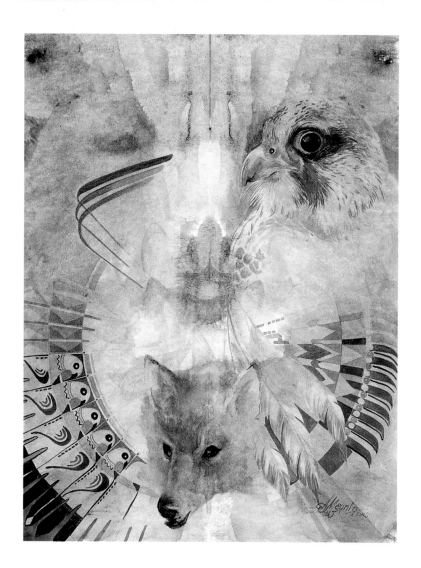

ANITA MEYNIG
Hunter/Hunted
30" x 22" (76 cm x 56 cm)
Arches 140 lb. cold press

DONNE F. BITNER
Watershed Reliquary
30" x 22" (76 cm x 56 cm)
Strathmore Aquarius II 90 lb. cold press
Watercolor crayon and acrylic

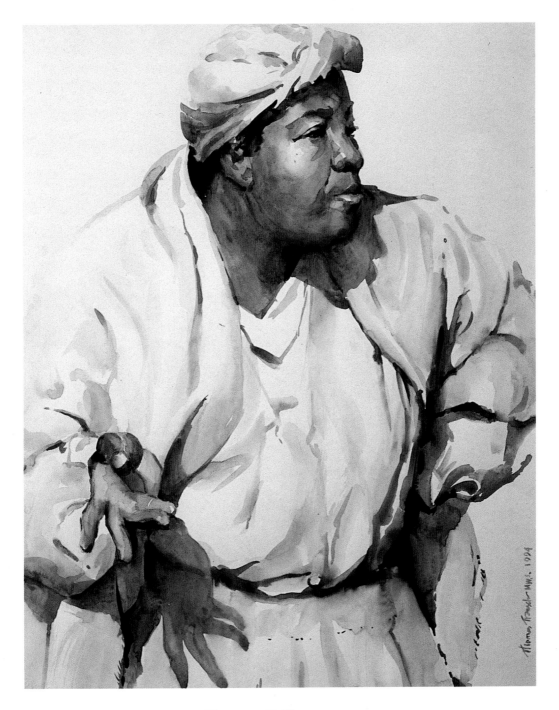

THOMAS V. TRAUSCH

Storyteller

28" x 17" (71 cm x 43 cm)

Arches 140 lb. cold press

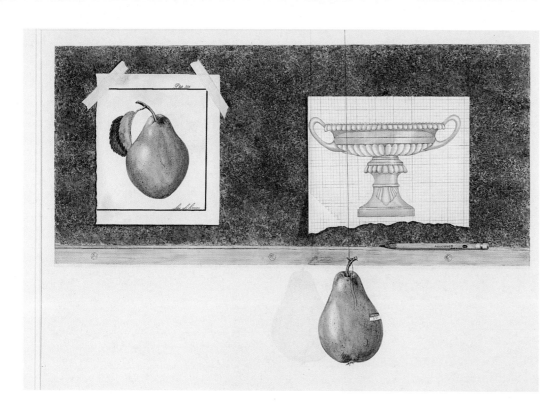

MARI M. CONNEEN
i.e., Still Life
19" x 26" (48 cm x 66 cm)
Strathmore 500 series

DOROTHY WATKEYS-BARBERIS
White Patterns
21" x 29" (53 cm x 74 cm)
Arches 140 lb. medium texture

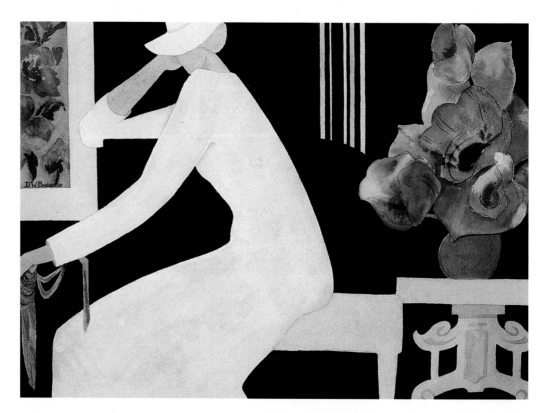

E. GORDON WEST
Inner Landscape
30" x 22" (76 cm x 56 cm)
Arches 300 lb. cold press

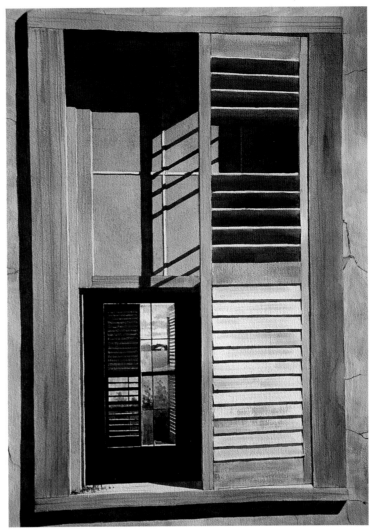

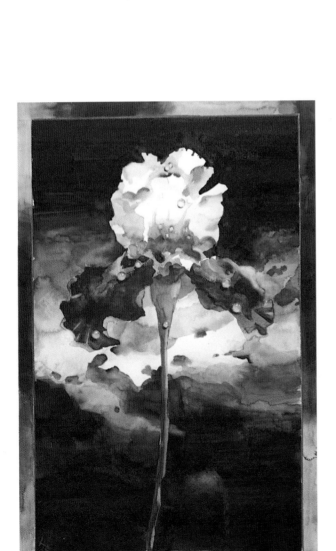

SHARON HILDEBRAND
The Iris Picture
34" x 24" (86 cm x 61 cm)
Fabriano 280 lb. cold press

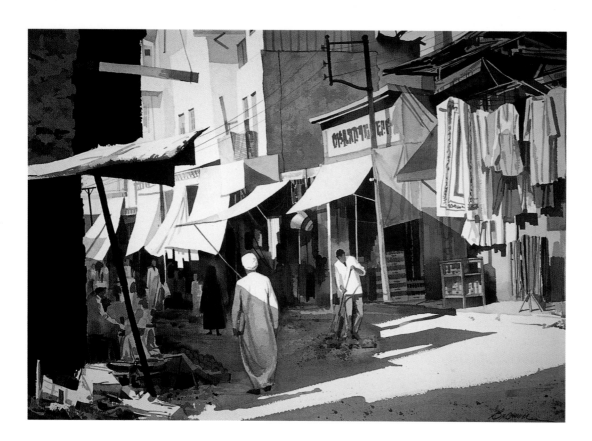

JACK R. BROUWER
Egyptian Market
24" x 29" (61 cm x 74 cm)
Arches 300 lb. cold press

RICHARD SULEA
Coop, South Face
30" x 40" (76 cm x 102 cm)
300 lb. cold press

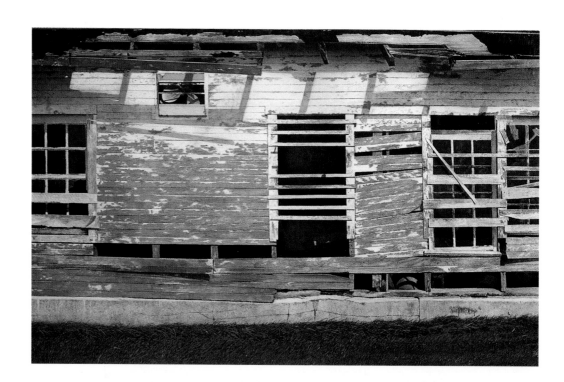

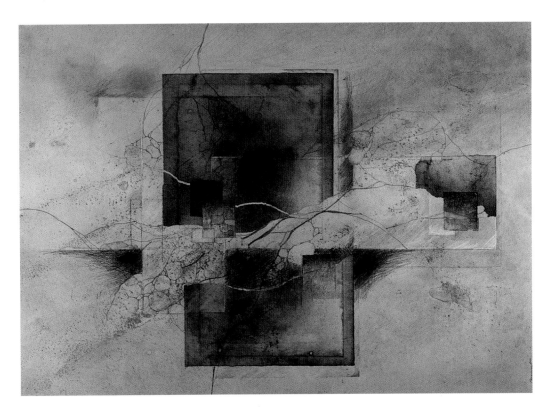

PEGGY BROWN
Crosscurrents
36" x 26" (91 cm x 66 cm)
Rives heavyweight
Watercolor, charcoal, and graphite

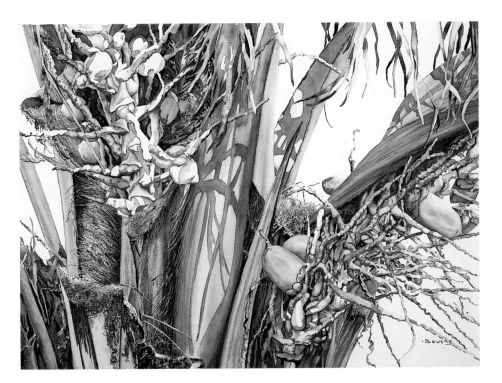

JUNE Y. BOWERS
We're Nuts, of Course
29.5" x 41" (75 cm x 104 cm)
Arches 555 lb. cold press

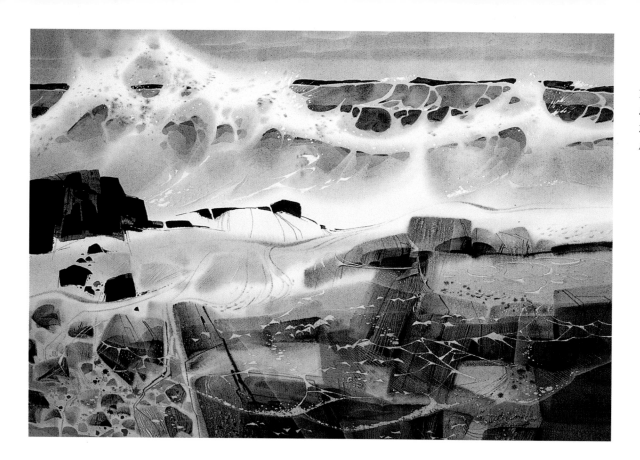

ROBERT ERIC MOORE
Surf-Covered Ledges
29" x 28.5" (74 cm x 72 cm)
Arches 140 lb. cold press

JERRY H. BROWN
Bobbie
22" x 30" (56 cm x 76 cm)
Arches 300 lb. cold press

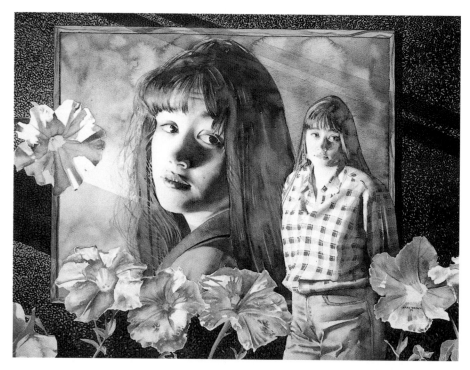

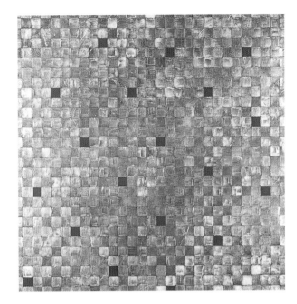

ANNELL LIVINGSTON

Urban Intersections—City Lights

30"x 30" (76 cm x 76 cm)

Arches 140 lb.

Watercolor and acrylic

EDWIN C. SHUTTLEWORTH

Road Work

21.5" x 29.5" (55 cm x 75 cm)

Arches 140 lb. cold press

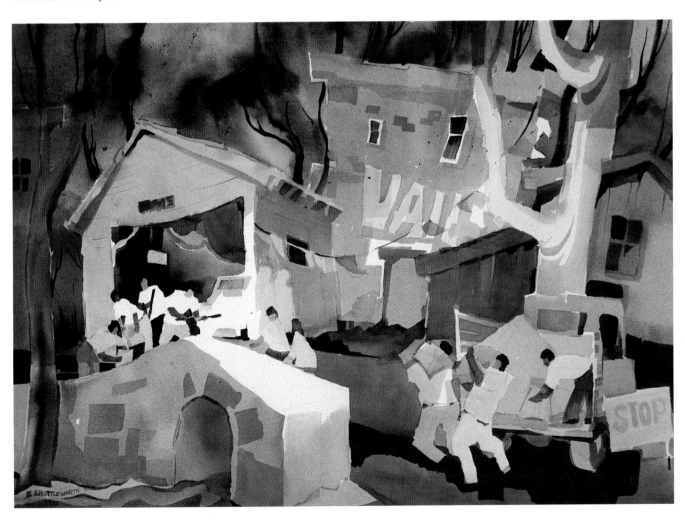

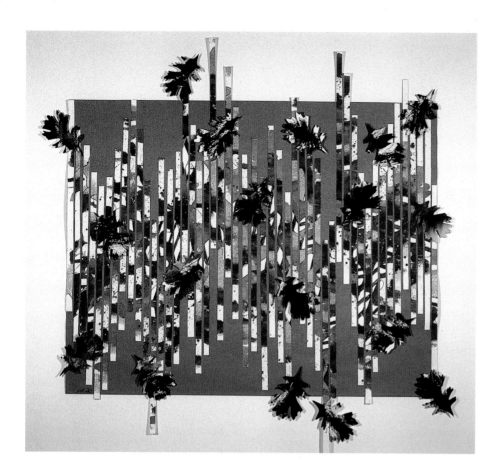

SHARON J. NAVAGE
Random Fall
29" x 28" (74 cm x 71 cm)
Arches 140 lb. rough; Canson gray
Watercolor, collage, and ink

PAUL D. BOBO
Convergence
11" x 14" (28 cm x 36 cm)
Winsor & Newton 140 lb. cold press
Watercolor and gouache

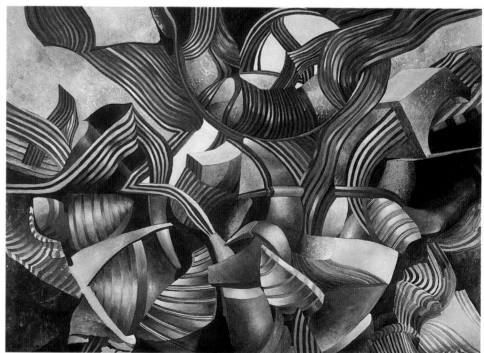

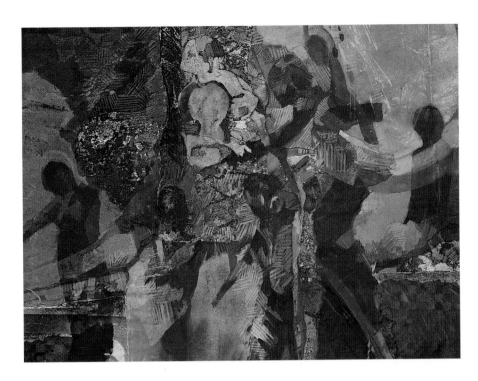

LENA R. MASSARA
Market Day
21" x 23" (74 cm x 53 cm)
Arches 140 lb. cold press
Watercolor, acrylic, stained rice papers,
collage on surface, ink, and line work

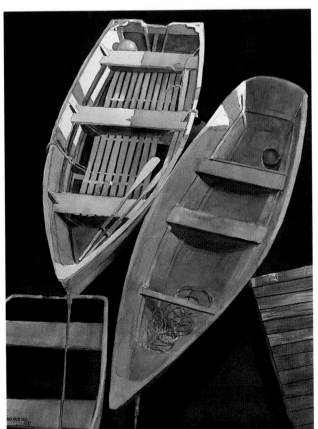

KUO YEN NG
Rockport Harbor
29" x 21" (74 cm x 53 cm)
Arches 300 lb. cold press

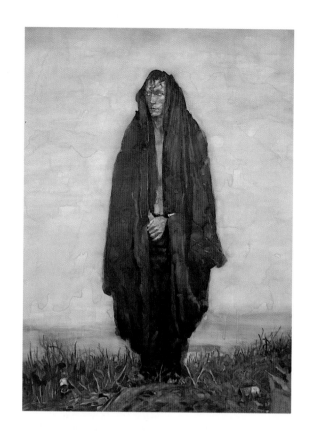

BILL JAMES
The Throwaway
30" x 24" (76 cm x 61 cm)
Crescent watercolor and gouache

EDITH MARSHALL
Dappled Vegetation
20" x 30" (51 cm x 76 cm)
Arches 140 lb. hot press
Watercolor, ink, and watercolor pencil
Special Technique: Paint was sprayed
onto gauze, wax paper and leaf shapes
were then laid onto the wet surface.

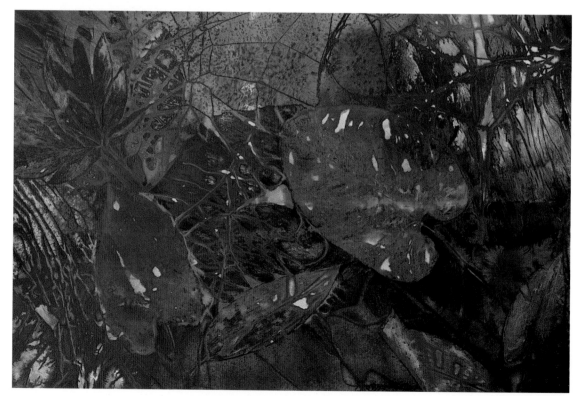

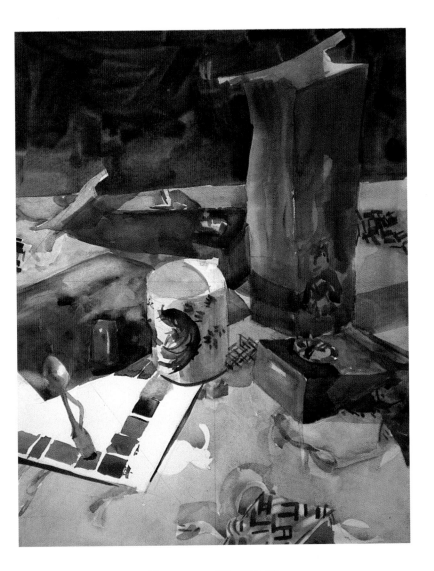

BARBARA M. PITTS
Cups and Bags
26" x 20.5" (66 cm x 52 cm)
Arches 140 lb. cold press

PHYLLIS HELLIER
D'Vinely Entwined
30" x 22" (76 cm x 56 cm)
300 lb. cold press
Watercolor, gouache, and ink

137

BOGOMIR BOGDANOVIC
Central Park in Winter
22" x 30" (56 cm x 76 cm)
140 lb. cold press

NATALIE GILLHAM
Canterbury Lantern Light
22" x 27" (56 cm x 69 cm)
Arches 140 lb. rough

NORMAN HINES
Wetlands
36" x 52" (91 cm x 132 cm)
300 lb.
Watercolor and acrylic

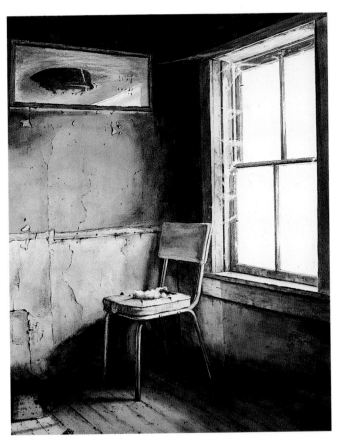

CLIFF AMRHEIN
Now We See in a Mirror Dimly
30" x 22" (76 cm x 56 cm)
Arches 300 lb. rough

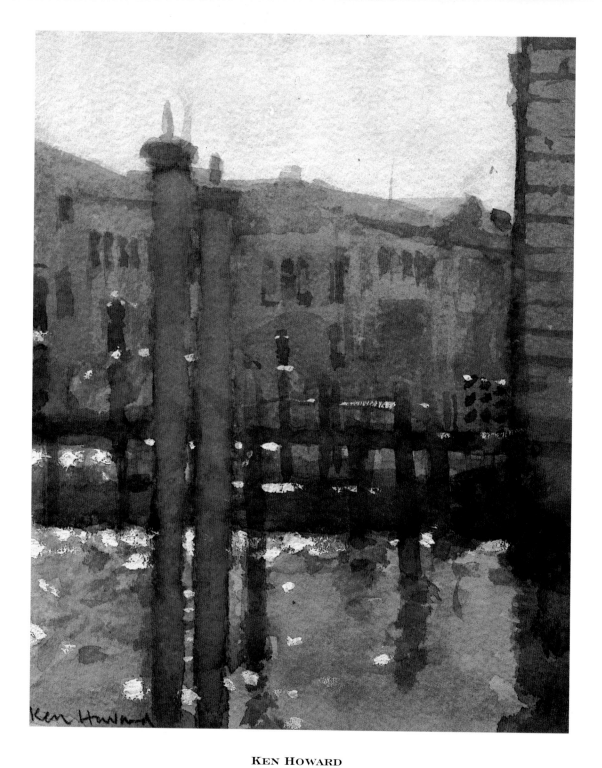

KEN HOWARD

Venice—Green and Grey

7" x 5" (18 cm x 13 cm)

Arches rough

Watercolor and Chinese white

About the
JUDGES

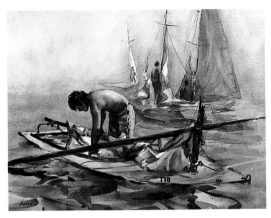

After the Storm
22" x 30" (56 cm x 76 cm)
Arches 140 lb. cold press

BETTY LOU SCHLEMM, A.W.S., D.F., has been painting for more than thirty years. Elected to the American Watercolor Society in 1964, and later elected to the Dolphin Fellowship, she has served as both regional vice-president and director of the American Watercolor Society. Ms. Schlemm is also a teacher and an author. Her painting workshops in Rockport, Massachusetts, have become renowned during the past twenty-nine years. Her book *Painting with Light*, published by Watson-Guptill in 1978, has remained a classic. She also has recently published *Watercolor Secrets for Painting Light*, distributed by North Light, Cincinnati, Ohio.

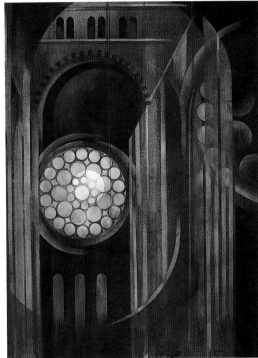

English Cathedral
30" x 22" (76 cm x 56 cm)
Arches medium

LARRY WEBSTER, N.A., A.W.S., D.F., is a painter, printmaker, and graphic designer. His awards include second prize in the North American Open Watercolor Competition, the Art Room Award of the North American Watercolor Society, and the High Winds Medal and the Dolphin Fellowship of the American Watercolor Society. A graduate of Massachusetts College of Art and Boston University, he resides in Topsfield, Massachusetts. His work is shown at Colby College Art Museum, Waterville, Maine; the DeCordova Museum, Lincoln, Massachusetts; the Houghton Library, Harvard University, Cambridge, Massachusetts; and the First National Bank of Boston, among other places.

Z. L. Feng, A.W.S., N.W.S.
89
1006 Walker Drive
Radford, VA 24141

Mary Lou Ferbert *31*
334 Parklawn Drive
Cleveland, OH 44116

Joseph Fettingis *29*
Lakeview Studio
625 Lakeview Drive
Logansport, IN 46947

Jack Flynn, A.W.S. *87*
3605 Addison Street
Virginia Beach, VA 23462

Kay Rebber Foote *108*
74 Emerald Bay
Laguna Beach, CA 92651

Christine Fortner *102*
10114 Ronald Place
Eagle River, AK 99577

Pat Fortunato *91*
70 Southwick Drive
Orchard Park, NY 14127-1650

Rowena Francis *101*
P.O. Box 1087
Rimrock, AZ 86335

Barbara Freedman *23, 64*
14622 W. Arzon Way
Sun City West, AZ 85375

Kass Morin Freeman, A.W.S.
23
1183 Troxel Road
Lansdale, PA 19446

Jane Frey *51*
518 W. Franklin
Taylorville, IL 62568

Henry Fukuhara *85*
1214 Marine Street
Santa Monica, CA 90405

Judith Steele Gaitemand *39*
37 Rocky Neck Avenue
Gloucester, MA 01930

Dorothy Ganek *46*
125 Rynda Road
South Orange, NJ 07079

Helen Garretson, A.W.S.,
N.W.S. *48*
717 Maiden Choice Lane
Apt. 217
Baltimore, MD 21228

Bernard Gerstner *81*
3 Norseman Avenue
Gloucester, MA 01930

Natalie Gillham, M.W.S. *138*
289 Martin Road
Albion, MI 49224

Molly Gough *10*
3675 Buckeye Court
Boulder, CO 80304

Nessa Grainger *115*
212 Old Turnpike Road
Califon, NJ 07830

Jean Grastorf *94*
6049 4th Avenue N
St. Petersburg, FL 33710

Irwin Greenberg *23*
17 N. 67th Street
New York, NY 10023

Dorothy D. Greene *47*
6500 S.W. 128th Street
Miami, FL 33156

Beverly Grossman *70*
17960 Rancho Street
Encino, CA 91316

Robert Hallett *19*
30002 Running Deer Lane
Laguna Niguel, CA 92677

Charlotte Halliday *96*
36A Abercorn Place,
St. John's Wood
London, NW8 9XP
England

Dodie Hamilton *16*
3838 Cherry Lane
Medford, OR 97504

Ken Hansen Watercolors *78*
241 JB Drive
Polson, MT 59860

Noriko Hasegawa *5*
3105 Burkhart Lane
Sebastopol, CA 95472

Shirley Kruise Hathaway *100*
30583 J. Carls
Roseville, MI 48066

Phyllis Hellier *137*
2465 Pinellas Drive
Punta Gorda, FL 33983

Sandra Hendy *65*
82 Hunter Avenue
St. Ives 2075, Sydney
New South Wales
Australia

Sharon Hildebrand *129*
5959 St. Fillans Court W.
Dublin, OH 43017

Alan Hill *38*
2535 Tulip Lane
Langhorne, PA 19053

Norman Hines *139*
719 Flint Way
Sacramento, CA 95818

Susan Holefelder *72*
P.O. Box 1666
Scottsdale, AZ 85252

John R. Hollingsworth *109*
15426 Albright Street
Pacific Palisades, CA 90272

Ken Howard *21, 99, 140*
8 South Bolton Gardens
London, SW5 0DH
England

Sandra Humphries *18*
3503 Berkeley Place, NE
Albuquerque, NM 87106

Yumiko Ichikawa *26*
1706 Downey Street
Radford, VA 24141

Bill James, P.S.A.-M., K.A.,
A.W.S., N.W.S. *11, 136*
15840 S.W. 79th Court
Miami, FL 33157

Bruce G. Johnson *98*
953 E. 173rd Street
South Holland, IL 60473-3529

Edwin L. Johnson *53*
7925 N. Campbell Street
Kansas City, MO 64118-1521

Aletha A. Jones *18*
2133 Linden Avenue
Madison, WI 53704

Jane E. Jones *50*
5914 Bent Trail
Dallas, TX 75248

Jean Kalin, A.P.S.C., K.W.S.
119
11630 NW 64th Street
Kansas City, MO 64152

M. C. Kanouse *28*
6346 Tahoe Lane, SE
Grand Rapids, MI 49546

Dell Keathley *73*
124 Waterford Place
Alexandria, Virginia 22314

Barbara Keyser *102*
304 Tower Drive
San Antonio, TX 78232

Everett Raymond Kinstler,
N.A., A.W.S. *6*
15 Gramercy Park
New York, NY 10003

Judith Klausenstock *14, 30*
94 Reed Ranch Road
Tiburon, CA 94920

Lynne Kroll *116*
3971 N.W. 101 Drive
Coral Springs, FL 33065

Chris Krupinski *17*
10602 Barn Swallow Court
Fairfax, VA 22032

Sandra Thruber Kunz *83*
249 Daffodil Drive
Freehold, NJ 07728

Margaret Laurie *72*
4 Blake Court
Gloucester, MA
01930-3204

Alexis Lavine *36*
8 Greene Street
Cumberland, MD 21502

Nat Lewis *22, 27*
51 Overlook Road
Caldwell, NJ 07006

Jerry Little *26*
2549 Pine Knoll Drive #4
Walnut Creek, CA 94595

Katherine Chang Liu *14*
1338 Heritage Place
Westlake Village, CA 91362

Annell Livingston *133*
4032 NDCBU
Taos, NM 87571

Sherry Loehr *12, 91*
1365 Shippee Lane
Ojai, CA 93023

Connie Lucas *40*
1933 Bellingham
Canton, MI 48188-1808

Rosemary MacBird, N.W.S.
125
913 Q Ronda Sevilla
Laguna Hills, CA 92653

James Malady *25*
HC89 Box 223
Pocono Summit, PA 18346

Joseph Manning *36*
5745 Pine Terrace
Plantation, FL 33317

Martha Mans *57*
5755 Timpa Road
Chipita Park, CO 80809

Edith Marshall *136*
Rte. 1, Box 57-B
Hancock, MI 49930

Daniel J. Marsula, A.W.S.
123
2828 Castleview Drive
Pittsburgh, PA 15227

Lena R. Massara *135*
3 Lee Ward Court
Salem, SC 29676

Benjamin Mau, N.W.S. *47*
One Lateer Drive
Normal, IL 61761

Diane Maxey *7*
7540 N. Lakeside Lane
Paradise Valley, AZ 85253

John McIver, A.W.S., N.W.S.,
W.H.S. *58*
1208 Greenway Drive
High Point, NC 27262

Joan McKasson *84*
7976 Lake Cayuga Drive
San Diego, CA 92119

Geraldine McKeown, N.W.S.
42
227 Gallaher Road
Elkton, MD 21921

Suzanne McWhinnie *8*
32 Paper Mill Drive
Madison, CT 06443

Morris Meyer, N.W.S. *59*
8636 Gavinton Court
Dublin, OH 43017

Anita Meynig *86, 126*
6335 Brookshire Drive
Dallas, TX 75230-4017

Edward Minchin, A.W.S. *24*
54 Emerson Street
Rockland, MA 02370

Robert Eric Moore, N.A.,
A.W.S. *132*
111 Cider Hill Road
York, ME 03909-5213

Scott Moore *5, 52*
1435 Regatta Road
Laguna Beach, CA 92651

Sharon J. Navage *134*
2906 Laurel Avenue
Odessa, TX 79762

Georgia A. Newton *35, 42*
1032 Birch Creek Drive
Wilmington, NC 28403

JoRene Newton *41*
50 Palmer Lane, Woodcreek
Wimberley, TX 78676

Kuo Yen Ng *135*
4514 Hollyridge Drive
San Antonio, TX 78228-1819

Tom Nicholas, N.A., A.W.S.
79
7 Wildon Heights
Rockport, MA 01966

Michael L. Nicholson *15, 54*
255 South Brookside Drive
Wichita, KS 67218

Paul W. Niemiec, Jr. *32, 68*
P.O. Box 674
Baldwinsville, NY 13027

Vernon Nye *69*
305 Chablis S.
Calistoga, CA 94515

Terry O'Maley *111*
131 Richards Road
Benton, ME 04901

Rudolph Ohrning *25*
3318 Wilder Street
Skokie, IL 60076

Robert S. Oliver *60*
4111 E. San Miguel
Phoenix, AZ 85018

Jane Oliver *84*
20 Park Avenue
Maplewood, NJ 07040

Belle Osipow *114*
3465 Wonderview Drive
Los Angeles, CA 90068

Donald W. Patterson *106*
441 Cardinal Court N.
New Hope, PA 18938

Dick Phillips *51, 68*
7829 E. Hubbell
Scottsdale, AZ 85257

Jim Pittman *88*
Box 430
Wakefield, VA 23888

Barbara M. Pitts *137*
355 East Marion Street
Seattle, WA 98122-5258

John Pollock *38, 66*
1009 Nutter Boulevard
Billings, MT 59105

Barbara Sorenson Rambadt
62
3440 Nagawicka Road
Hartland, WI 53029

Judithe Randall *62, 82*
2170 Hollyridge Drive
Los Angeles, CA 90068

L. Herb Rather, Jr. *17, 98*
Rt. 1 Box 89
Lampasas, TX 76550

Pat Regan *125*
120 W. Brainard
Pensacola, FL 32501-2625

Donald G. Renner *97*
540 Holly Lane
Plantation, FL 33317

Robert Sakson *32*
10 Stacey Avenue
Trenton, NJ 08618-3421

John T. Salminen *46*
6021 Arnold Road
Duluth, MN 55803

Betty Carmell Savenor *45*
4305 Highland Oaks Circle
Sarasota, FL 34235

Janice Ulm Sayles *10*
4773 Tapestry Drive
Fairfax, VA 22032

Nick Scalise *96*
59 Susan Lane
Meriden, CT 06450

Betty Lou Schlemm, A.W.S.,
D.F. *141*
11 Caleb's Lane
Rockport, MA 01966

Aïda Schneider *20*
31084 E. Sunset Drive N.
Redlands, CA 92373

Ken Schulz, A.W.S. *59*
P.O. Box 396
Gatlinburg, TN 37738

Susan Amstater Schwartz
101
509 Linda
El Paso, TX 79922

Barbara Scullin *92*
128 Paulison Avenue
Ridgefield Park, NJ 07760

George Shedd, A.W.S.,
A.A.A., N.E.W.S. *55*
46 Paulson Drive
Burlington, MA 01803

Morris Shubin *124*
313 N. 12th Street
Montebello, CA 90640

Edwin C. Shuttleworth,
F.W.S. *133*
3216 Chapel Hill Boulevard
Boynton Beach, FL 33435

Delda Skinner *112*
8111 Doe Meadow
Austin, TX 78749

Susan Spencer *100*
306 Gordon Parkway
Syracuse, NY 13219

Donald Stoltenberg *43*
947 Satucket Road
Brewster, MA 02631

Gregory Strachov *12*
797 Mentor Avenue
Painesville, OH 44077

Paul Strisik, N.A., A.W.S.
110
123 Marmion Way
Rockport, MA 01966

Richard Sulea *130*
660 E. 8th Street
Salem, OH 44460

Anne D. Sullivan *77*
28 Rindo Park Drive
Lowell, MA 01851

Heidi Taillefer *67*
470 6th Avenue
Verdun, Quebec H4G 3A1
Canada

Janis Theodore *9*
274 Beacon Street
Boston, MA 02116

Greg Tisdale *50*
35 Briarwood Place
Grosse Pointe Farms, MI
48236

Linda Tompkin, A.W.S.,
N.W.S. *83, 105*
4780 Medina Road
Copley, OH 44321-1141

James Toogood, A.W.S.
33, 107
920 Park Drive
Cherry Hill, NJ 08002

Thomas V. Trausch *127*
2403 Mustang Trail
Woodstock, IL 60098

Harold Walkup *65*
5605 S.W. Rockwood Court
Beaverton, OR 97007

Wolodimira Vera Wasiczko
79
5 Young's Drive
Flemington, NJ 08822

Dorothy Watkeys-Barberis
128
217 Lincoln Avenue
Elmwood Park, NJ 07407-
2822

Larry Webster, N.A., A.W.S.,
D.F. *141*
116 Perkins Row
Topsfield, MA 01983

Alice W. Weidenbusch *35*
1480 Oakmont Place
Niceville, FL 32578

Sharon Weilbaecher *93*
31 Plover Street
New Orleans, LA 70124

Murray Wentworth *122*
132 Central Street
Norwell, MA 02061

E. Gordon West, A.W.S.,
N.W.S. *129*
2638 Waterford
San Antonio, TX 78217

Michael Whittlesea *41*
Richmond Cottage High Street
Hurley, Berkshire SL6 5LT
England

Mary Wilbanks, N.W.S. *49*
18307 Champion Forest Drive
Spring, TX 77379

Joyce Williams *86*
P.O. Box 192
Tenants Harbor, ME 04860

Douglas Wiltraut *13, 53*
969 Catasauqua Road
Whitehall, PA 18052

Ruth Wynn, A.W.S. *118*
30 Oakledge Road
Waltham, MA 02154

Ann Zeilinski *119*
Ford Cove
Hornby Island, BC V0R 1Z0
Canada

Elena Zolotnitsky *80*
205 Duke of York Lane, T-2
Cockeysville, MD 21030